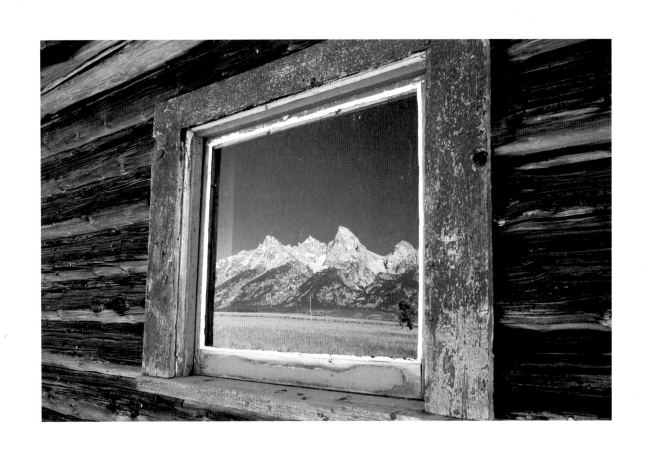

Wildlife Photographer of the Year

Portfolio 13

Wildlife Photographer of the Year

Portfolio 13

Published by
BBC Worldwide Limited,
Woodlands,
80 Wood Lane,
London W12 0TT

First published 2003

Managing editor
Rosamund Kidman Cox
Editor
Anna Levin
Designer
Traci Rochester
Jacket designer
Pene Parker
Caption writers
Rachel Ashton
Tamsin Constable
Production controller
Christopher Tinker
Competition manager
Sarah Kavanagh
Competition officer
Gemma Webster

ISBN 0 563 48772 0

Printed and bound in
the UK by Butler & Tanner Limited,
Frome
Jacket printed by
Lawrence-Allen Limited,
Weston-Super-Mare
Colour separations by
Pace Digital Limited, Southampton

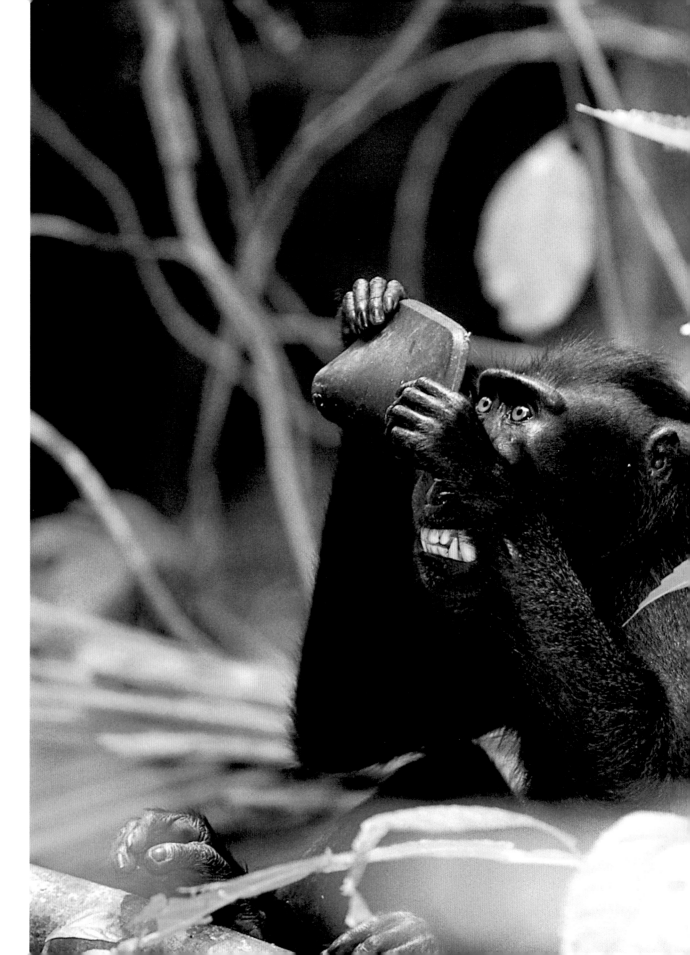

Contents

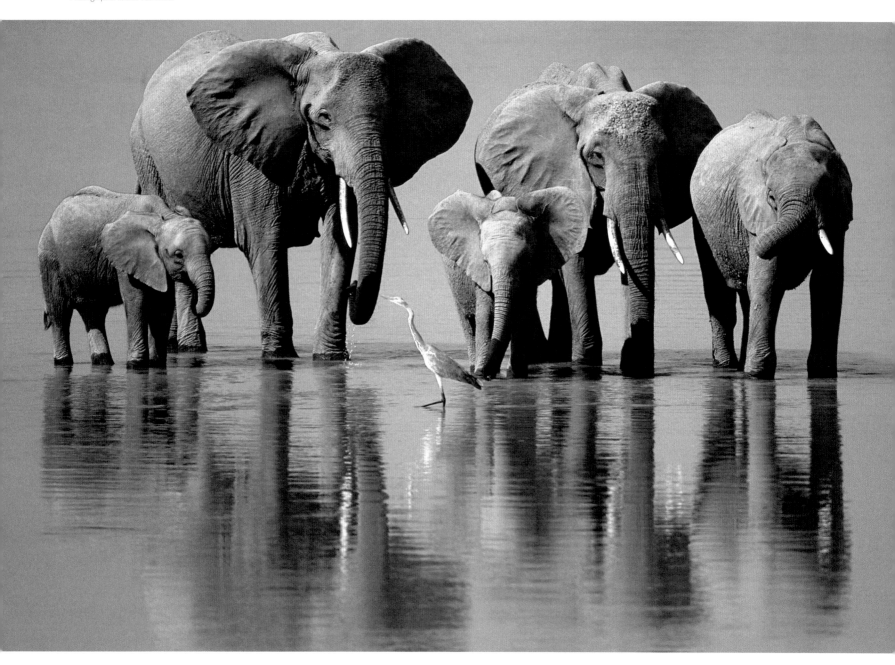

Foreword

by Simon King

Listening and hearing, touching and feeling, tasting and savouring, our senses may be applied generally or very specifically, none more so than our sense of sight.

The difference between looking and seeing is enormous. We may spend our whole lives looking at the world about us without truly seeing it. In its simplest expression, this means knowing what we're looking at in a factual way. Someone with a passing interest in birds may enjoy the spectacle of a flock of gulls, but an ornithologist will be able to see that the flock is made up of herring and lesser black-backed gulls, with a ring-billed gull thrown in for good measure. Does this then mean that the ornithologist sees what the other only looks at? On one level the answer must be yes, and yet the untrained eye may often see on an emotional level far clearer than the educated one. Ask a child of four what colour the evening sky has cast on the horizon, and purple, green, and yellow may well be in the mix. Ask the same child 10 years on, and red or orange is likely to be the response. To an extent, we learn what is expected of the world about us and sacrifice seeing for the easier route of preconceived looking.

This book is full of the evidence from people who can see. Some may argue, and not without reason, that photography is nothing more than a record, a virtual look at something. The vast majority of photographs taken are just that. The emotional engagement is restricted only to the experience of the moment when the photograph was taken and is not translated into the image itself. How many tedious heaps of someone else's holiday snaps have we all had to sit through while the person who took them giggles and savours the memories? But the medium of photography can transcend this level, and the image itself may encapsulate much more than light bouncing back from a subject.

The photographer's job is a tricky one, though. Compared to other media for artistic expression, photography is unforgiving. Painters or sculptors can choose to show only what they see in colour or form. In a landscape in oil, the paint can capture the perfect curve of the mountain in perpetuity, and the bulging muscle of an athlete may be isolated into a single block of bronze. These artists can express on the canvas or in clay the quintessence of their subjects. But the photographers have, to a point, their hands tied. In the competition from which this magnificent selection of photographs has sprung, image manipulation after the picture is taken is not endorsed, and manipulation of subjects is positively discouraged. The challenge is great. Wild creatures and wild places are tough enough to capture on film at all, let alone with depth and feeling. How extraordinary, then, that the following pages are stuffed full of passion that oozes out of every frame.

To further add to the task, the world of wildlife photography is a changing one, and many of the images in this book are a testament to that change. Where once it was sufficient simply to record a subject, now, and in this competition in particular, there is a hunger and demand for greater 'personalisation' of the image – for the viewer to be able to 'see' what the photographer saw, whether it is drama, sadness, pathos, power, grace or spine-tingling beauty. That is not to say that the days of the classic portrait are gone – far from it. Sometimes the most gripping emotion is in the eyes of the subject photographed. But it takes a very fine photographer to see that potential, and finer still to capture it on film.

But however masterfully the photographer, or any artist for that matter, conveys his or her message, the final test, is, to coin a cliché, in the eye of the beholder. Not everyone will see the same thing in each of the images, and that surely is the test of greatness – that even once executed there is room for the viewer to find their own way of seeing. So from here I urge you not simply to *look* through the following pages but instead to *see* what you can find.

This is a showcase for the very best photography worldwide featuring natural subjects. It is organised by two UK institutions that pride themselves on revealing and championing the diversity of life on Earth – the Natural History Museum and *BBC Wildlife Magazine*.

Its origins go back as far as 1964, when the magazine was called *Animals* and there were just three categories and about 600 entries. It grew in stature over the years, and in 1984, *BBC Wildlife Magazine* and the Natural History Museum joined forces to create the competition as it is today, with the categories and awards you see in this book. Now there are more than 20,500 entries and exhibitions touring through the year, not only in the UK but also worldwide,

from the US, Caribbean and South Africa, through Europe to Kazakhstan and Pakistan and across to Australia, Japan and China. As a result, the photographs are now seen by millions of people.

The aims of the competition are:
- To raise the status of wildlife photography into that of mainstream art.
- To be the world's most respected forum for wildlife photographic art, showcasing the very best photographic images of nature to a worldwide audience.
- To inspire a new generation of photographic artists to produce visionary and expressive interpretations of nature.
- To use its collection of inspirational photographs to make people, worldwide,

wonder at the splendour, drama and variety of life on Earth.

The judges put aesthetic criteria above all others but at the same time place great emphasis on photographs taken in wild and free conditions, considering that the welfare of the subject is paramount.

Winning a prize in this competition is something that most wildlife photographers, worldwide, aspire to. Professionals do win many of the prizes, but amateurs succeed, too. And that's because achieving the perfect picture is down to a mixture of vision, luck and knowledge of nature, which doesn't necessarily require an armoury of equipment and global travel, as the pictures by young photographers so often emphasise.

1991
Frans Lanting.

1992 André Bärtschi.

Previous award-winners

1993
Martyn Colbeck.

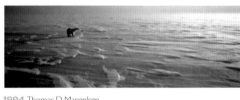

1994 Thomas D Mangelsen.

1995
Cherry Alexander.

1996
Jason Venus.

The Natural History Museum

Home to a world-class natural history collection and one of London's most beautiful landmarks, the Natural History Museum is also highly regarded for its pioneering approach to exhibitions, welcoming this year more than two million visitors of all ages and levels of interest.

Wildlife Photographer of the Year is one of the Museum's most successful and long-running special exhibitions, and we are proud to have helped make it the most prestigious competition of its kind in the world. The annual exhibition of award-winning images – now in its twentieth year – attracts a large audience, who come not only to admire the stunning images but also to gain an insight into important global concerns such as conservation, pollution and biodiversity – issues at the heart of the Museum's work.

In 2002, the Museum opened Phase One of the Darwin Centre, a significant new development, which reveals for the first time the incredible range of our

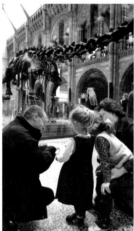

collections and the scientific research they support. Both the Darwin Centre and *Wildlife Photographer of the Year* celebrate the beauty and importance of the natural world and encourage visitors to see the environment around them with new eyes.

Please visit **www.nhm.ac.uk** for further information about activities at the Museum. Phone: +44 (0)20 7942 5000, email: information@nhm.ac.uk Information Enquiries, The Natural History Museum, Cromwell Road, London SW7 5BD

BBC Wildlife Magazine

BBC Wildlife is the UK's leading monthly magazine on nature and the environment. It showcases world-class photography and the best and most informative writing of any consumer magazine in its field. The contents include photographic portfolios, the latest biological discoveries, insights, views and news on wildlife, conservation and environmental issues in the UK and worldwide and a monthly illustrated natural history field guide. The magazine's aim is to inspire readers with the sheer wonder of nature and highlight our dependence on it, and to present them with a view of the natural world that has relevance to their lives.

Further information
BBC Wildlife Magazine, Broadcasting House,

Whiteladies Road, Bristol BS8 2LR wildlife.magazine@bbc.co.uk

Subscriptions
Tel: +44 (0) 870 4447013 Fax: +44 (0) 870 4442565 wildlife@galleon.co.uk Quote WLPF03 for the latest subscription offer.

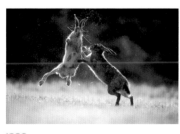

1998
Manfred Danegger.

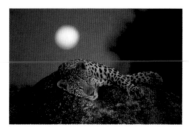

1999
Jamie Thom.

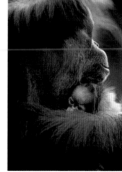

2000
Manoj Shah.

1997
Tapani Räsänen.

2001
Tobias Bernhard.

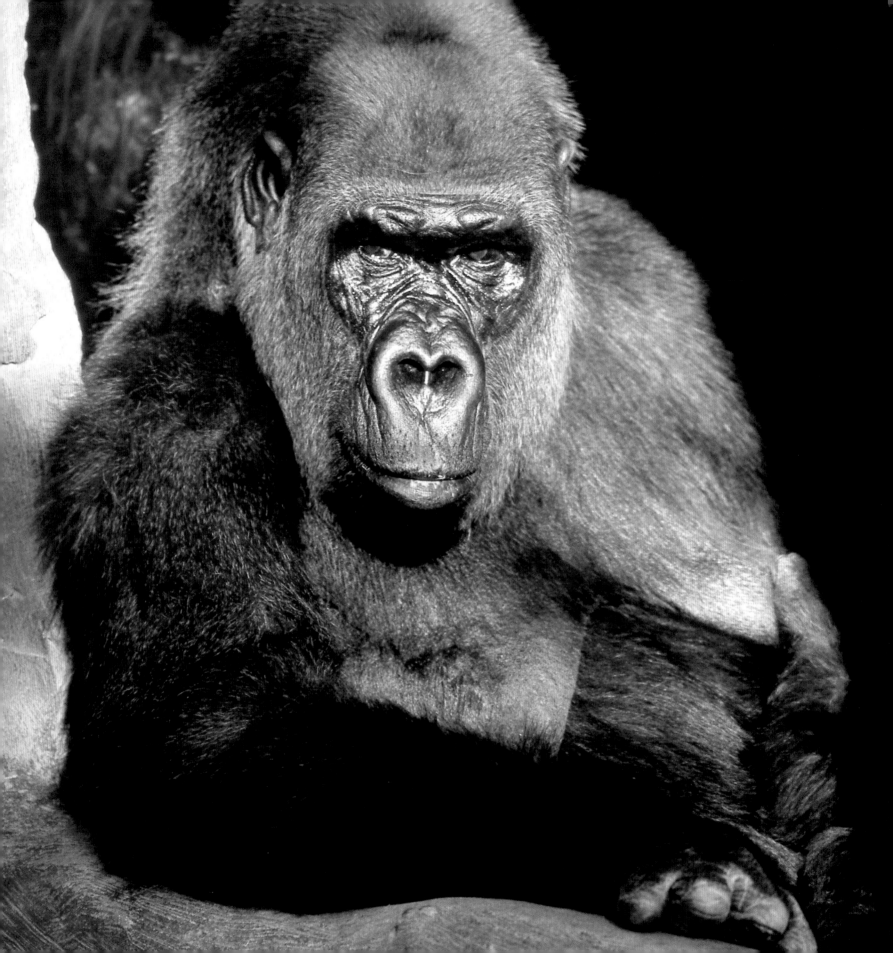

Wildlife Photographer of the Year Award
Gerhard Schulz

This is the photographer whose picture has been voted as being the most striking and memorable of all the competition's entries. In addition to a big cash prize, the award winner receives the coveted title Wildlife Photographer of the Year.

 WINNER

THE WORLD IN OUR HANDS

Gerhard Schulz
Germany

GORILLA AND BOY
From the other side of the gorilla house at Miami Metrozoo in Florida, I could watch the visitors' reactions as they encountered their relatives at close quarters. Many people came by, pointed at the lowland gorillas and continued on their way, but this boy stopped and stared in awe. It was their expressions that made such an impression on me. There was such a depth of feeling in the gorilla's eyes, and the boy leant against the glass as if he wanted to reach through and make contact. It was a poignant juxtaposition.
Canon EOS 1V, with 600mm f4 lens; 1/250 sec at f8; Fujichrome Sensia 100; Sachtler tripod.

Gerhard Schulz has been fascinated by the natural world since childhood and has always found inspiration in wildlife books and magazines. A holiday in Kenya in 1987 first inspired him to explore his interest through the means of photography. He describes this trip as a turning point in his life, as though he was a complete beginner with only a small amateur camera, he decided to commit himself to learning photography step by step. For 12 years, he worked as a taxi driver in Hamburg so that he could take the time to develop his photographic interests with regular trips to the national parks of Europe and the US. Since 2001, he has been a full-time professional photographer, specialising in the ospreys of the Everglades National Park and European otters in Germany and the Czech Republic.

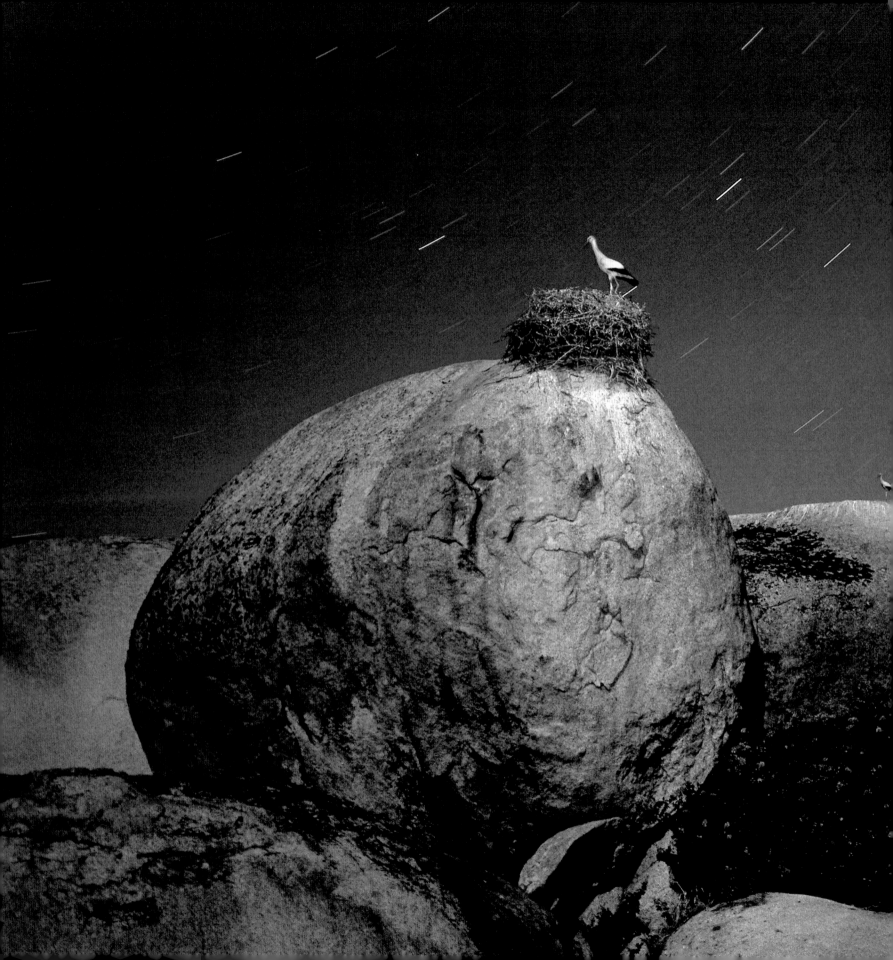

Innovation Award
José B Ruiz

This award exists to encourage innovative ways of looking at nature. It is given for the photograph that best illustrates originality of both composition and execution.

A self-taught photographer and naturalist, José B Ruiz began his professional career after winning a wildlife photography competition at Murcia University. Since then he has worked as a photographer and adviser for a range of councils and environmental organisations in Spain, as well as script writing and presenting wildlife documentaries for television. The author of eight books, he teaches wildlife photography and his work has been widely published in leading environmental magazines. José has spent the past year travelling though Spain photographing landscapes and wildlife for a book on photography at night.

 WINNER
DUSK TO DAWN

WHITE STORKS ROOSTING AT NIGHT
In Barruecos Natural Park, in Extremadura, Spain, the storks nest on these impressive boulders to avoid predators. After breeding, the birds still use their nests for roosting. It took several months to make exposure tables for night photography, including the moon phase, distance, lens and flash (the storks were unpeturbed by the flash), and memorise the information. I photographed from a distance to emphasise the drama of the landscape and leave a proportion of sky to be filled with star trails (caused by the rotation of the Earth, which makes the stars appear to move). The camera was pointing south-east during the six-minute exposure – the further you point from the North star, the longer the trails appear.
Nikon FM-2, with 50mm f2 A1S lens; 6 mins at f2.8; Fujichrome Velvia; flash fired 5 times; teleflash.

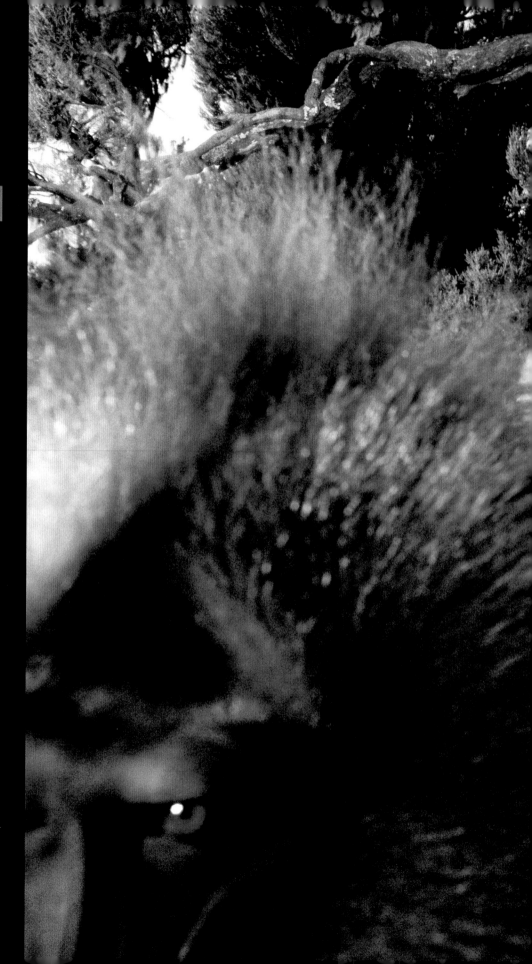

The Gerald Durrell Award for endangered wildlife

This award commemorates the late Gerald Durrell's work with endangered species and his long-standing involvement with the competition. It features species that are critically endangered, endangered, vulnerable or at risk (as officially listed in the IUCN Red List of Threatened Species).

Michael 'Nick' Nichols, currently a staff photographer at *National Geographic*, says photography is the only job he has ever had and the only life he has ever known. He studied with American LIFE civil-rights photographer Charles Moore (from the same small town in Alabama) before joining Magnum Photos in 1982, where the legacy of socially conscious images inspired him to create environmentally conscious work. He has spent 10 years working in Central Africa with conservationist Mike Fay and aims to document the truly wild, rather than tame or captive subjects, believing that even habituation lessens the impact of the work. Michael is the author of a number of books, including *Brutal Kinship* with Jane Goodall.

 WINNER

Michael Nichols
USA

GELADA TROOP
Geladas enjoy a rich social life, and I wanted to capture that intimacy. Here, bachelor males watch a family near 100- 200-year-old heather trees in Ethiopia's Simien National Park. The geladas climb down a sheer cliff face every evening to sleep on ledges, safe from predators. At dawn, they climb up again to exactly the same spot to warm themselves in the sun. Geladas are isolated in pockets of fragile alpine grassland, which continue to shrink with the pressure of livestock- grazing and habitat-clearance for crops. They have nowhere else to go.
Nikon n90, with 24mm Nikkor lens; 1/125 sec at f8; Kodak 100 SW; radio trigger and three strobelights.

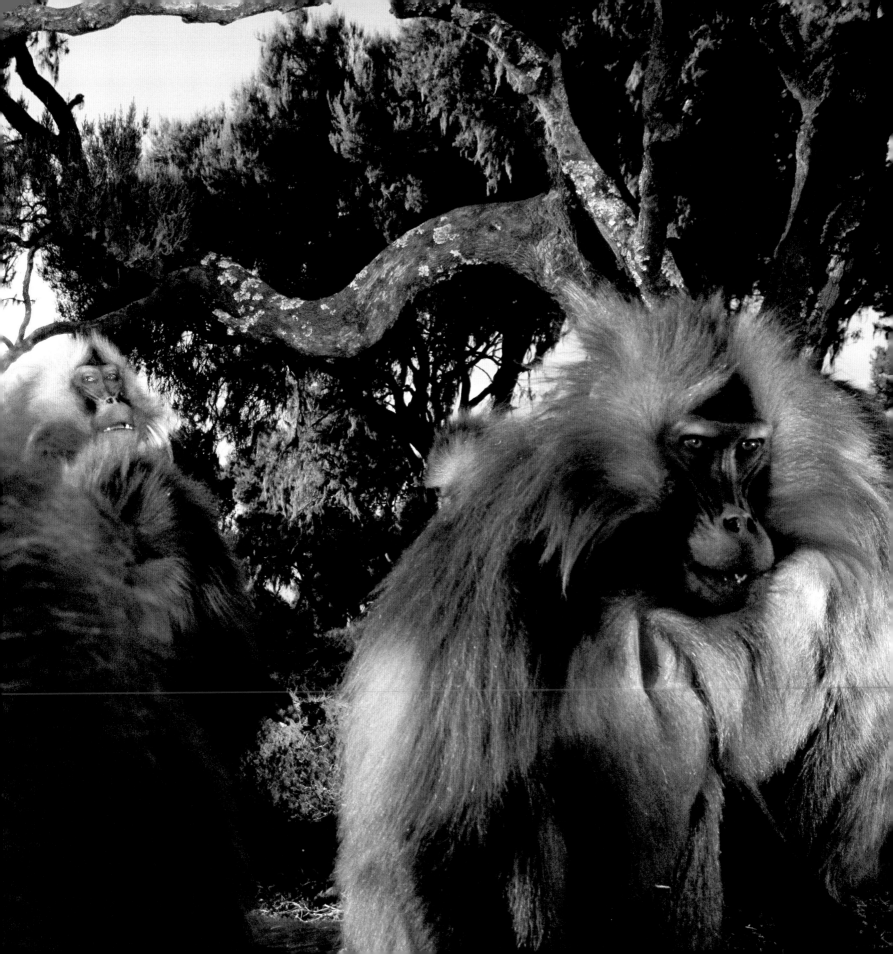

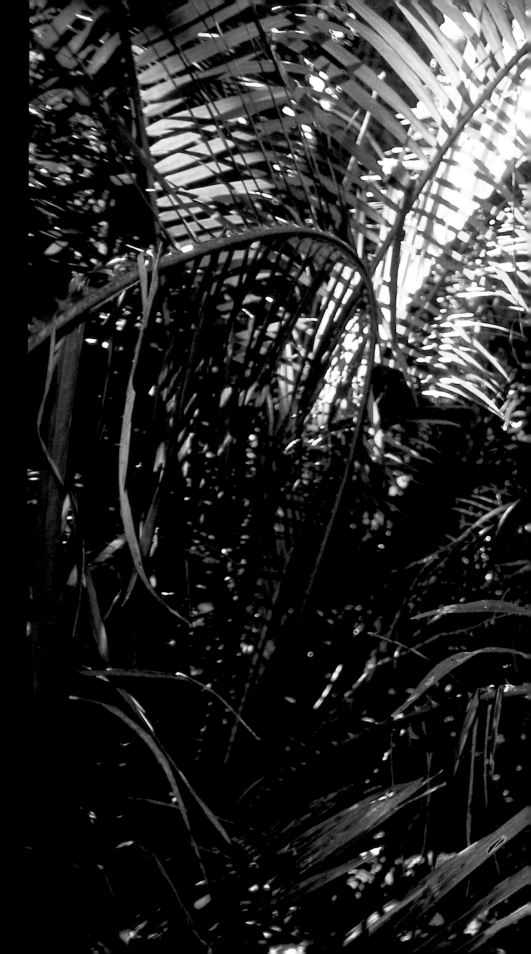

 RUNNER-UP

Stefano Unterthiner
Italy

**ZANZIBAR RED
COLOBUS MONKEY**
Indigenous to the island of
Zanzibar off Tanzania,
Zanzibar red colobus
monkeys have become a
tourist attraction. With 2,000
or fewer individuals
remaining, the species is one
of the most endangered
primates in Africa.
I photographed this individual
last September in Jozani
Forest, which is the last safe
refuge for the monkeys.
Unfortunately, the animals
stray into agricultural fields
and damage crops south of
the forest, which puts them at
risk from farmers.
**Nikon F5, with 17-35mm lens;
Fujichrome Provia F; flash.**

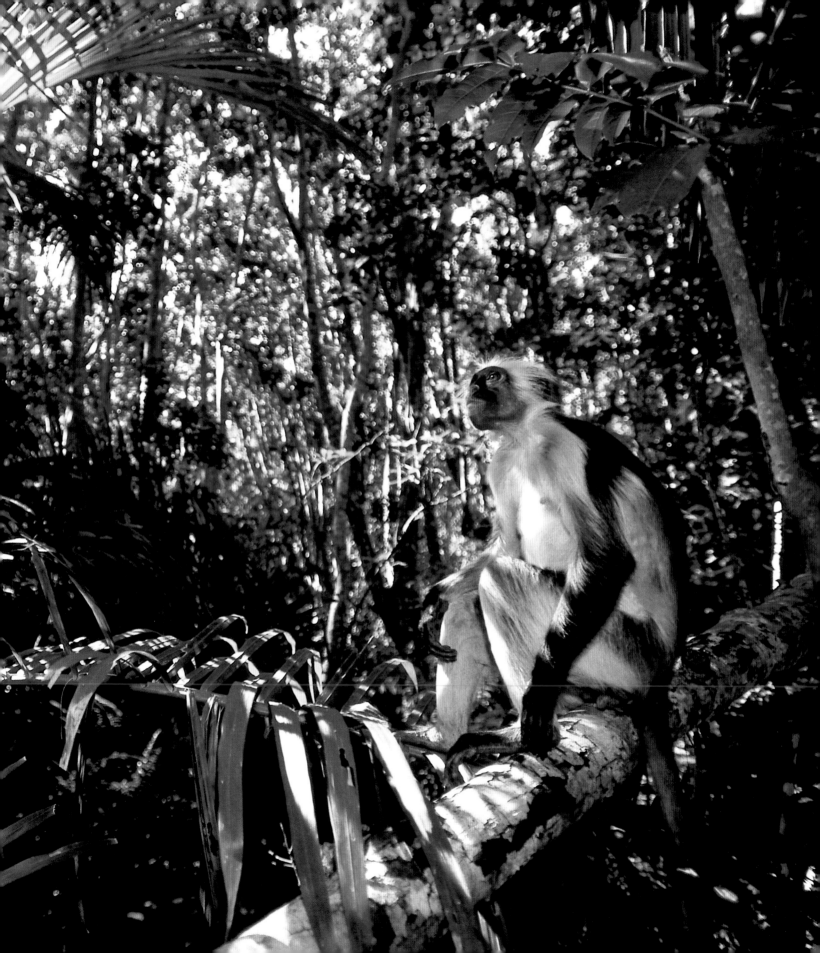

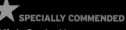 SPECIALLY COMMENDED

Nick Garbutt
UK

**PROBOSCIS MONKEY
LEAPING**
Proboscis monkeys leap
across the waterways that
criss-cross Borneo's
mangrove forests, where they
live in troops of 10-30. They
can clear distances of up to 10
metres. If the river is wider
than this, a proboscis monkey
will jump into the middle and
paddle to the other side.
These endemic monkeys are
skilled swimmers – and the
only primates with partially
webbed feet. I took a small
boat out on the Mananggol
River, a tributary of the
Kinabatangan River in Sabah,
to photograph this alpha male
in mid-leap. He belongs to a
population of just 2,000
proboscis monkeys left in
the area.
**Nikon F5, with 500mm F4 Nikkor
lens; 1/125 sec at f4; Fujichrome
Provia F 100; tripod.**

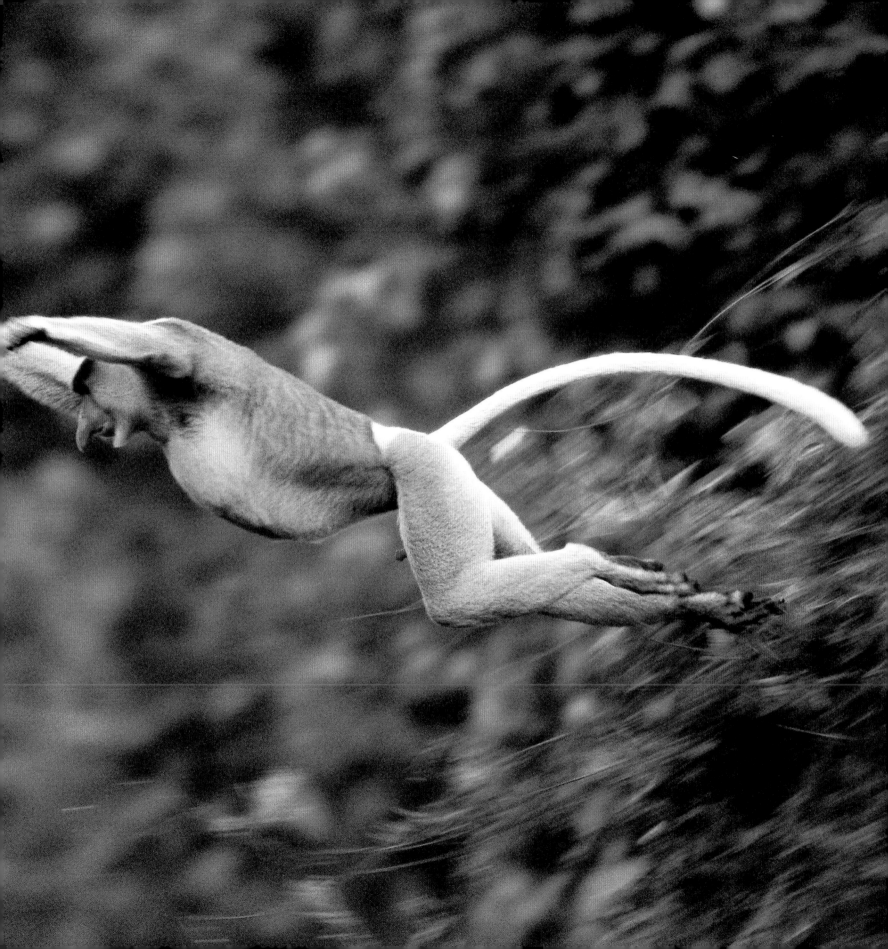

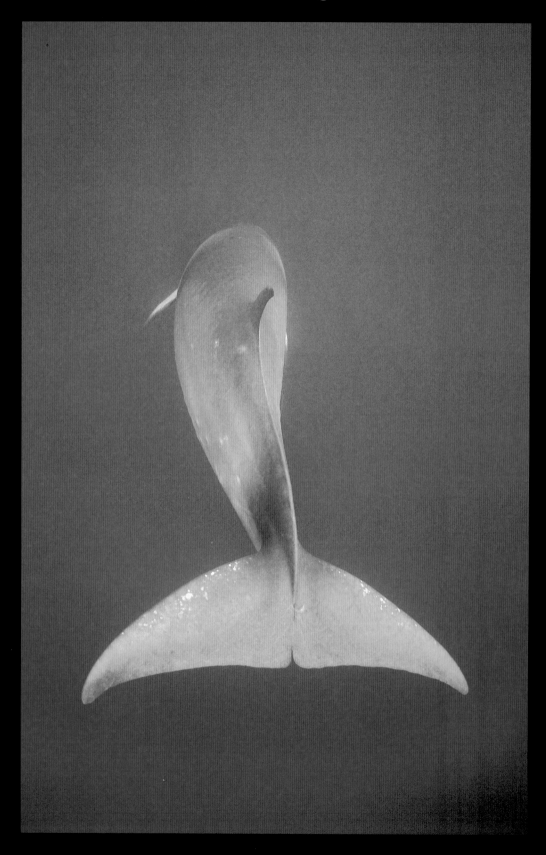

Stephen Wong
UK

DWARF MINKE WHALE
In May and June, about 200 of these small baleen whales, found only in the southern hemisphere, come to Australia's Great Barrier Reef. They readily approach snorkellers, divers and boats, swimming close, then veering away at the last moment with precision control. This individual approached me head-on, dipped below my fins and then immediately rose up again. I spun around to see that it had stalled momentarily, as if showing off another perspective of its beauty.

Nikon RS, with 20-35mm zoom lens; 1/125 sec at f4; Fujichrome Provia 100 rated at 200.

HIGHLY COMMENDED

Pete Oxford
UK

**LEAR'S MACAWS
FEEDING**

With a cacophony of raucous screeches, a flock of rare Lear's macaws descended on the licuri palm in front of my hide. I was in the Caatinga area, a spiny, semi-arid habitat in north-eastern Brazil. It's the only place where Lear's macaws still live wild, illegal trafficking and other pressures having decimated their numbers. By the late 1990s, only about 170 individuals remained. With help from the Bio Brasil Foundation, which has been protecting nesting areas and licuri palms (the macaws' favourite food), numbers probably now hover at about 400 individuals.

Nikon F5, with 600mm lens and 1.4x teleconverter; f5.6; Fujichrome; tripod; flash.

HIGHLY COMMENDED

Claudio Calosi
Italy

CHEETAH HUNTING AN IMPALA

Panting heavily, this male cheetah lay in shade by the Timbavati River in South Africa's Kruger National Park, recovering from a failed hunting attempt. After a few minutes, he spotted an impala and exploded into a sprint. He hooked his claws into the impala's rump, trying to yank it to the ground, but the impala managed to stay upright. It struggled desperately against what seemed like an inevitable death. But in the end, the impala's sheer survival instinct won the day and it managed to escape. The cheetah, once again, had to lie down and recover from a fruitless chase.

Canon EOS 3, with 300mm EF-IS f2.8 lens; 1/500 sec at f5.6; Fujichrome Provia F100; beanbag.

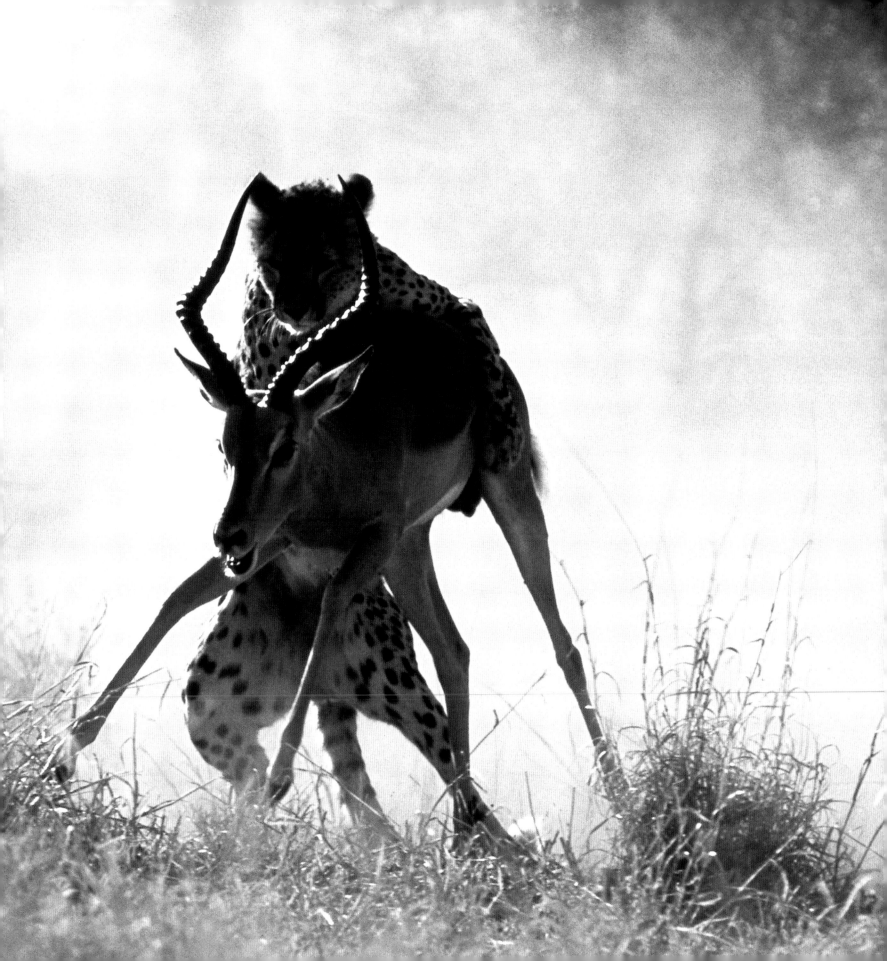

Animals in their environment

These photographs must show the habitat as an important a part of the picture as the plants or animals being shown. The image must also convey a sense of the relationship between the plant or animal and its habitat.

 WINNER

Jean-Pierre Zwaenepoel
Belgium

HANUMAN LANGURS PLAYING
For the past three years, I have spent my holidays following a troop of Hanuman Langurs at the edge of the Thar Desert in Rajasthan, India. I chose this particular troop because it roamed around spectacular scenery. Some of the young liked playing on these rocks, and I took a photograph almost identical to this a while ago but wasn't satisfied with the light conditions. I had this picture in my mind all the time, but had to wait until my third trip to get it right.
Nikon F801, with 20mm lens; Fujichrome Velvia.

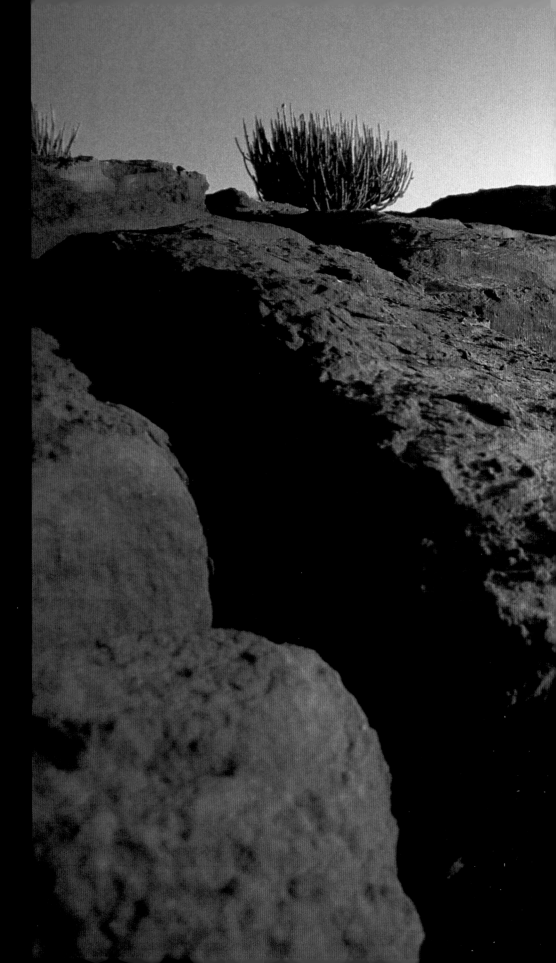

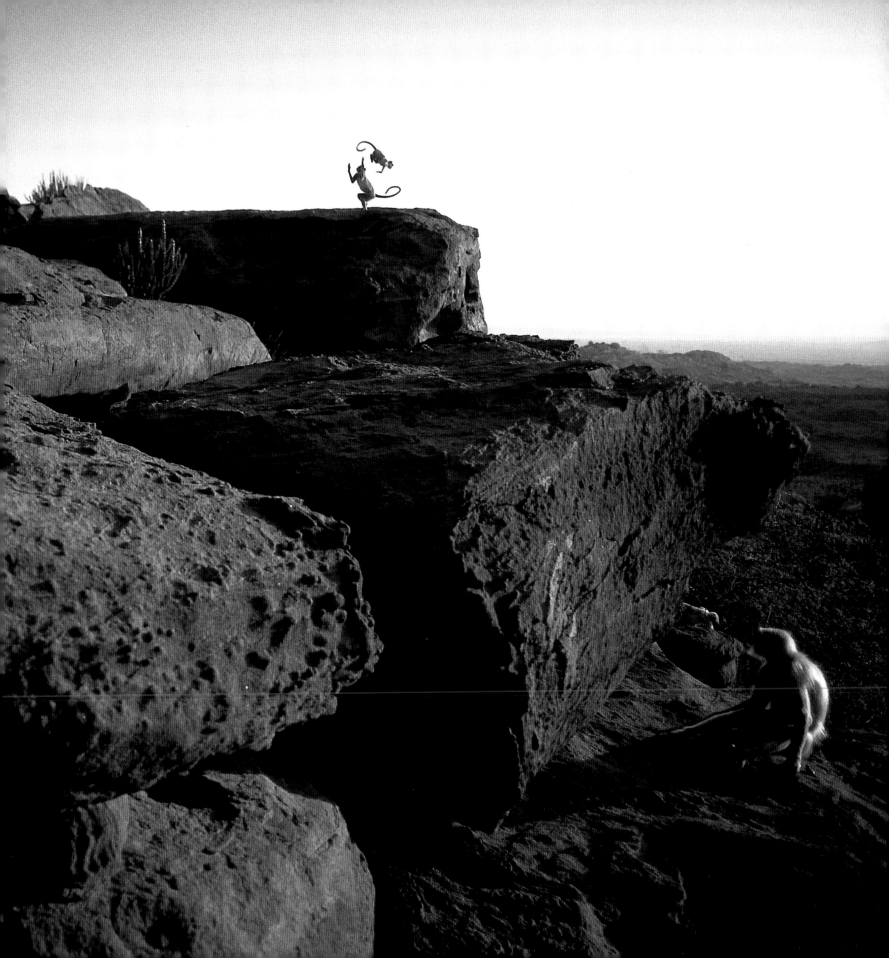

 RUNNER-UP

Olivier Grunewald
France

**TENEBRIONID BEETLE
DRINKING DEW**
I was in the northern, sandy part of the Namib Desert, Namibia, studying the adaptation of the wildlife to this arid land. One early morning in October, after a foggy, cold night, I watched this tenebrionid beetle climb onto the edge of a high dune and do 'headstands'. It turned its body so that it faced into the wind, straightened out its rear legs and lowered its head. In this way, its back served as a condensation surface for the fog. Then the beetle could drink the water, which hung in droplets from its mouthparts.
Nikon F801, with 17-35mm f2.8 lens; 1/8 sec at f16; Fujichrome Velvia rated at 40; tripod; grey gradual filter.

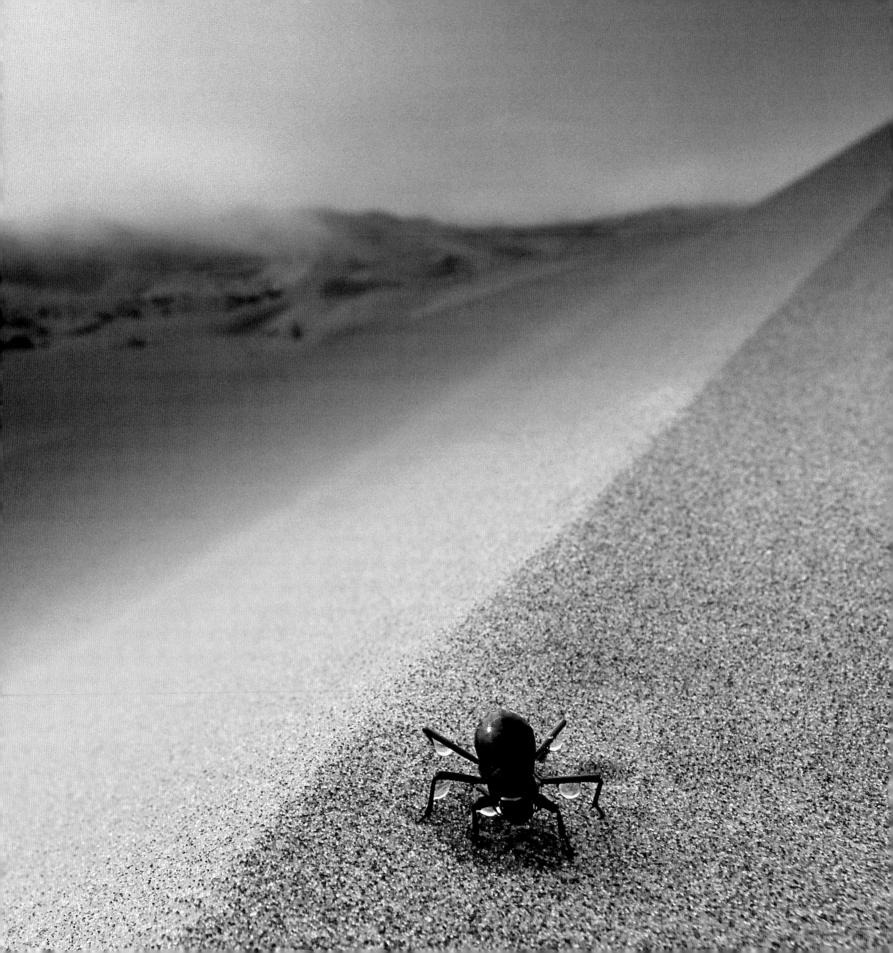

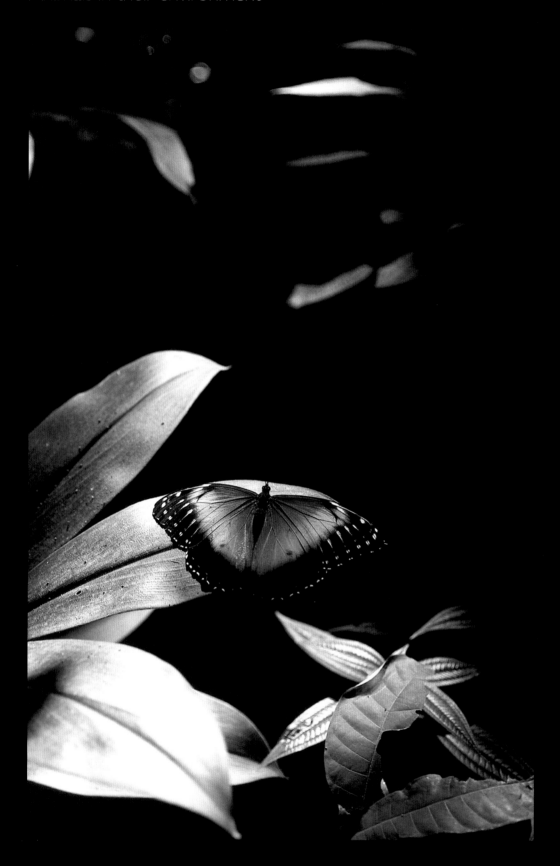

David Maitland
UK

MORPHO BUTTERFLY DISPLAYING
Morpho butterflies flit through the forest revealing their presence with tantalising, neon-blue flashes. As a tropical field researcher, I have seen many morpho butterflies over the years, but this is the most intimate view I've had – of a female, in Trinidad's northern rainforest in Arima Valley, basking in a shaft of sunlight and displaying to a passing male. This particular species, *Morpho deidamia*, was only named in 1993.

Olympus OM4Ti, with 50mm macro lens; 1/125 sec at f5.6; Kodachrome 64.

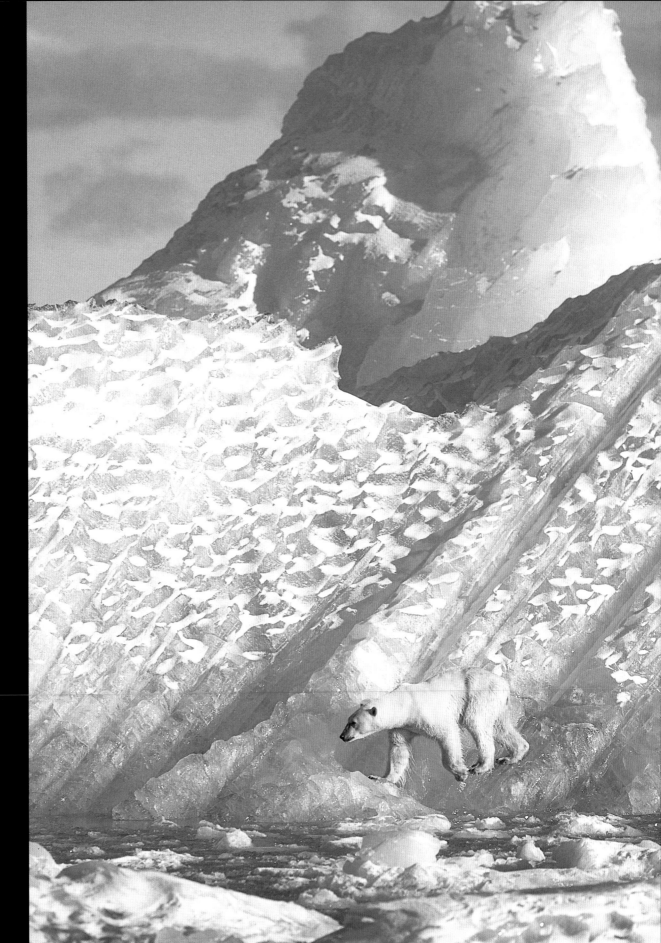

 SPECIALLY COMMENDED

Jan-Peter Lahall
Sweden

POLAR BEAR

Norwegian polar bears live on a freezing treadmill. Wind and currents constantly shift the sea-ice around. To avoid losing contact with the main pack-ice and floating out into the open waters further south, the polar bears of the Svalbard Islands spend most of the year trudging against the drift. This relentless walking uses up lots of energy, which may explain why they are smaller than their North American cousins. I had already been to Svalbard three times but had not managed to get a single decent photograph. On the fourth trip, just as I was about to give up, this bear wandered across the glacier and gave me the perfect shot.

Canon EOS 3 with 70-200mm f2.8 lens; 1/250 sec at f8; Fujichrome Velvia.

Daniel Magnin
France

IBEX ABOVE THE CLOUDLINE

Ibex spend most of the year above the treeline, at altitudes of 2,500 to 3,500 metres, though they have occasionally been seen at more than 6,000 metres. I was in the Swiss Jura Mountains during the annual rut in December when I came across this old male settled on a promontory gazing over the sunlit clouds. I wanted to include part of the sky in the shot, but the only way to do so was for me to lie down in the snow. After a few minutes, the ibex left, negotiating the narrow rock ledges with incredible agility.

Canon EOS 3 with 20-35mm lens used at 20mm; 1/250 sec at f11; Fujichrome Sensia 100.

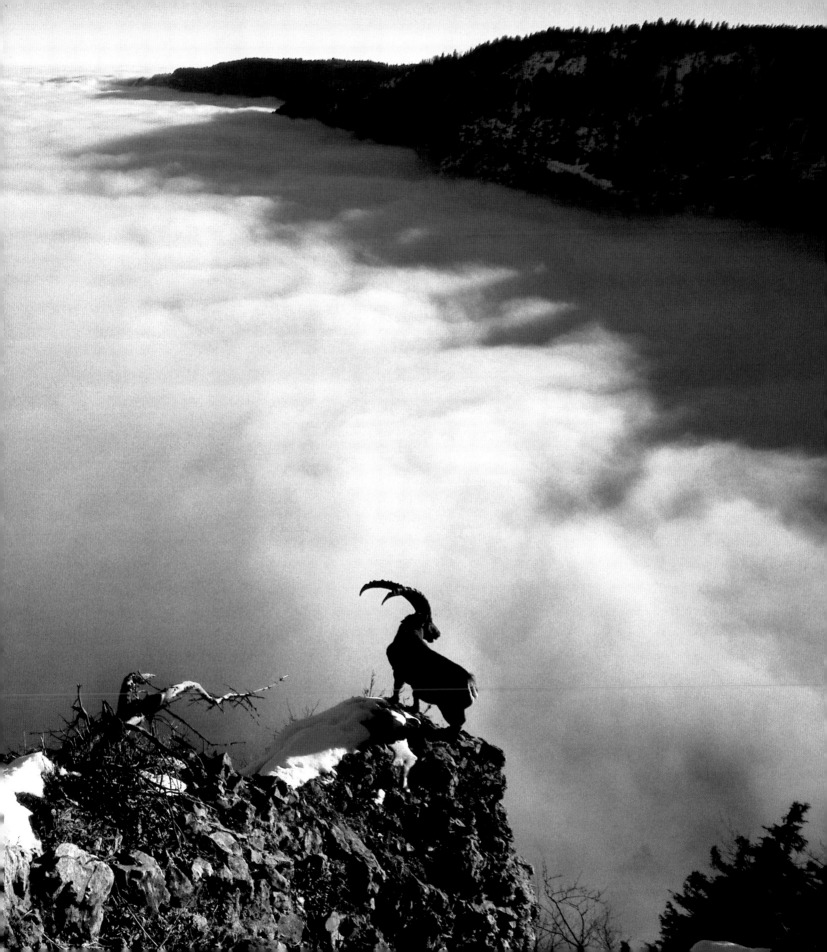

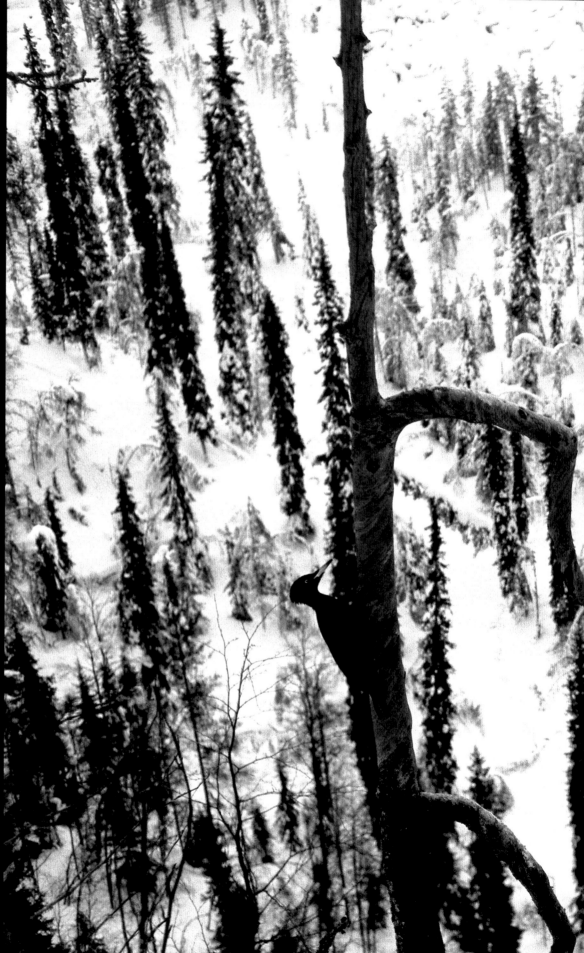

Benjam Pöntinen
Finland

BLACK WOODPECKERS

From inside a hide built right
on the edge of a ravine in
Korouoma, near Posio,
Finland, I gazed down a sheer
50-metre drop. Siberian tits,
Siberian jays, great spotted
woodpeckers and crow-sized
black woodpeckers all
ventured very close to the
hide. This caused quite a
problem because, though I
had some great photographic
opportunities, the birds were
so close that they could hear
every sound the camera
made, and the slightest click
startled them away.

**Canon EOS 3 with 20-35mm zoom
lens; 1/1250 sec at f4; Fujichrome
400 F; hide.**

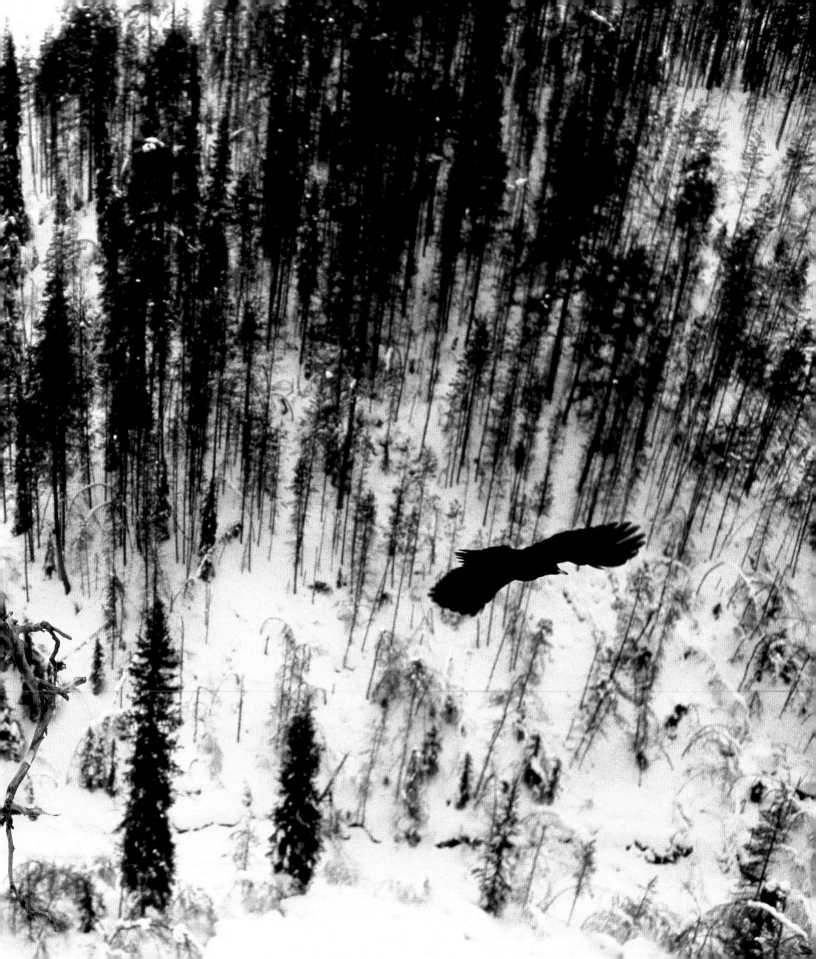

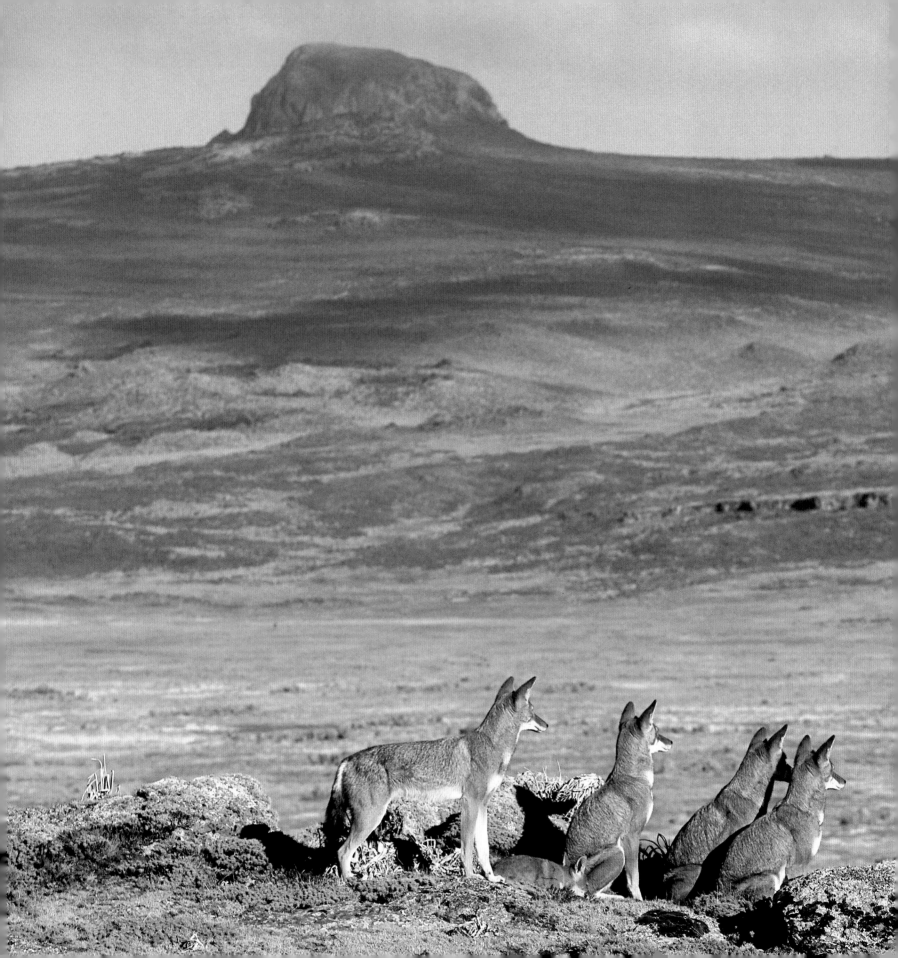

Martin Harvey
South Africa

ETHIOPIAN WOLVES

Ethiopian wolves usually hunt alone, but each morning the pack patrols its territory. Very early one morning, in Bale Mountains National Park, Ethiopia, I photographed these wolves on their daily scout. When they stopped at the top of a rise to scan the valley below, I was able to get this picture showing the wolves' bleak, highland environment.

Canon EOS 1V, with 70-200mm f4 lens; Fujichrome Velvia; bean bag.

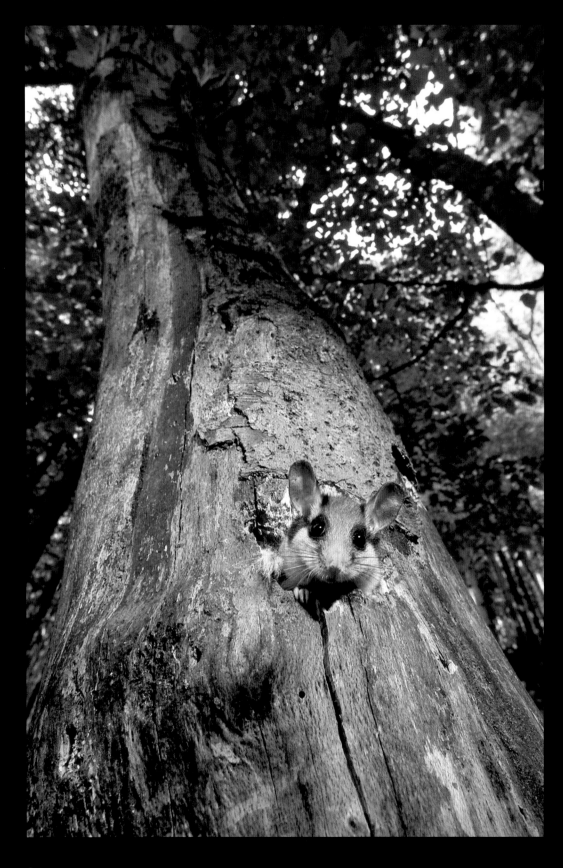

Klaus Echle
Germany

GARDEN DORMOUSE
Through my work as a
forester in the Black Forest,
Germany, I have got to know a
lot about the wildlife there.
The garden dormouse is one
of my favourite small
mammals, with its striking
black mask and habit of
nesting in birdboxes, bird
holes or forest huts.
A crested tit originally
occupied this hole, and I was
checking to see if one was
using it again this year.
Instead, this bright-eyed
character popped out.
**Canon EOS 3, with 20mm lens;
1/15 sec at f11; Fujichrome Sensia
100; tripod; flash.**

Animal
behaviour
Birds

e pictures in this category can't
t be record shots or beautiful
ages – they must show action and
ve interest value as well as
sthetic appeal.

★ WINNER
ck Oliver

ARN OWL – A
OLE'S-EYE VIEW

atched this barn owl hunt
r rough grassland in
folk for hours, until I knew
r habits intimately. I then
up a camera trigger and
e near a post she
metimes perched on. I
used the camera at the
ght at which I hoped she
uld hover. When the owl
ded on the post, I tugged at
ength of fishing line to
tch the lure. She leapt off
e post and hovered above
e camera, which I operated
g a second line. Once she
satisfied herself that the
e was inedible, she flew off
ain and soon caught a vole.

olta x-700, with motordrive and
mm Tamron lens; 1/250 sec at
Fujichrome Provia 100 rated at
0; Manfrotto tripod head fixed to
ooden peg; remote trigger made
m perspex, nail and fishing line.

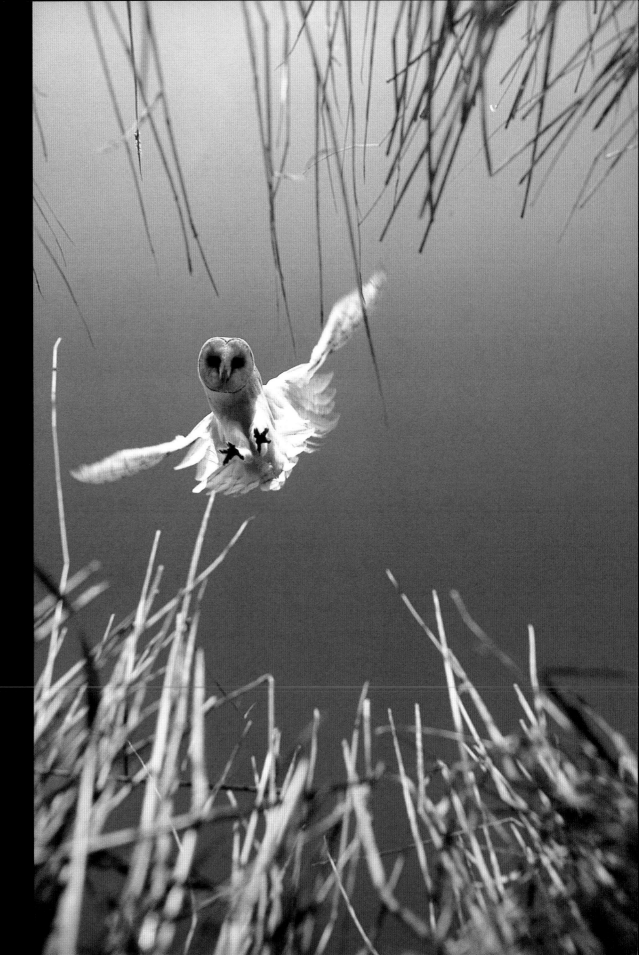

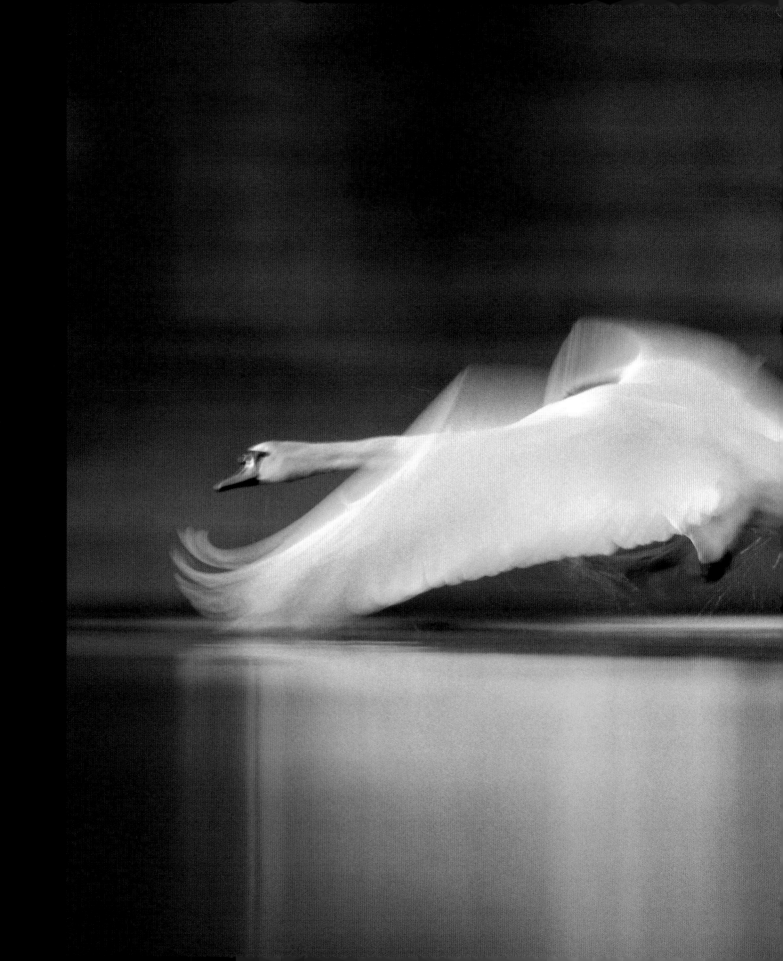

 RUNNER-UP

Rob Jordan
UK

MUTE SWAN IN PURSUIT OF AN INTRUDER

One evening in early April, I was chest-deep in freezing water in a Northumberland lake, in the North of England. Drysuit-clad in my floating, camouflaged hide, I was hoping to photograph black-necked grebes displaying. Instead, I saw this mute swan take off and attack another swan that was encroaching on its territory – behaviour known as 'busking'. I took a sequence of images, panning with the bird as it flew, using my floating hide to rest the camera on. Low evening sunlight required a very slow shutter speed but accentuated the warm colours and ephemeral light. I wasn't hopeful of the results, but I was delighted when the film was developed.

Nikon F4s, with 500mm f4 lens; 1/15 sec at f4; Fujichrome Provia 100; floating hide; beanbag.

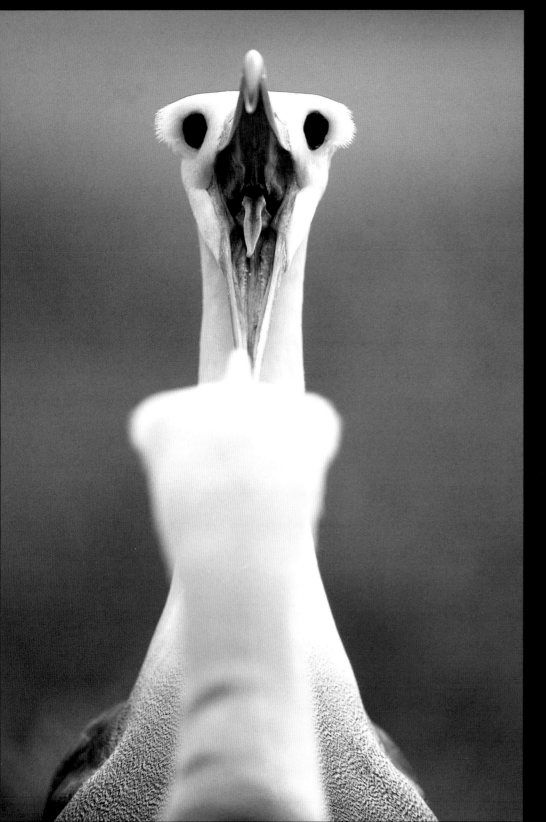

HIGHLY COMMENDED

Winfried Wisniewski
Germany

COURTING GÁLAPAGOS ALBATROSSES

After spending most of the year alone at sea, Gálapagos albatross pairs rendez-vous to breed at exactly the same spot each year. They mate for life and can live for 45 years. To reinforce the pair-bond after such a long time apart, the birds perform intricate courtship rituals. They bow, sway their heads and snap their bills shut with a loud clap and 'fence' – each rapidly flicking its bill against the other's.

Canon EOS-1V, with 600mm f4 lens with 1.4 extender; automatic exposure; Fujichrome Velvia; Sachtler tripod.

HIGHLY COMMENDED

Yva Momatiuk and John Eastcott
US/New Zealand

STEPPE EAGLE FIGHTING OFF A MARABOU STORK

This steppe eagle's feast of lesser flamingo, by Kenya's Lake Nakuru, didn't last long. A scavenging marabou stork soon strutted in for a closer look. At first, the eagle mantled the meat – hiding it with its outstretched wings. But the stork wasn't fooled. Then the eagle lunged, beak open and wings flapping, trying to shoo the stork away. But this didn't work, either. Finally, the eagle hurled itself at the stork. When both were airborne, the eagle flipped upside down and lunged at the stork's throat, all the time avoiding the formidable beak. In the end the eagle lost, but what a display of gall and prowess it gave.

Canon EOS 3, with 600mm f4 lens; Fujichrome Provia 100 F; tripod.

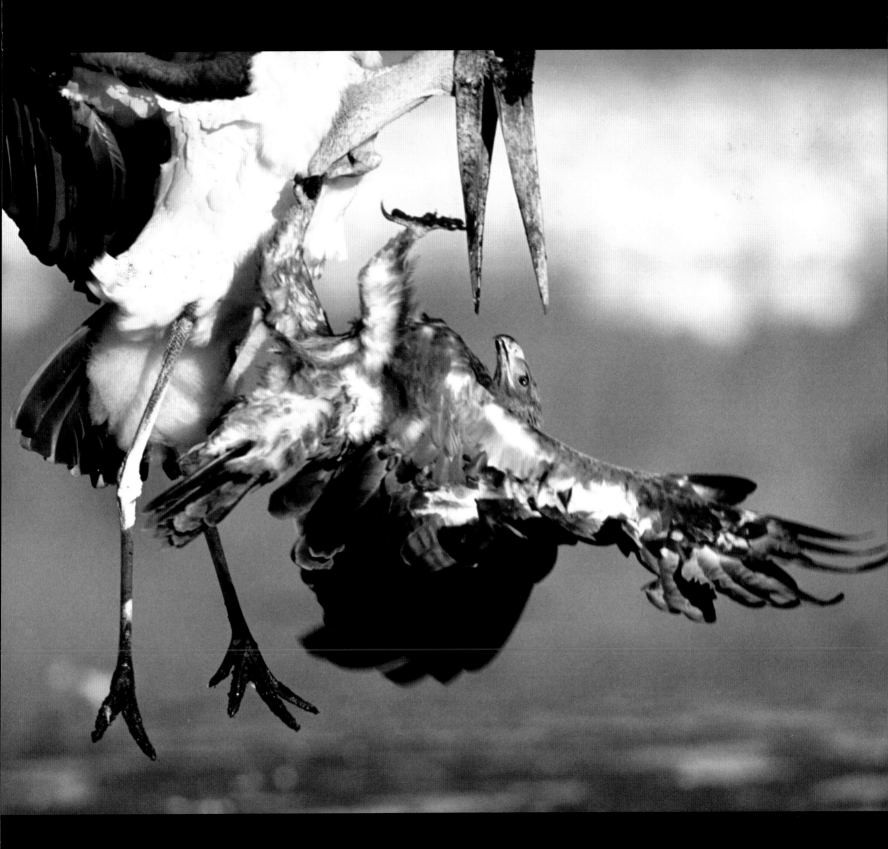

Michael Forsberg
USA

SANDHILL CRANE WITH HER CHICK

One blustery, February day, I took this photograph of a day-old sandhill chick that had climbed onto its mother's back for warmth. The birds were on a nest in a small lake in central Florida, where I had spent several days hoping to photograph sandhill cranes hatching their young. These particular cranes had nested in the same territory for years and were used to the small boat I was on – piloted by a local who monitored crane-nesting activities in the lake.

Nikon F5, with 500mm f4 lens with 1.4 teleconverter; 1/500 sec at f8; Fujichrome Provia 400F; tripod.

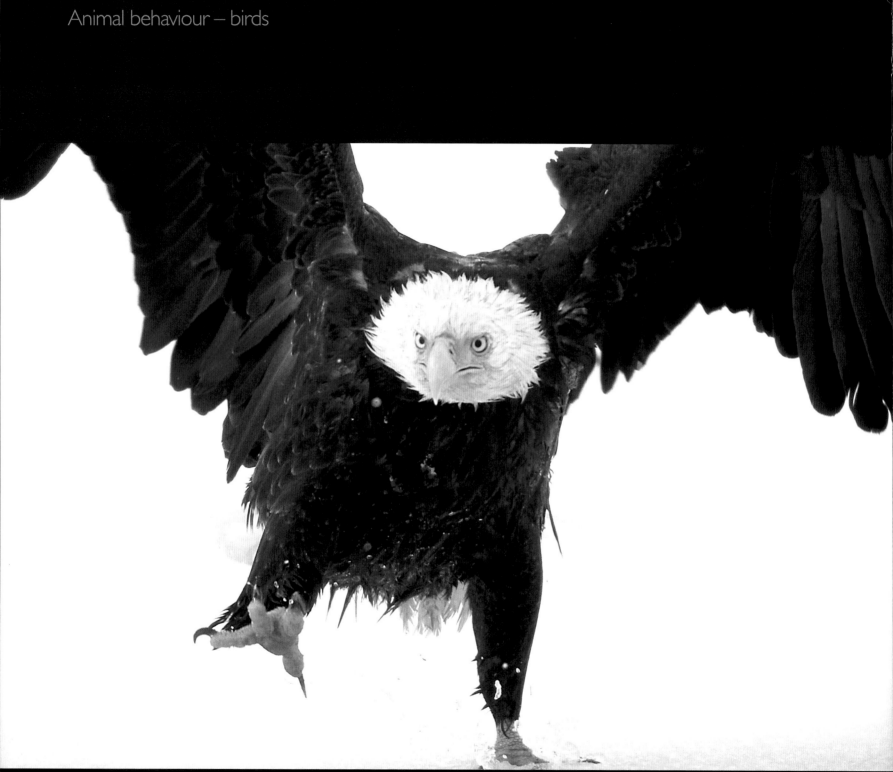

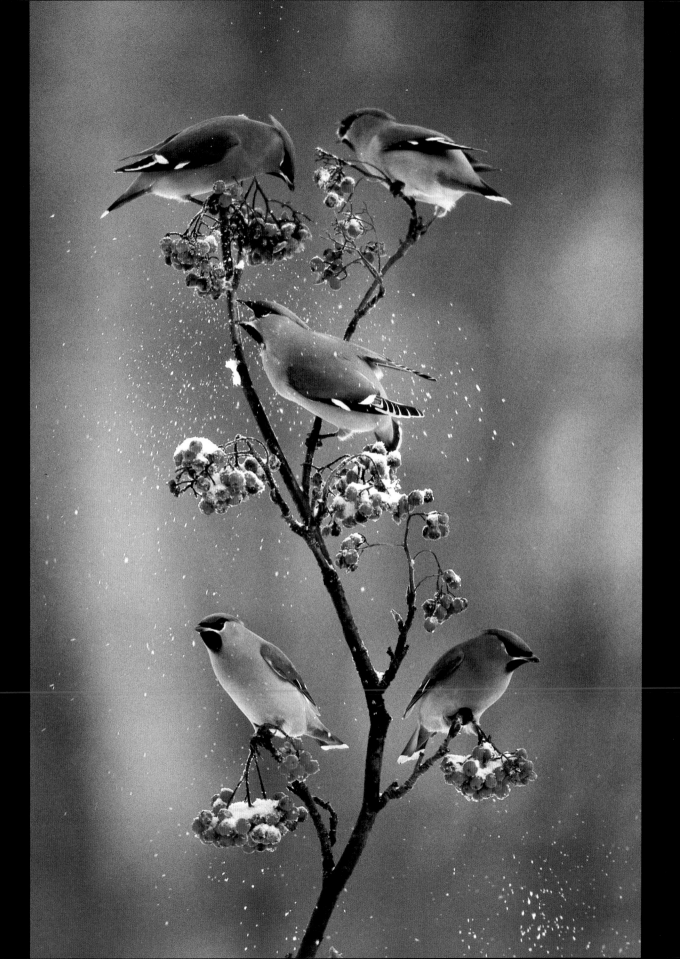

Klaus Nigge
Germany

BALD EAGLE

I went to the Aleutian Islands, Alaska, USA, to photograph bald eagles. The eagles are not particularly shy here (especially in winter) because they are used to feeding on leftovers from the local fishing industry. I brought fish to the same place each day so that the birds would get used to me. This individual had no inhibitions about flying straight at me to get its booty. The bald eagle is the USA's national symbol and the only eagle endemic to North America, ranging across most of the continent, from the northernmost areas of Alaska and Canada down to northern Mexico.

Nikon D1X, with 80-200mm f2.8 lens; digital image, ISO 200.

Hannu Hautala
Finland

WAXWINGS FEEDING ON ROWAN BERRIES

In winter, waxwings leave the vast northern tracts of conifer forests and move into urban areas in search of berries. Huge flocks descend on the rowan trees that line many avenues and grow in gardens and parks. These waxwings in Kuusamo, eastern Finland, were so busy squabbling over the last few berries that they paid no attention to my camera. The moment of photographic opportunity didn't last long – a flock of waxwings can strip a rowan tree in a matter of minutes.

Canon EOS 5, with 400/600 mm lens and 1.4 teleconverter; 1/60 sec, automatic exposure; Fujichrome Provia 400; hide and tripod.

Animal behaviour
Mammals

These photographs are selected for their interest value as well as their esthetic appeal, showing familiar as well as seldom-seen active behaviour.

 WINNER

André Cloete
South Africa

AFRICAN WILD DOG CHASING A ZEBRA
I had spent the night at Kasumo Pan in Zimbabwe's Hwange National Park. At dawn, a lone wild dog came to drink, followed by a herd of Burchell's zebras. Wild dogs hunt in packs, and they usually aim for small victims. But this one initiated a game of chase with the zebras. It never bothered to attack – perhaps it was simply curious. Eventually, it tired of the zebras and disappeared into the bush in the direction of a herd of impala, with perhaps less playful intentions.
Canon EOS 1V, with 100-400mm f4.5-5.6 Canon EF lens; 1/40 sec at f5.6; Fujichrome Velvia; tripod.

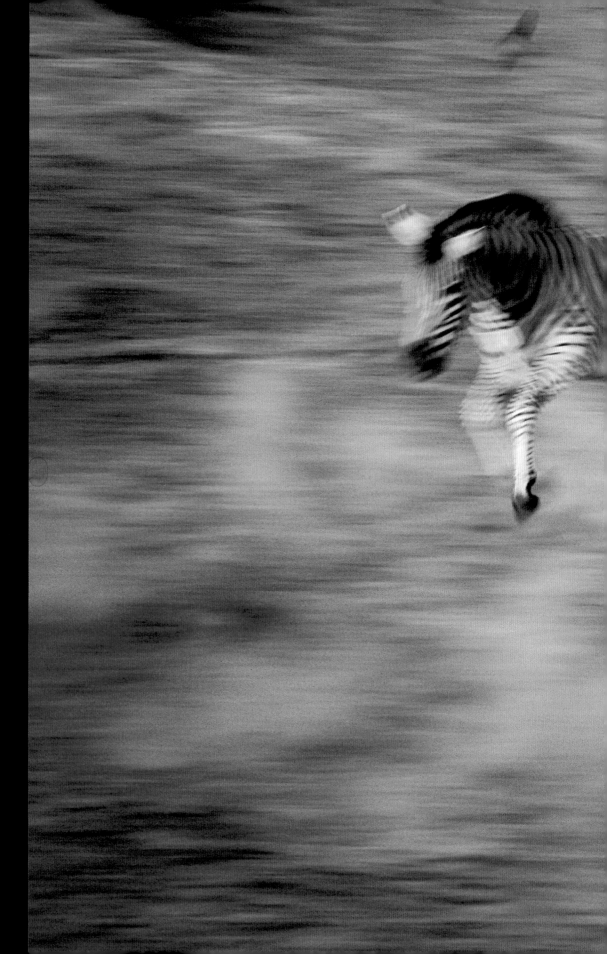

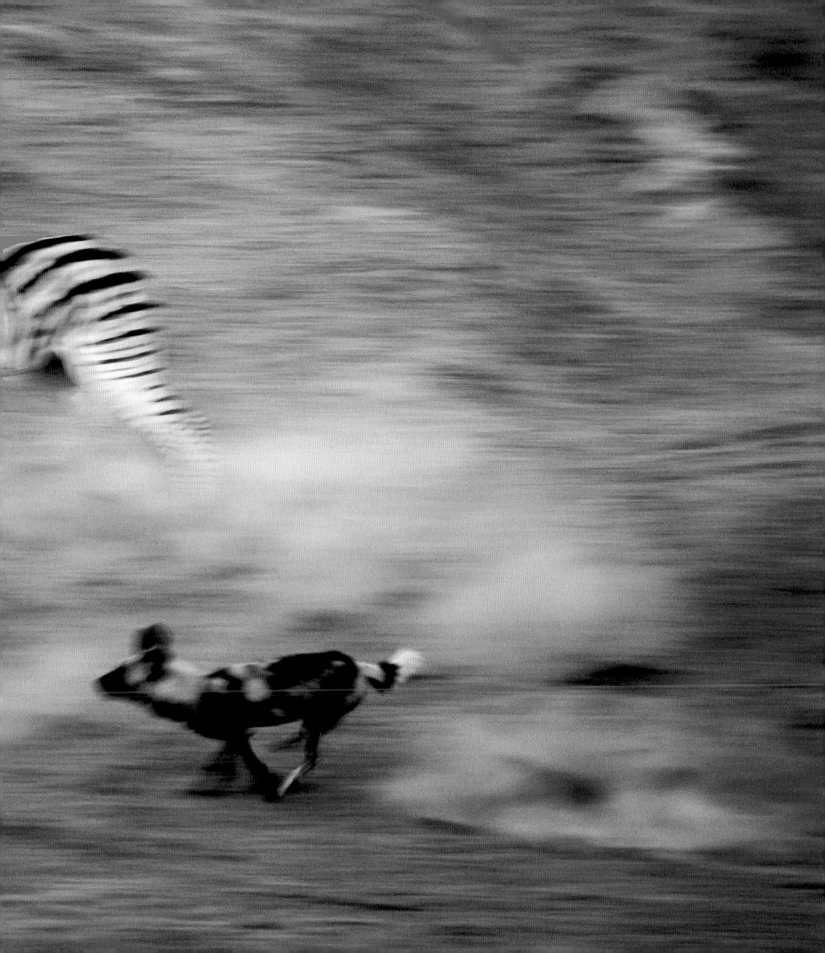

RUNNER-UP

Eric Dragesco
France

RED FOXES FIGHTING

One May evening, I was in my hide near our home in the Swiss Alps watching a vixen tucking into her prey when the dog turned up, advancing slowly with his head lowered. Feeling sure something was about to happen, I grabbed my camera. Suddenly, he charged the female, springing at her aggressively to make her flee. The dispute lasted a fraction of a second; I turned on the motor, and the camera took care of the rest.

Minolta Dynax 9, with 300mm f2.8 lens; 1/750 sec at f4; Fujichrome Provia 100.

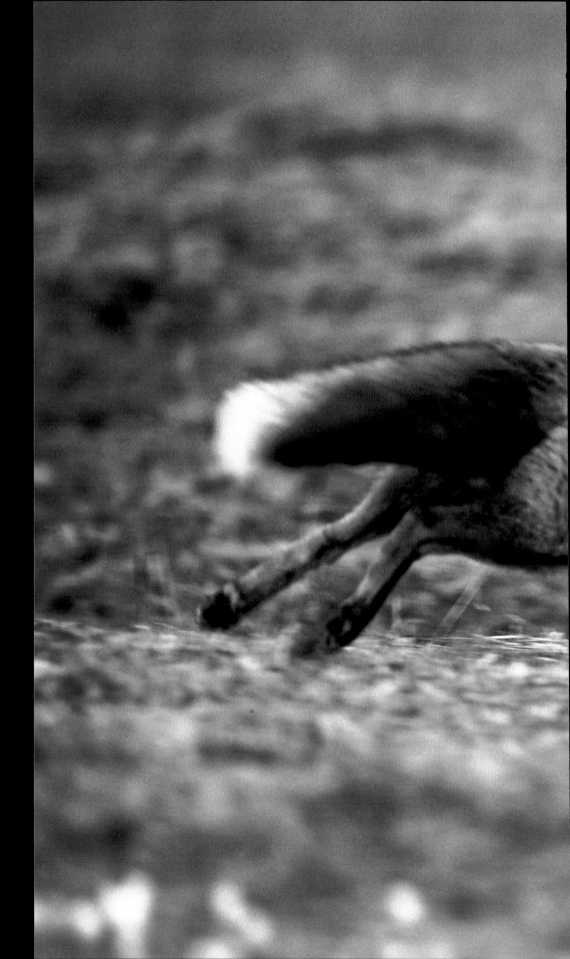

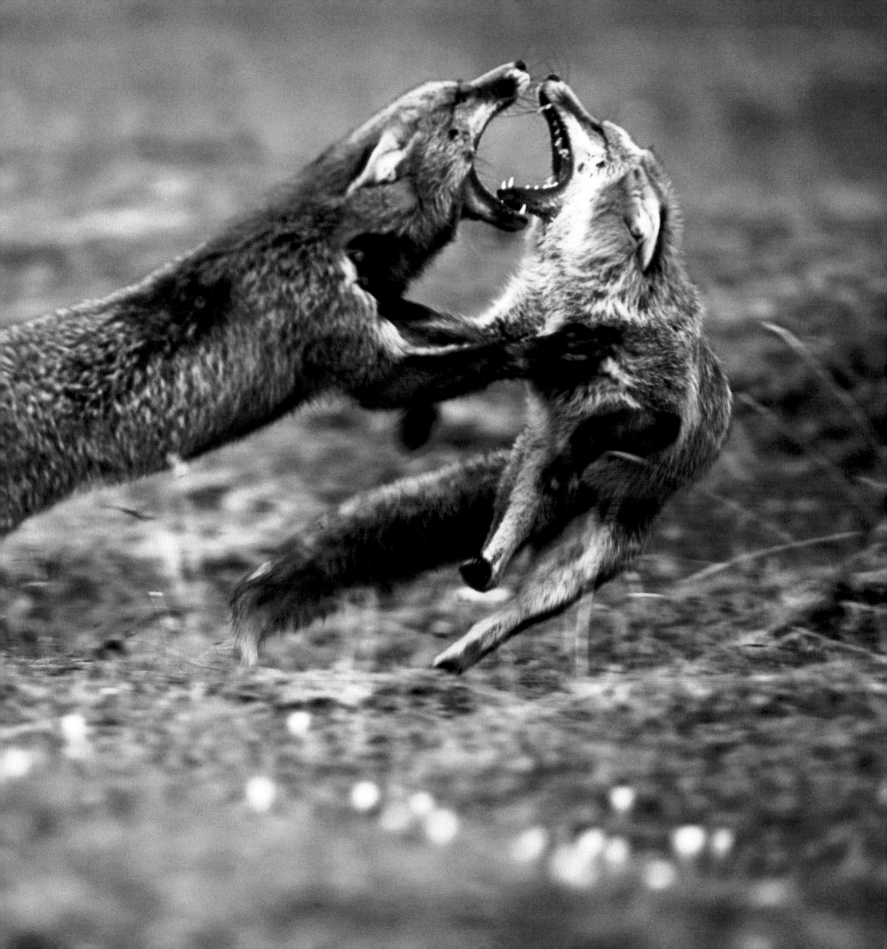

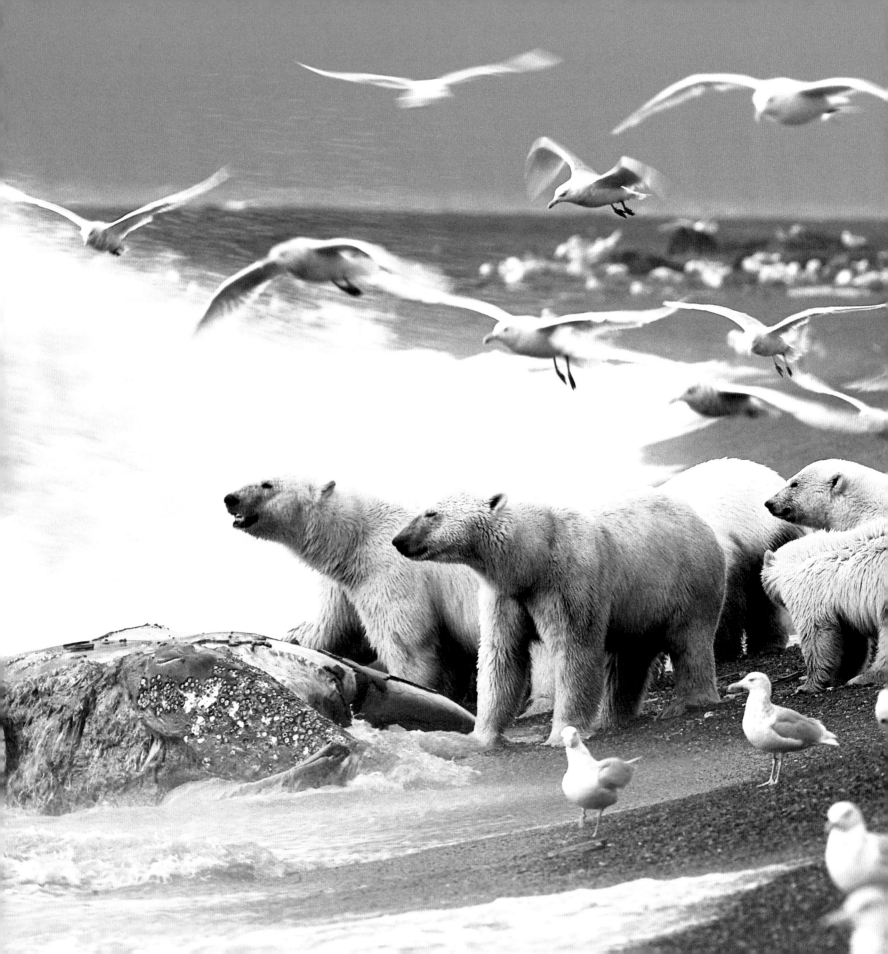

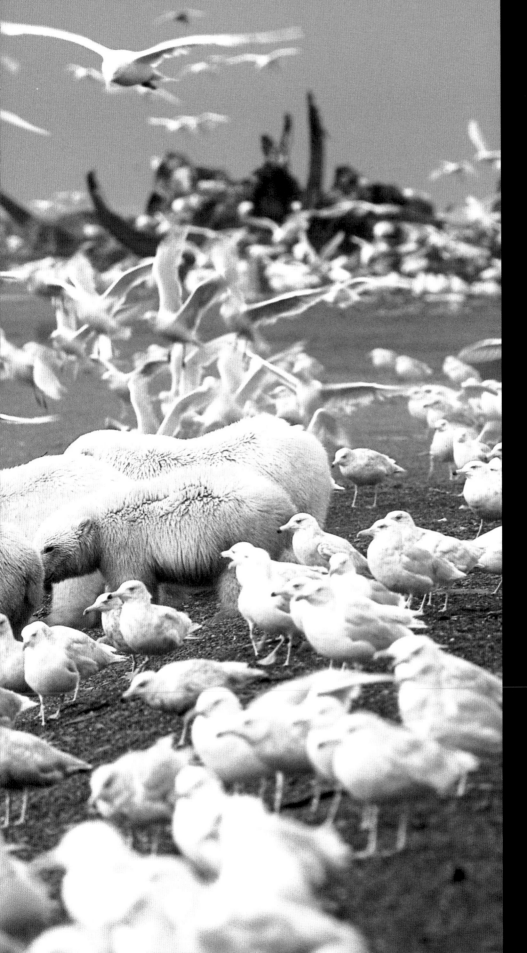

 SPECIALLY COMMENDED

Howie Garber
USA

POLAR BEARS SCAVENGING

Polar bears are usually solitary, but this grey whale corpse on the Chukshi Sea coast of northern Alaska hosted an unusual aggregation: adult males, at least one female, subadults, yearlings and cubs. Another 30 or so bears waited their turn. The whitest bear probably swam in from the pack ice, as resident land-bound bears are usually smudged brown from whale oil and gravel.
In recent summers, the sea-ice has retreated record distances from the coast, and in 2002, these and many other bears were stranded far from the ice and so from the main prey, seals. This scene may be a manifestation of global warming.

Nikon F5, with 500mm Nikkor f4 lens; 1/500 sec at f5.6; Fujichrome Provia 100; Gitzo tripod.

Kristin J Mosher
USA

CHIMPANZEE STRIPPING A VINE

I had been following Freud and Gimble since dawn, in Gombe National Park, Tanzania. The two males spent their morning grooming and eating in Mkenke, one of Gombe's main river valleys, then disappeared into a thicket of leafy vines. When Gimble reappeared, he was 'vine-stripping', selecting sections of a vine and using his teeth to strip off and eat the cambium and pith inside.

Canon EOS 1N, with 100-400mm lens; 1/125 sec at f6.7; Fujichrome Velvia; tripod.

Jari Peltomäki
Finland

BROWN BEAR CUB

This was one of a family of brown bears that I watched in thick taiga forest in Finland. The youngsters, three boisterous two-year-olds, practised climbing the pine trees in front of the hide. I took hundreds of photos. Many ended up in the bin – as might this one have done, had it not been for the woman working in the processing laboratory, who told me how she had laughed at the image of the little bear playing hide-and-seek – a reaction that made me take a fresh look.

Nikon F5, with 300mm Nikkor f2.8 lens; 1/250 sec at f4; Fujichrome Provia 400; beanbag; hide.

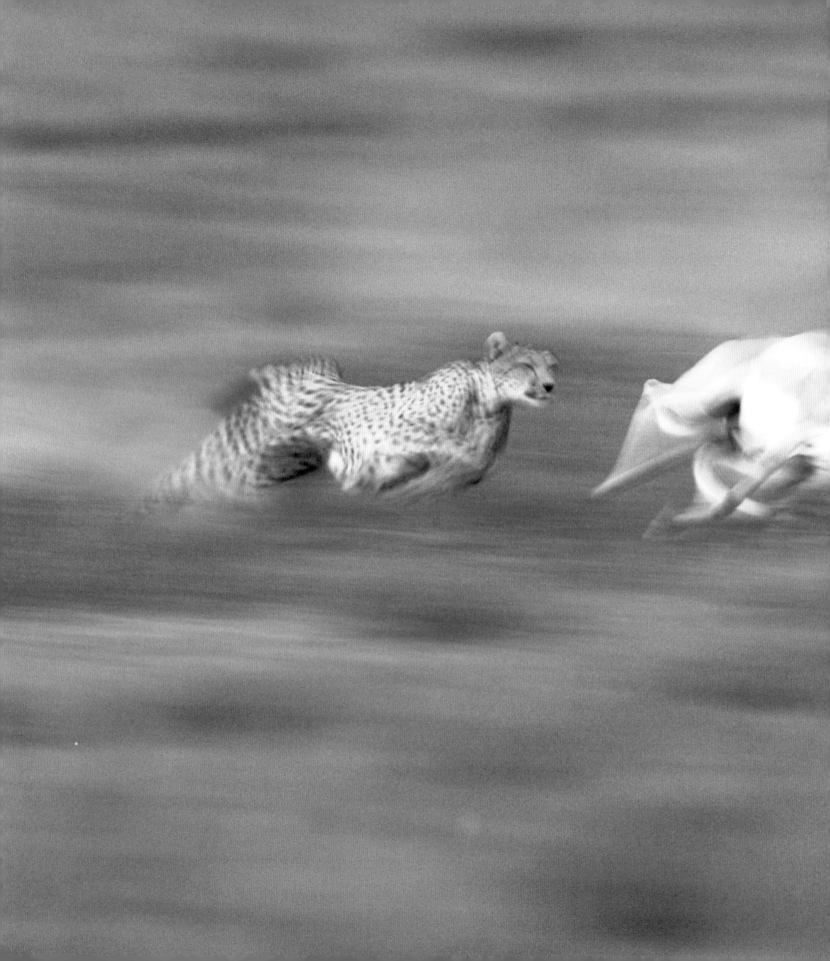

Thomas D Mangelsen
USA

CHEETAH CLOSING IN ON A GRANT'S GAZELLE

This female cheetah, in Serengeti National Park, Tanzania, had four ten-week-old cubs to care for. I watched her stalk a Grant's gazelle buck for about an hour on the grass plains, waiting for it to graze closer to her. At a distance of about 250 metres, I was too far away to photograph her, but I didn't want to move any closer for fear that I might disturb the hunt. When the gazelle eventually fed within striking distance, the cheetah charged. As she moved in for the kill, she tried to trip the gazelle with her right paw but missed by centimetres, and the gazelle escaped.

Nikon F5, with 600mm lens with 2x extender; Fujichrome Velvia; beanbag.

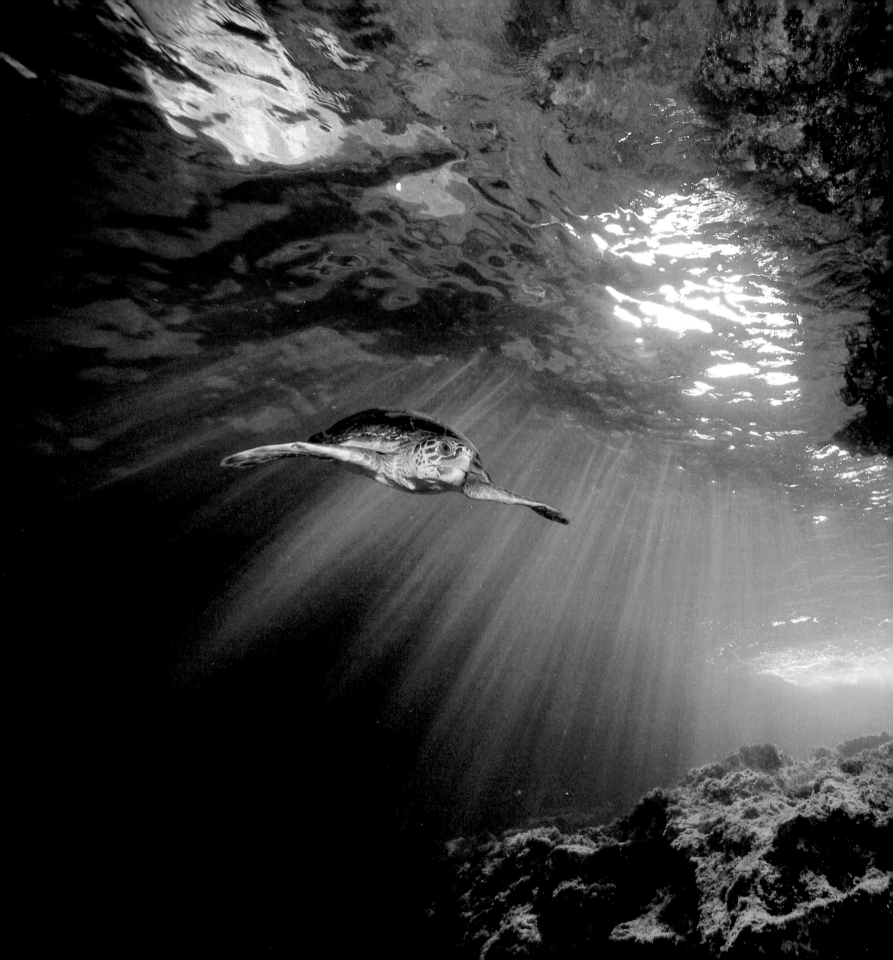

The underwater world

These photographs can show marine or freshwater animals or plants. The most important criteria are aesthetic ones, but interest value is also taken into account.

 WINNER

Manu San Félix
Spain

LOGGERHEAD TURTLE
This loggerhead had been found with a fishing hook through its body and had been taken to a rehabilitation centre on Formentera Island, in the Balearic Islands. The centre restored the turtle to health, releasing it on the west shore of the island, an important site for loggerheads in the Mediterranean. I took this photo just before the turtle headed off into the blue. Loggerheads continue to decline, mainly because of shrimp-trawling, coastal development and marine pollution.
Nikon F5, with 14mm Tamron lens; 1/60 sec at f8; Ektachrome 100; Underwater housing.

 RUNNER-UP

Pete Atkinson
UK

CROWN JELLYFISH
Beautiful hard corals encircle
the South Pacific island of Niue.
I intended to photograph the
reef, but as soon as I entered
the water from my dinghy,
I saw this 30cm crown float
by. I drifted alongside it in the
current and was carried out
into the blue. To get a dramatic
sunburst, I underexposed the
background and used flash to
add colour. I was so
mesmerised by the pulsating
image in my viewfinder that I
lost all sense of how far I had
gone. Once the film was
exhausted, I surfaced, scanned
the horizon for my dinghy and
realised it was going to be a
long swim back.
**Subeye Reflex, with 13mm R-UW
AF Fisheye Nikkor lens; 1/125 sec
at f11/16; Fujichrome Velvia; Ikelite
substrobe 200.**

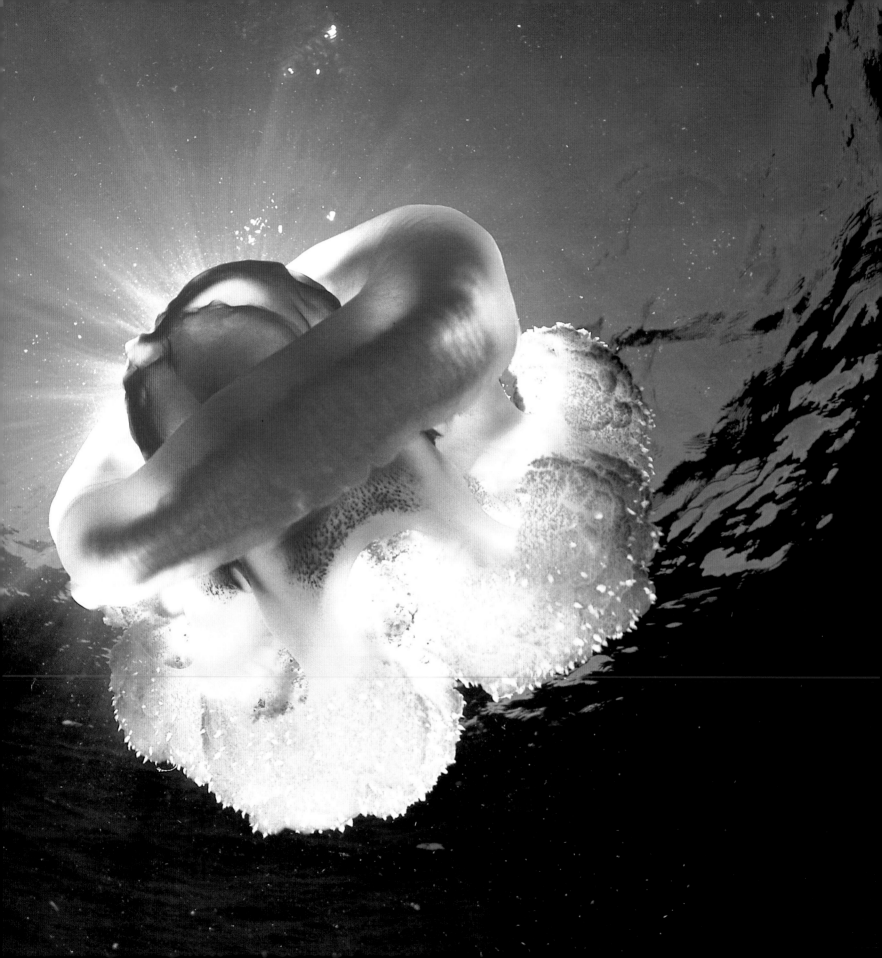

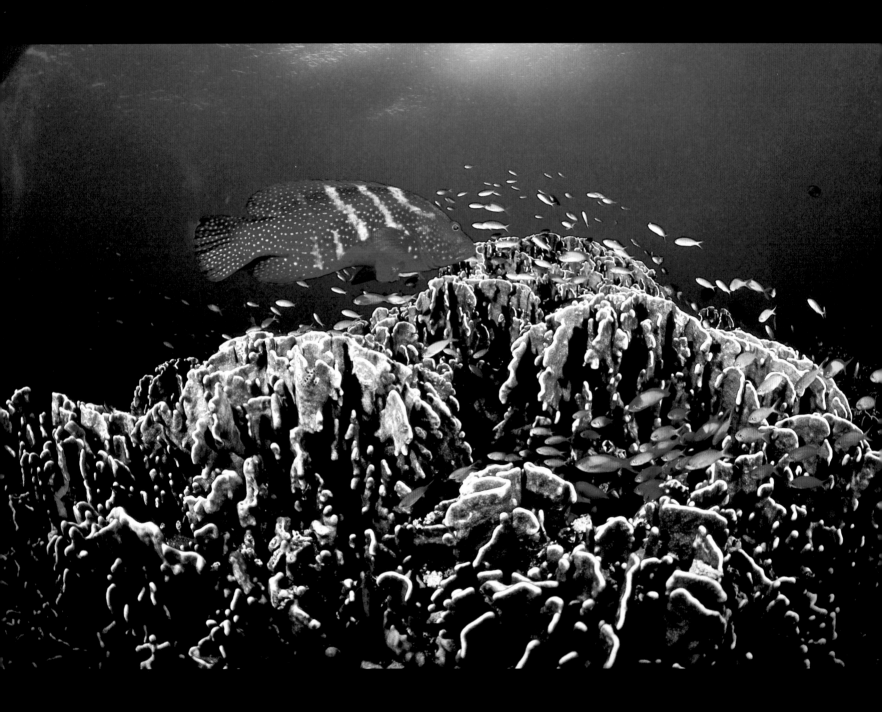

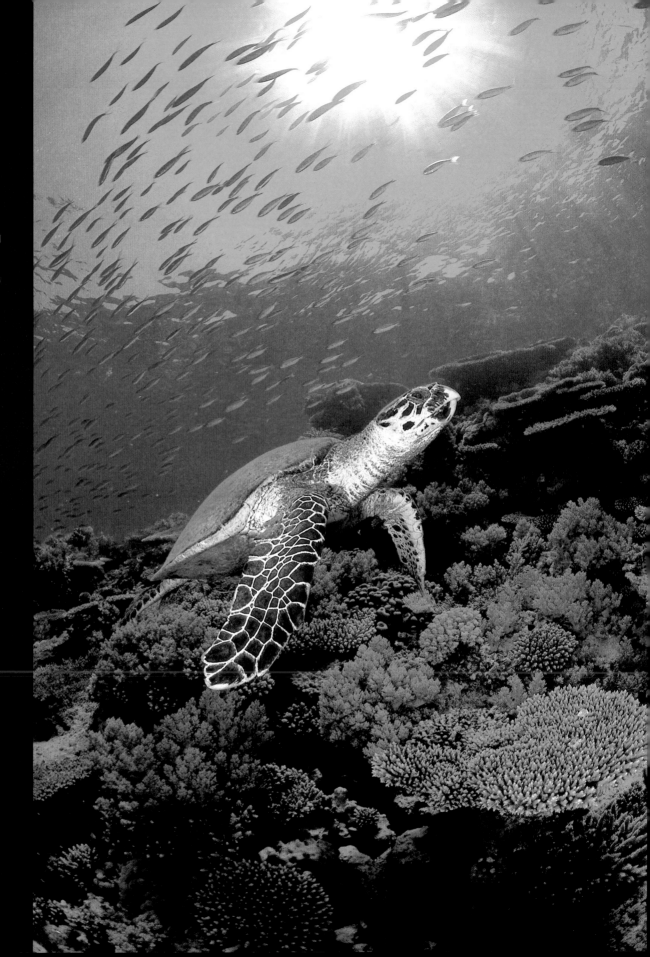

Darryl Torckler
New Zealand

CORAL TROUT AND ANTHIAS SHOAL

This picture was taken on a remote reef between Walandi in New Britain and the Witu Islands in Papua New Guinea. This coral trout hovered among a cloud of anthias fish that darted back into the coral when any divers approached. After the other divers had moved on, I waited motionless on the reef. The coral trout reappeared, and eventually the shoal of anthias fish ventured out from their protective lattice of fire coral.

Subeye reflex camera with 13mm f2.8 Nikon lens; 1/125 sec at f8; Kodak E100vs; two Ikelite 200 watt/sec strobes.

Linda Dunk
UK

SLEEPING HAWKSBILL TURTLE

I got up early for a pre-breakfast dive in the Gulf of Suez. On the pristine outer reef wall, I came across this metre-long hawksbill turtle relaxing on coral. It seemed dozy – I don't know which of us was the sleepier. The fact that I could get so close, along with the crystal-clear water and the first dancing rays of sunlight, provided a fantastic opportunity. Just then, as though to prove a point, a shoal of wide-awake Suez fusiliers hurtled by just below the surface. Hawksbills face extinction due to many threats, including hunting for their carapace – the original 'tortoiseshell'.

Nikon 801s, with 16mm Nikkor full-frame fisheye lens; 1/250 sec at f5.6/8; Fujichrome Velvia; SB25 flash, YS-30 slave flash.

HIGHLY COMMENDED

Steve Smithson
UK

PORCELAIN CRAB AND ANEMONE

The Andaman Sea in Asia is well known for its sharks, which were what attracted me there last year. But there were far fewer patrolling these beautiful waters than I expected, probably because of excessive and indiscriminate fishing. My focus turned instead to smaller marine creatures, which were still abundant. Lots of anemones nestled among the rocks and corals, and within their stinging-tentacle fortresses lurked porcelain crabs.

Nikon F90, with 105mm lens; 1/60 at f16; Fujichrome Velvia; strobes.

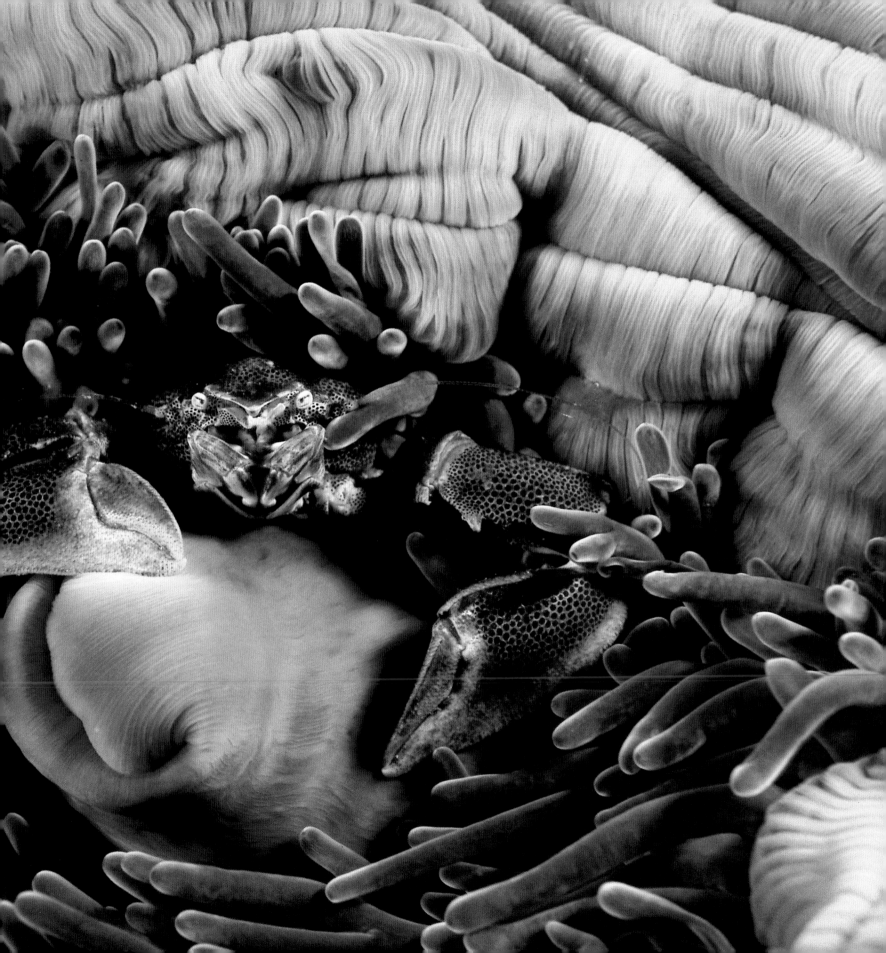

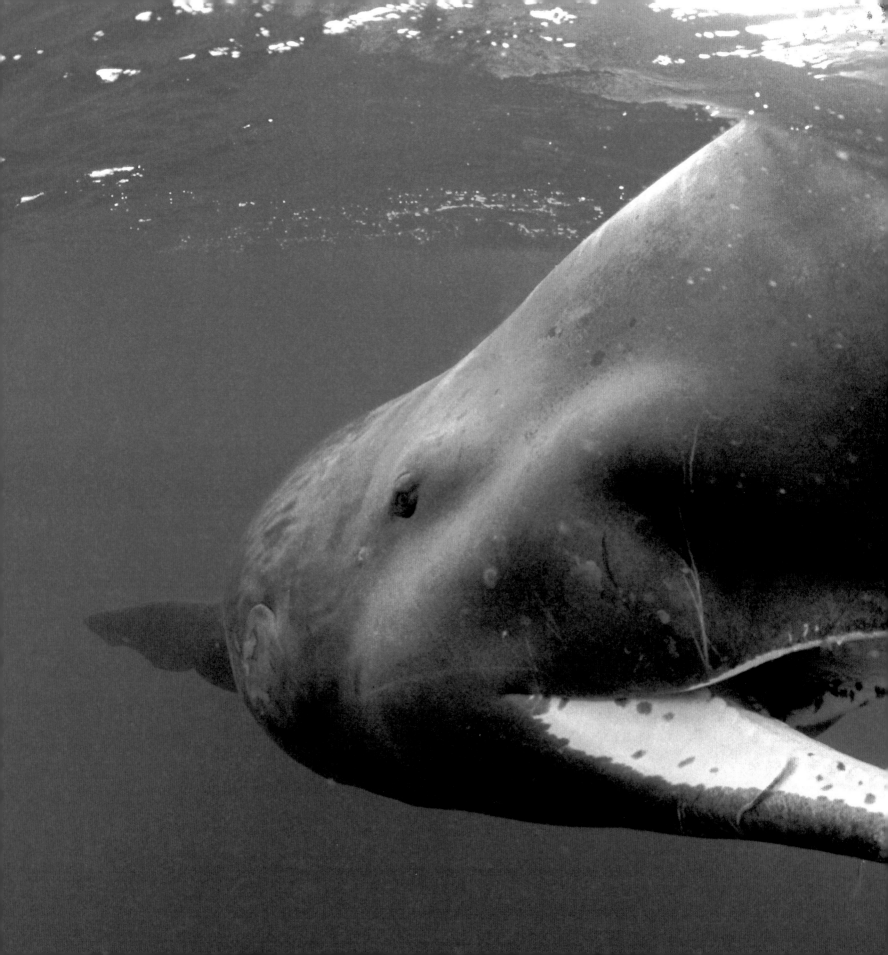

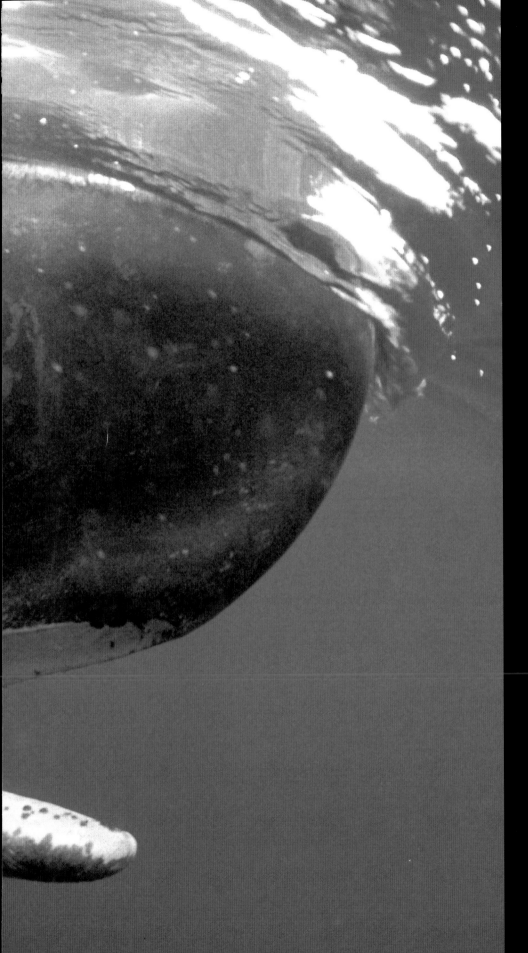

Thomas Haider
Austria

SPERM WHALE CALF

Sperm whale mothers wean
their calves on pieces of squid.
But zoologists have long
speculated that youngsters
also eat whole prey, even
while still suckling. This image,
taken near Grenada, in the
Caribbean, supports that
theory. The tip of a reddish
squid tentacle is stuck firmly
by its suction cup to this calf's
gummy mouth (unlikely to
happen if its mother had fed it).
Adults have fully developed
teeth in the lower jaw only,
which slot into sockets in the
upper jaw. This suggests that,
rather than chew their dinner,
sperm whales suck it down.

**Nikon F100 with 13mm fisheye lens;
1/125 sec at f5.6; Kodak 100; Subal
underwater housing.**

From dusk to dawn

The criterion for this category is strict: the wildlife must be photographed between sunset and sunrise, and the sun may be on but not above the horizon.

 WINNER

José B Ruiz
Spain

WHITE STORKS ROOSTING

Also winner of the

**INNOVATION
AWARD**

See p13

 RUNNER-UP

Theo Allofs
Germany

CROW AT SUNSET
I had been photographing at sunset the Kata Tjuta in Uluru National Park, west of Uluru (Ayers Rock), in Australia's Northern Territory. Afterwards, I decided to drive closer to the cliffs to try to get an image with the red-glowing rocks in the background. A dead tree looked a likely foreground contender, but when I got closer, just as the glow started to fade, I noticed a crow on one of the branches. I quickly attached the 300mm lens but had no time to fix the tripod.
Canon EOS 1V, with 300mm f2.8 lens; Fujichrome Velvia.

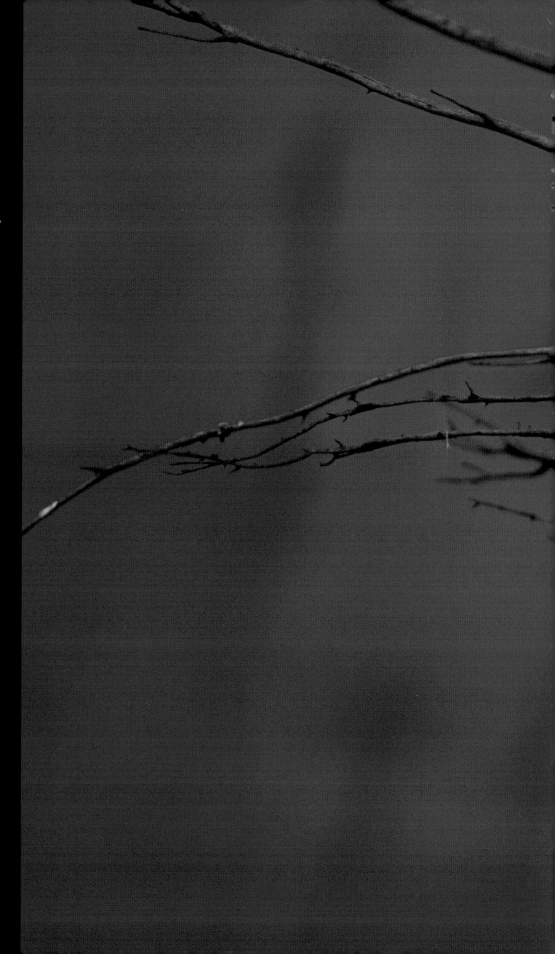

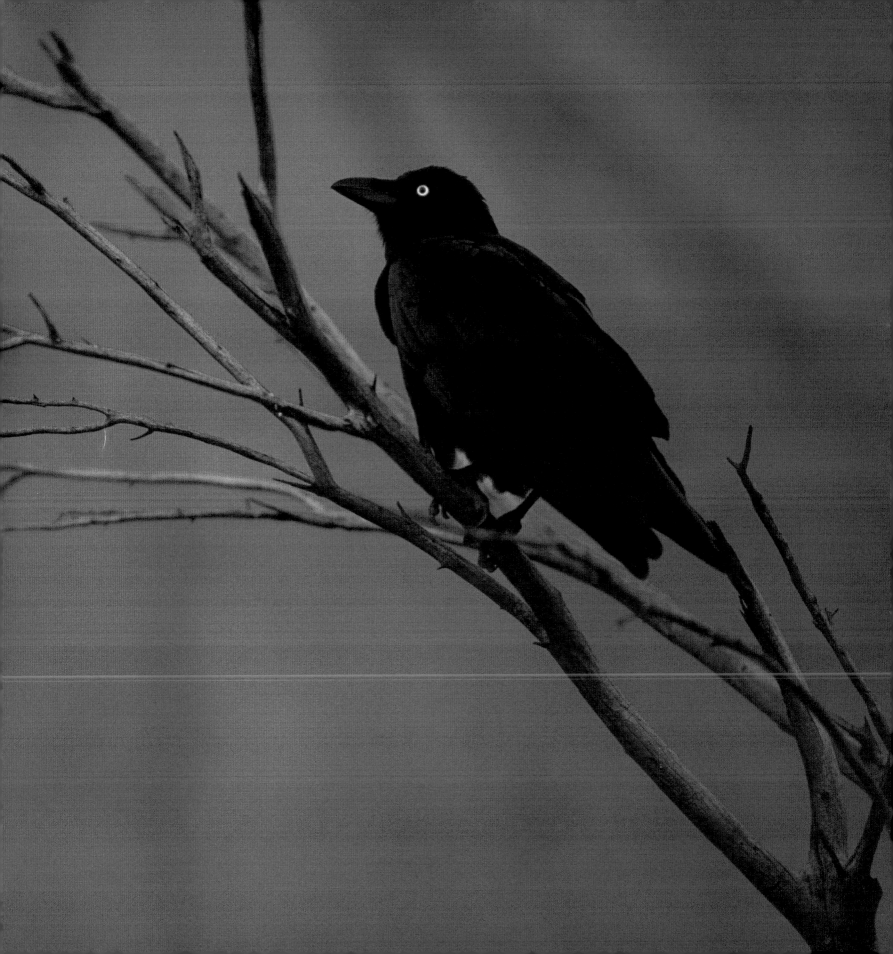

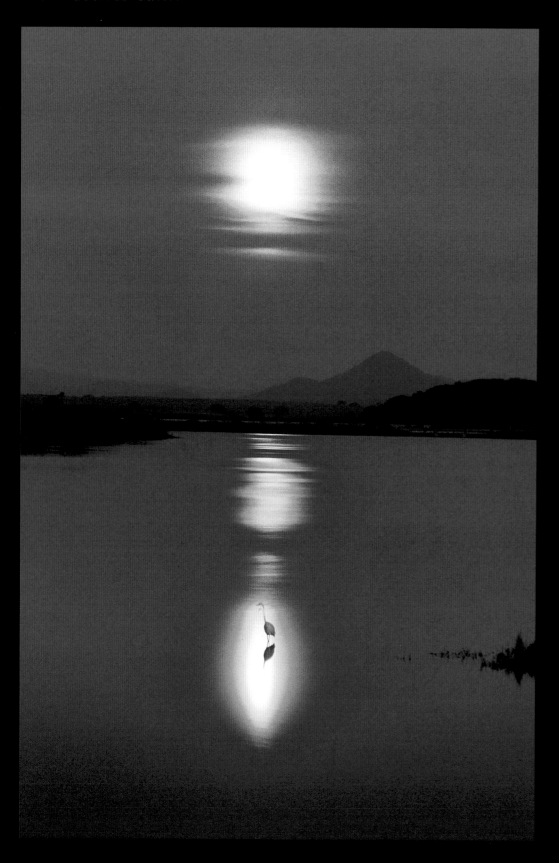

Alwin A K van der Heiden Roosen
Netherlands

GREAT WHITE EGRET FISHING

At an estuary north of Mazatlán, in Mexico, this great white egret stood almost immobile, knee-deep in water, scanning for fish, frogs or insects, its neck coiled and ready to strike. As I gazed at the full moon rising above the mountain range of Sierra Madre Occidental, I realised that, if the egret stayed in the same position, it would be spot-lit by a moonbeam.

Nikon N90, with 70-300mm lens; bulb 24 sec at f8; Ektachrome E 100 VS; tripod.

Urs Lüthi
Switzerland

LIONS HUNTING AT SUNRISE

A magnificent storm in Namibia's Etosha National Park brought the dry season to an end. Just before sunrise, I drove to a spot a few kilometres away from a waterhole. Three adolescent lions and an adult male were already there, gazing intently into the middle distance at two lionesses chasing springbok. But the hunt failed, the panting lionesses rejoined their family empty-handed and the pride moved on.

Nikon F5, with 80-200mm f2.8 lens; 1/125 sec at f2.8; Fujichrome Velvia rated at 100; car tripod.

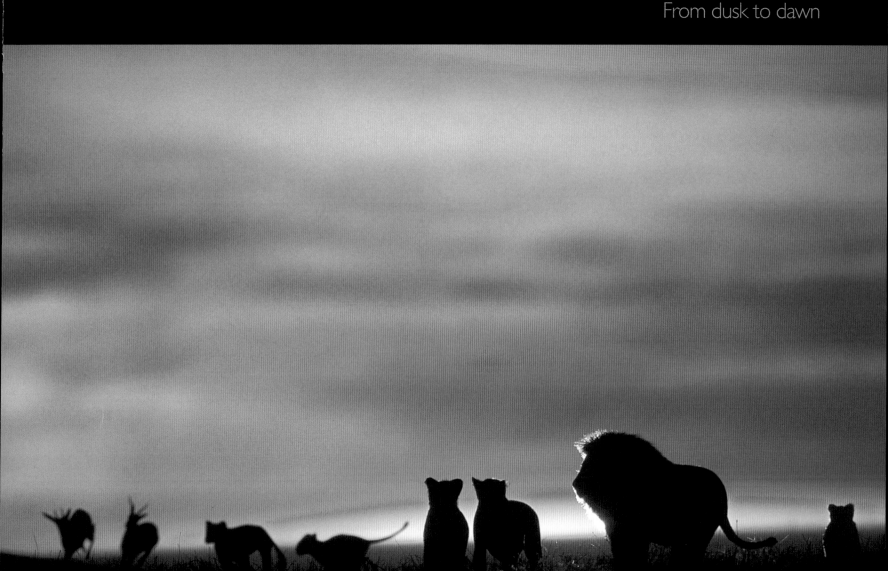

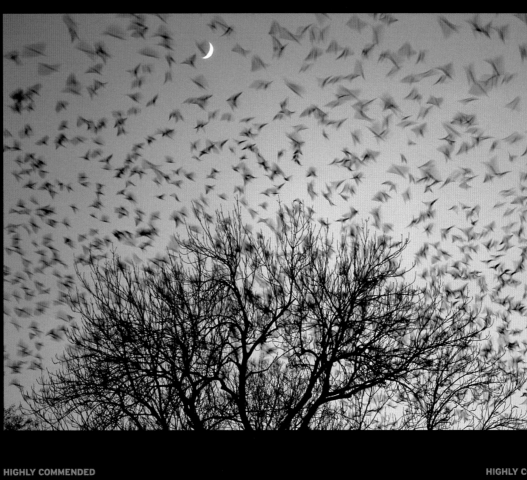

Milán Radisics
Hungary

BLACK-WINGED STILT
I took this long-exposure shot at a lake in Hungary to accentuate the stilt's speed and extraordinary red legs, which are longer in proportion to its body size than almost any bird – in flight, they project far beyond the tail. It walks quickly, taking big strides, and wades into the water to pick off insects and small aquatic animals from the vegetation and water surface.

Nikon F4, with 300mm lens with x2 extender; probably 1/20 sec at f4; Fujichrome Provia 400F; tripod.

Bernd Römmelt
Germany

ROOKS FLYING OFF TO ROOST
Each year, rooks from Siberia overwinter at Nymphenburger Palace Gardens in Munich. One December evening, just as I finished photographing a tranquil scene of a roosting flock, the birds suddenly took off. There was time to take just two frames with a slow shutter speed.

Nikon F4s, with 300mm lens; 1/15 sec at f4; Fujichrome Sensia 100; tripod.

Urban and garden wildlife

This category aims to encourage photographers to take pictures of wildlife close to home – in a garden or an obviously urban or suburban setting. It offers great scope for originality and innovation, but surprisingly, there are always comparatively few entries.

 WINNER

Hannu Hautala
Finland

YOUNG SWALLOWS
By the beginning of autumn, the supply of insects near this old country house in Kuusamo, Finland, began to dwindle. These barn swallow chicks, the last clutch of the year, could fly at 18 to 23 days old, but couldn't yet catch enough food to feed themselves. So their parents continued to provide for them. I often saw a parent flying in with something in its beak, such as a grasshopper, dragonfly, beetle or moth, to feed the hungry brood. The whole family would return to this window ledge at dusk. They occasionally stopped by during the day, too.
Canon EOS 5, with 400-600mm lens and 2x converter; 1/125 sec at f8; Fujichrome Provia 400; tripod.

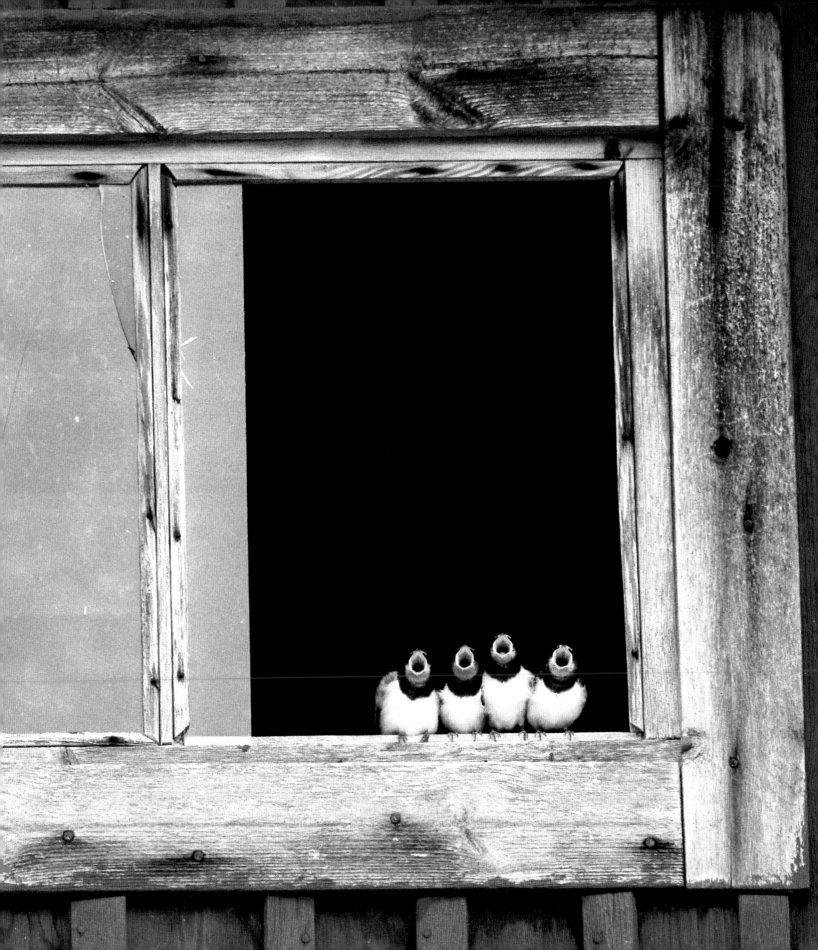

★ **RUNNER-UP**

Gordon Illg
USA

URBAN RED FOX
The Wheatridge greenbelt runs through a suburb of Denver, Colorado, and the foxes that live here have become used to hundreds of walkers, joggers, wildlife-watchers and photographers. Local inhabitants feed the foxes, too, and so getting a photograph is easy. Getting one that stands out, though, presents a challenge. I wanted to show the foxes' relationship with their urban habitat. One dark, stormy December morning, I decided to leave my telephoto lens at home and photograph foxes in their environment with just a 28-80mm lens. Catching one halfway across a bridge was my lucky break.

Canon EOS , with 28-80mm lens; 1/125 sec at f8; Fujichrome Sensia 100.

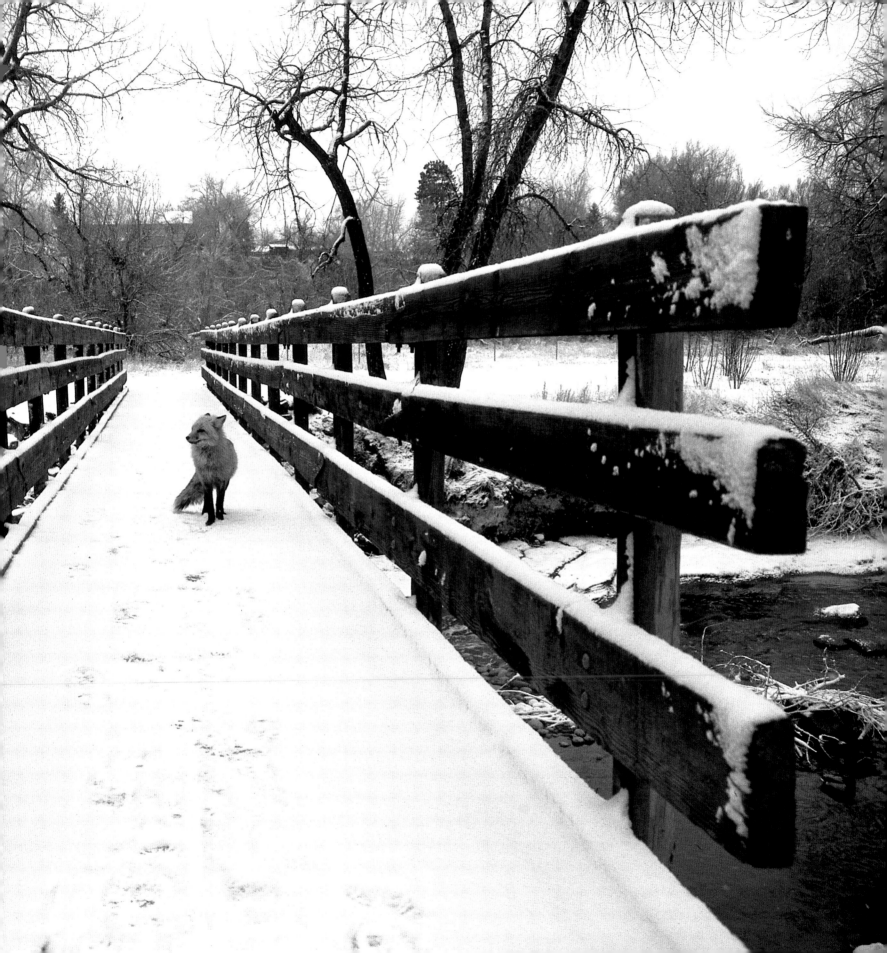

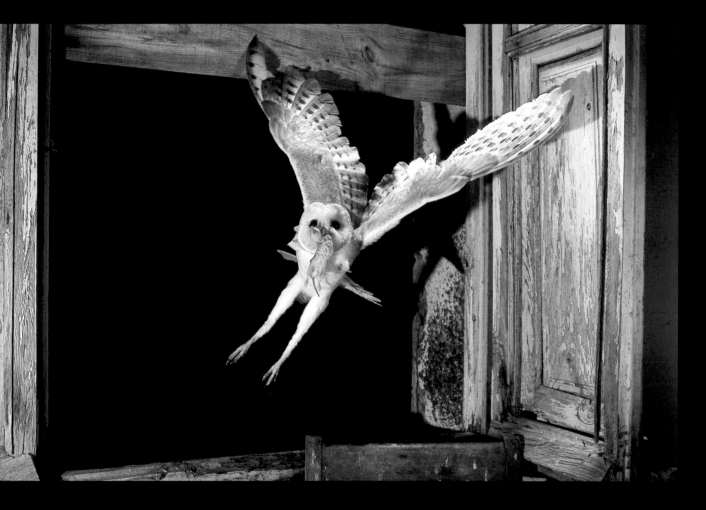

Jordi Bas Casas
Spain

BARN OWL FLYING BACK TO ITS CHICKS

A derelict old house in the middle of a field in Lleida, North-east Spain, was a prime location for a pair of nesting barn owls. I put them under house surveillance and worked out which window they used to return to their nest. I then set up my home-made, infrared sensor equipment so that the owls could take self-portraits as they flew in and out.
Each morning, I could see how many frames had been taken overnight but not if they were any good. When I got the film developed, more than 90 per cent of the slides were useless, but fortunately a few, like this one, worked out well.

Nikon F-401, with 50mm lens; approximately 1/60 sec at f.8; Fujichrome Velvia; 4 flashes, industrial infrared sensor modified to connect the camera.

Richard Packwood
UK

BADGER AT A GARDEN POND

In an attempt to stop the squirrels stealing the bird food, we offered them their own feeding-box. This, in turn, was soon raided every night by the peanut-loving badgers, who are now regular visitors. I watched them for six months at my leisure as they fed beside the pond just outside our sitting-room window, imagining the photograph I would take for this competition. But I ended up taking the photo in a hurry only a few days before the competition's closing date.

Nikon F5, with 35mm lens; 8 secs at f14; Fujichrome Sensia 100; flash guns.

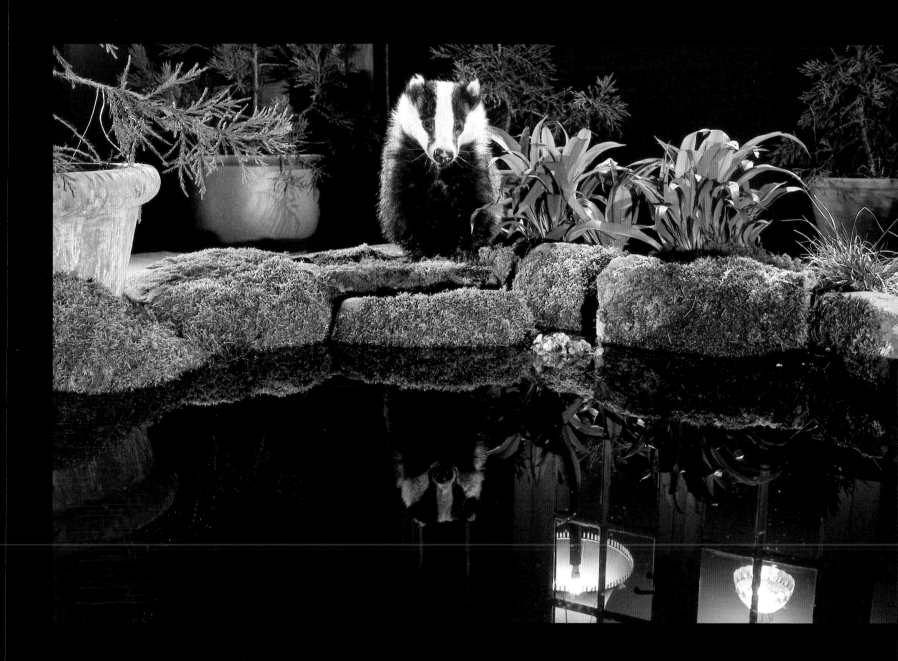

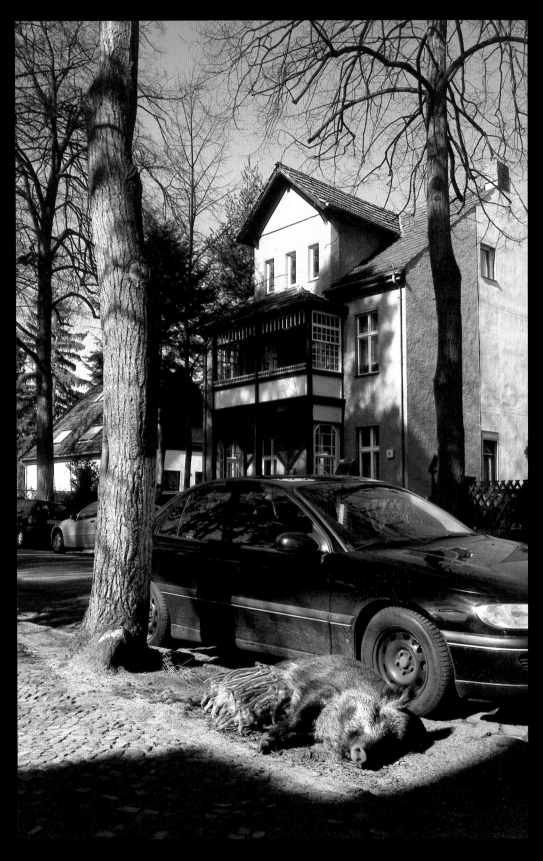

Florian Möllers
Germany

WILD BOAR SOW SUCKLING

Wild boars have increased tenfold in Europe since the 1950s because of changes in agriculture, the lack of predators and a fall in hunting. For the past 40 years, they have been living in the suburbs of Berlin. In spring, they give birth in gardens, parks and churchyards, and their population reaches about 4,000. I followed this sow for three days. One morning, she carefully led her five-day-old piglets through the streets for the first time. The family crossed a main road, and then walked past a bus stop, a supermarket and a playground before settling down to rest.

Canon EOS, with 28-135mm f3.5-5.6 USM Canon lens; 1/125 sec; Fujichrome Sensia 100; fill-in flash with soft bouncer.

Animal portraits

This category – one of the most popular – invites entries that are true portraits, showing an animal in full- or centre-frame, which convey the spirit of the subject.

WINNER

Helmut Moik
Austria

DALMATIAN PELICAN

Each spring, Dalmatian pelicans arrive from North-east Africa and South Asia to breed in the Danube Delta, Romania. Armed with a permit to enter the reserve and a guide with a small motorboat, I arrived at the delta before sunrise. My guide left me at a small island where a large colony of pelicans was sleeping. At first light, this pelican opened its eyes and gave me a penetrating stare. A few seconds later, it waddled into the water to wash and begin its day.

Nikon F5, with AFS 300mm f2.8 lens and x2 teleconverter OE; 1/30 sec at f5.6; Fujichrome Sensia 100; tripod.

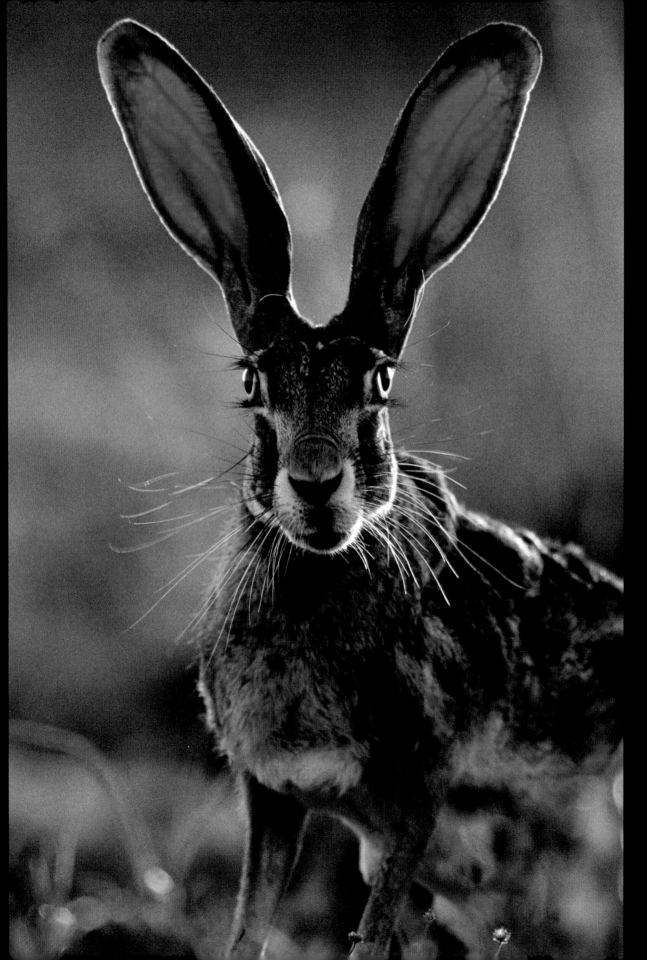

 RUNNER-UP

Jeremy Woodhouse
UK

BLACK-TAILED JACKRABBIT

Jackrabbits spend most of the day resting in scratched-out hollows in the ground, emerging at dusk. It was late afternoon in the Rio Grande Valley in South Texas when I spotted this one sitting calmly beneath a mesquite tree. The beautiful back-glow highlighted its whiskers and rim-lit its body. Jackrabbits (hares) seem always on their guard, and so I knew it would be difficult to get close. I climbed out of my truck, dropped to the ground and leopard-crawled across the desert scrub, braving ticks and burrs, to get close enough.

Canon EOS 1v, with 500mm f4L IS lens plus 1.4x extender; 1/8 sec at f5.6; Kodak E100VS rated at 200; beanbag.

Werner Bollmann
Germany

BLUE-FOOTED BOOBY
This is one of three resident
booby species on the
Galapagos Islands. It breeds
on the ground in large
colonies on several of the
islands. The birds often build
their simple nests right on the
footpaths that cross the
colonies. I was fascinated by
this bird's peaceful expression
and symmetrical patterns of
its plumage. Though already
midday, the light was
beautifully softened by high
clouds. A teleconverter
enabled me to achieve the
desired composition without
disturbing the bird.
**Nikon F100, with Nikon 80-200mm
f2.8 lens and 1.4 x teleconverter;
1/60 sec at f5.6; Fujichrome Velvia
rated at 40.**

forced many red foxes to change their habits. Normally nocturnal, this hungry adult had overcome its timidity to forage during the day.

It pounced into the low snow-bank in the foreground, desperately trying to catch a mouse. In between taking photos, I had to remove the batteries from the camera and hold them in the palm of my hand to get them working again. The mouse escaped, and the fox soon moved on to search for food elsewhere.

Nikon F100, with Nikon 300mm f2.8 lens; TC-301 x2 teleconverter and TC-14b 1.4x teleconverter; 1/125 sec at f2.8; Fujichrome Velvia.

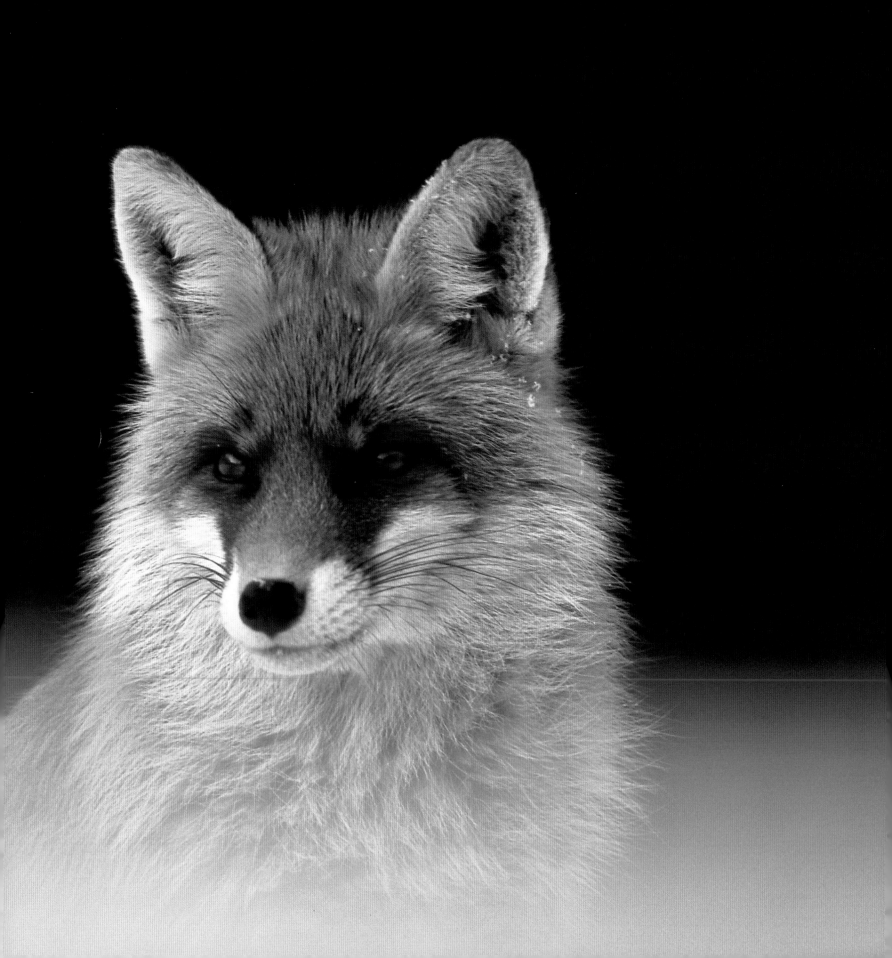

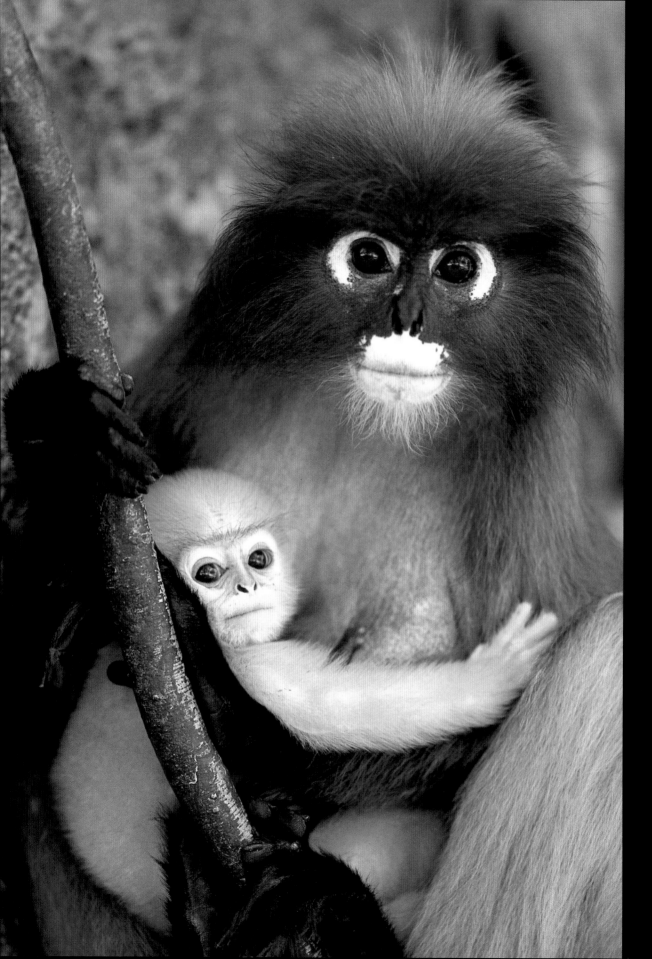

HIGHLY COMMENDED
Elio Della Ferrera
Italy

**DUSKY LANGUR MOTHER
AND BABY**
After following groups of
dusky langurs for weeks in
southern Thailand, I spotted
this mother with her small
baby at the edge of a forest.
The monkeys regularly feed in
this area and are used to
people. When both looked
straight at me, I managed to
get this portrait. The appeal of
the adults is enhanced by the
distinctive white circles
around their eyes, but the
apricot-coloured babies are
particularly delightful (their
fur turns to pale yellow and
then eventually to grey).
**Canon EOS 1N, with 300mm lens;
1/60 sec at f2.8; Fujichrome Provia
100; tripod.**

Theo Allofs
Germany

GIANT RIVER OTTER WITH A CATFISH

After a few weeks following a giant river otter family in Pantanal, Brazil, I gradually won their trust. The otters teased me by popping their heads out of the water close to my boat, looking at me for a second or two, and then diving down again before I could get a chance to aim my camera. But on one occasion, I saw an otter swim towards me and then dive. I guessed where it would surface and pointed my camera. Into my viewfinder appeared this head, a small catfish dangling from the corner of its mouth.

Canon EOS1V, with 600mm/f4 lens; exposure not recorded; Provia 100F rated at 200.

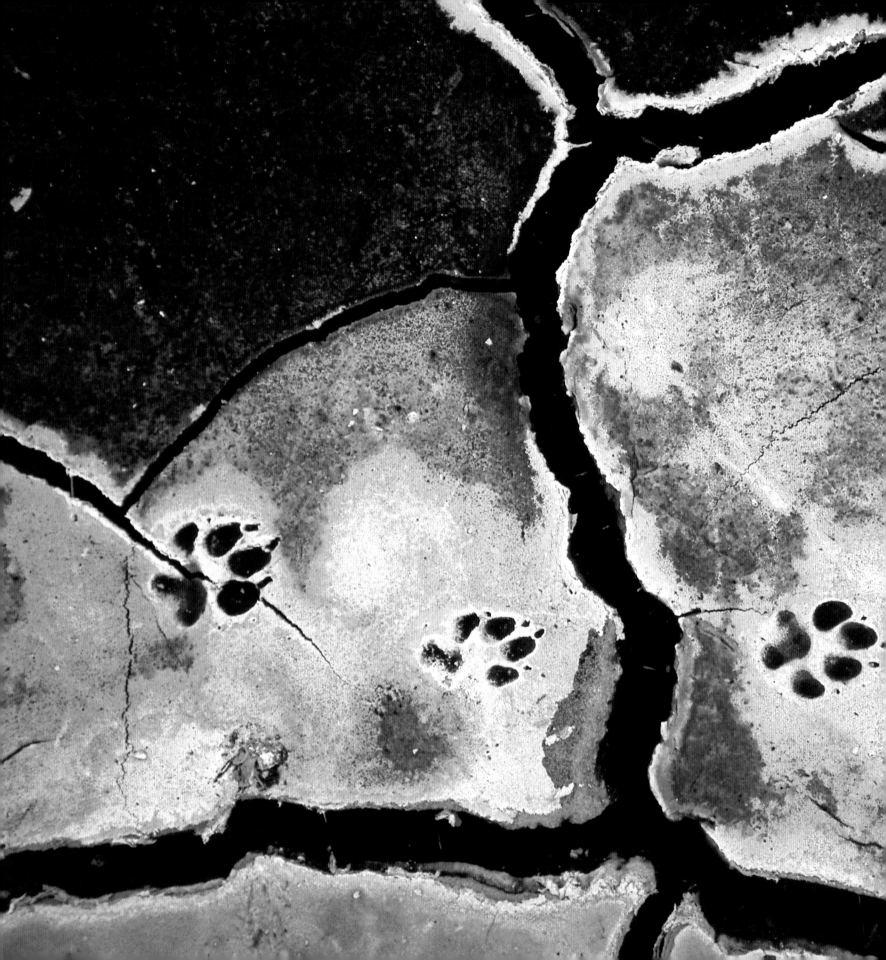

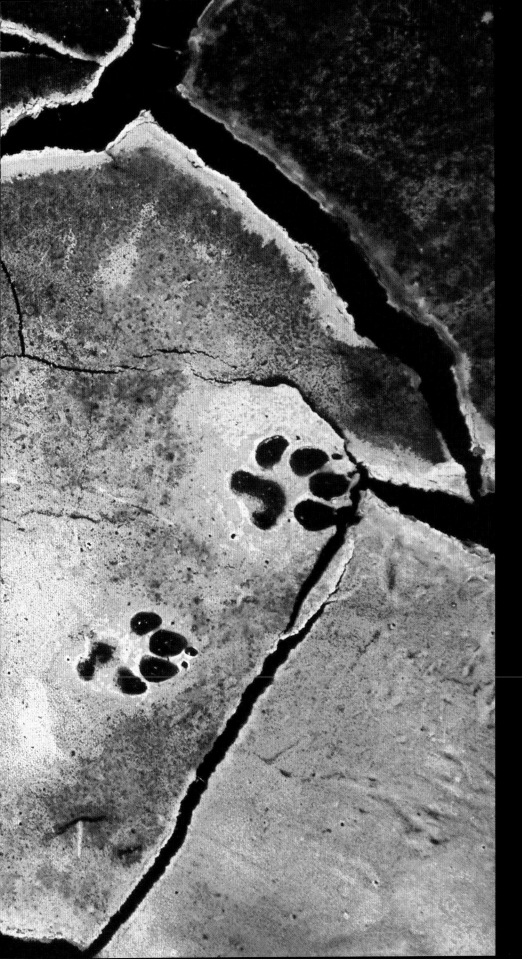

Composition and form

Here, realism takes a back seat, and the focus is totally on the aesthetic appeal of the pictures, which must illustrate natural subjects in abstract ways.

 WINNER

David W Breed
UK

SPOTTED HYENA FOOTPRINTS

I was searching for lions in a remote area of the Serengeti, known as Cub Valley, and had just spotted two large males resting in the shade of an acacia tree when I saw this wonderful hyena-print 'picture' in the mud of a dried up riverbed. To photograph them, I needed to be on foot, and so I positioned the Landrover between the lions and myself so that I wouldn't disturb their siesta. The edges of the prints are outlined with soda crystals left as the water evaporated. Spotted hyenas often like to spend the heat of the day in the shade provided by the banks of these dried up riverbeds and pools, often lying right in the water to keep themselves cool.

Canon EOS1V, with 17-35mm f2.8 lens; 1/25 sec at f5.6; Fujichrome Provia 100.

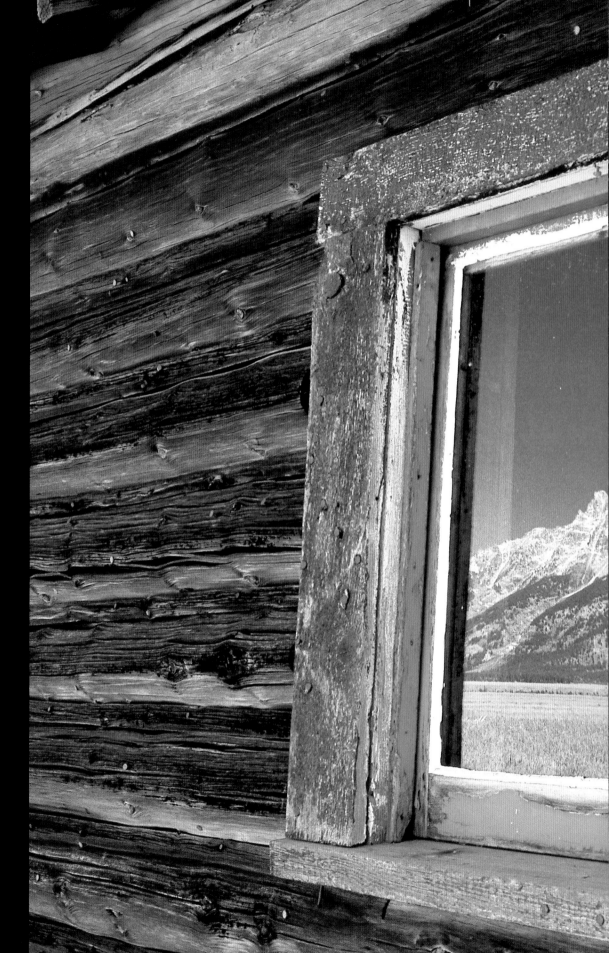

Herb Eighmy
USA

**THE GRAND TETON
MOUNTAINS REFLECTED
IN A WINDOW**

These mountains tower more than a mile above the valley of Jackson Hole, in Wyoming. This magnificent range, the youngest in the Rockies, contains some of North America's oldest rocks. I wanted to photograph the scene in an early morning light, but with a twist. On a walk around an abandoned farm one day, I saw the icy peaks sharply reflected and perfectly framed in one of the old, dusty windows.

Canon EOS 3. with 28-70mm lens; 1/4 sec at f16; Fujichrome Velvia; mirror lock-up and cable release; polariser.

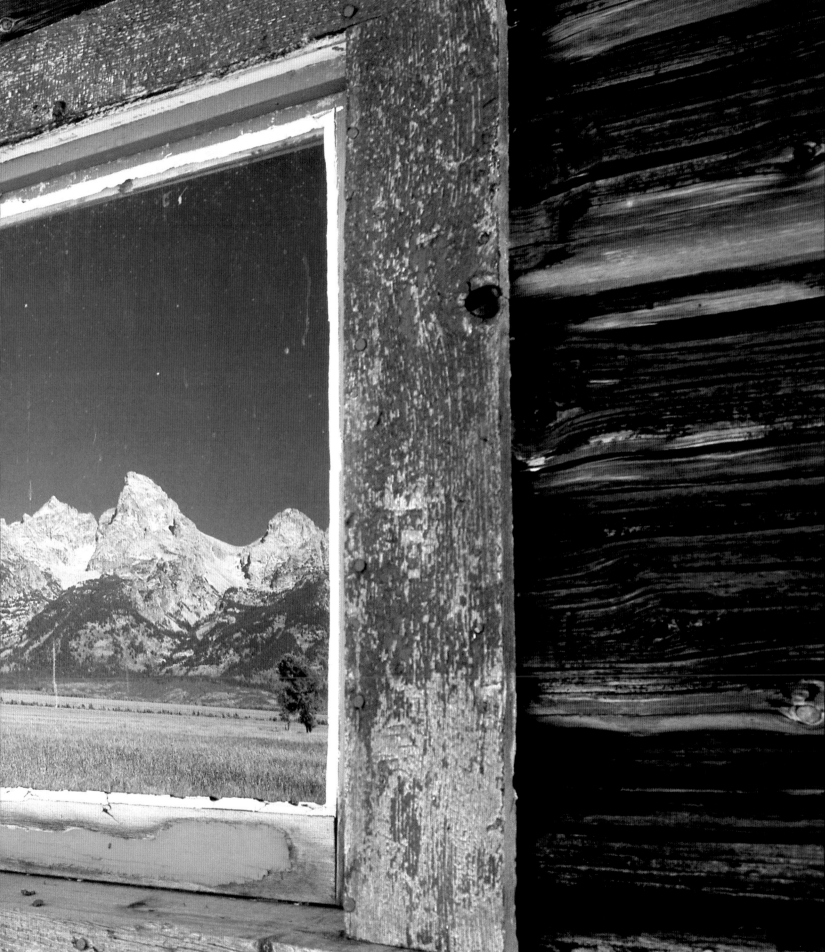

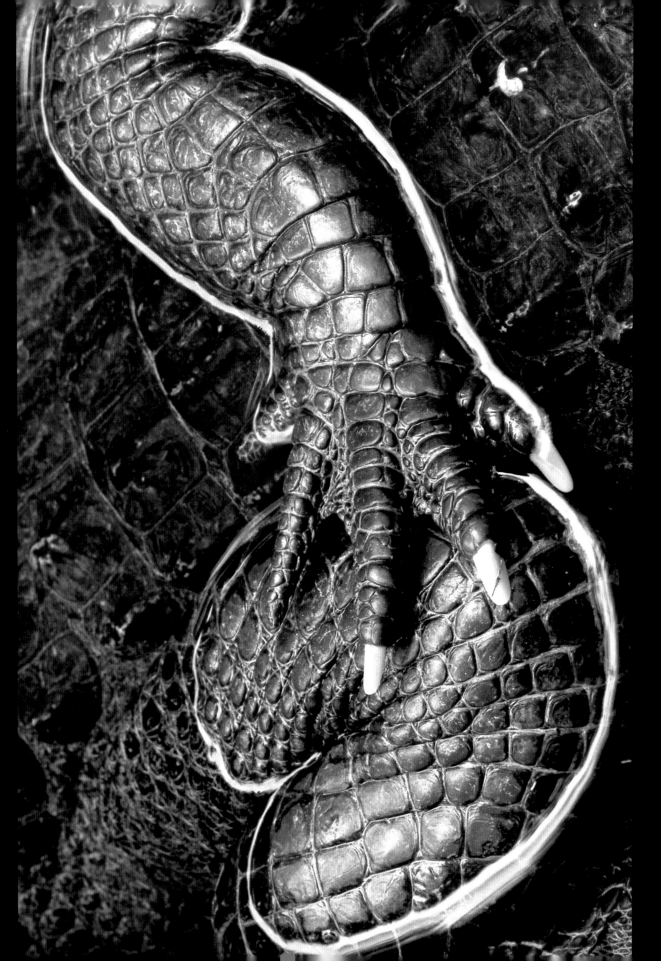

Tim Shuda
USA

ALLIGATOR LEGS

Inspired by the American alligator's bold, graphic appeal, I photographed these captive juveniles in Florida. As hatchlings, alligators get used to being physically close to each other. When one placed its foot over another's knee, I positioned myself so that the light made a strong outline around this interesting shape.

Canon EOS1V, with 400mm lens f2.8 with 2x converter; 1 sec at f22; Fujichrome RMS rated at 200; tripod; cable release; mirror lock-up.

Jenö Veres
Hungary

AUTUMN WOODLAND

Ancient forests still cover large parts of Hungary, exploding with colour in autumn. The experience affects all the senses, and I wanted to convey this in a photograph. I found a spot in the Mecsek Mountains where the trees, grasses and colours all worked well together. I shifted my camera up and down slightly as I took the shot to create an effect like an Impressionist painting, capturing the essence of light in autumn.

Canon EOS 30, with Canon EF 75-300mm f4.5-6 IS USM lens; 1.5 sec at f16; Fujichrome Velvia; ND filter.

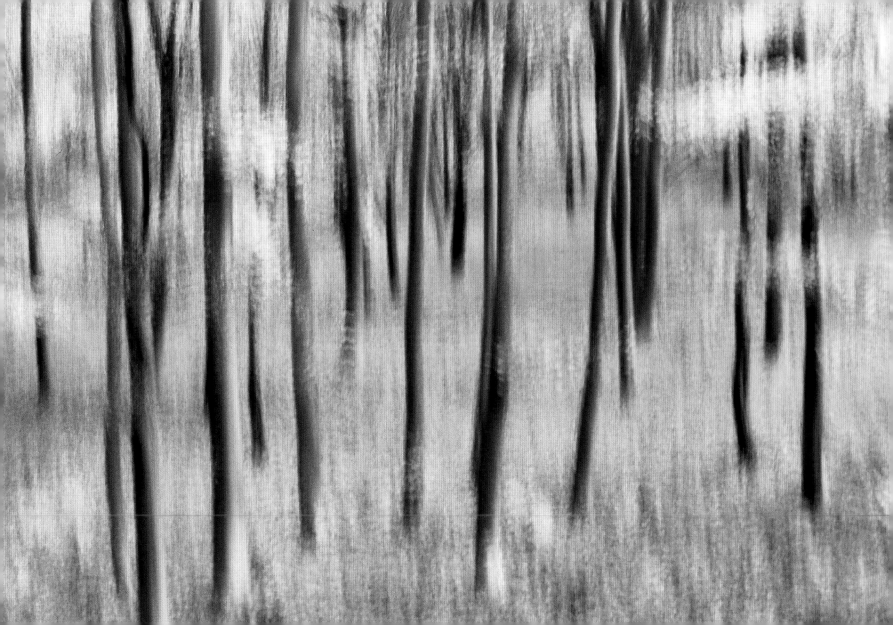

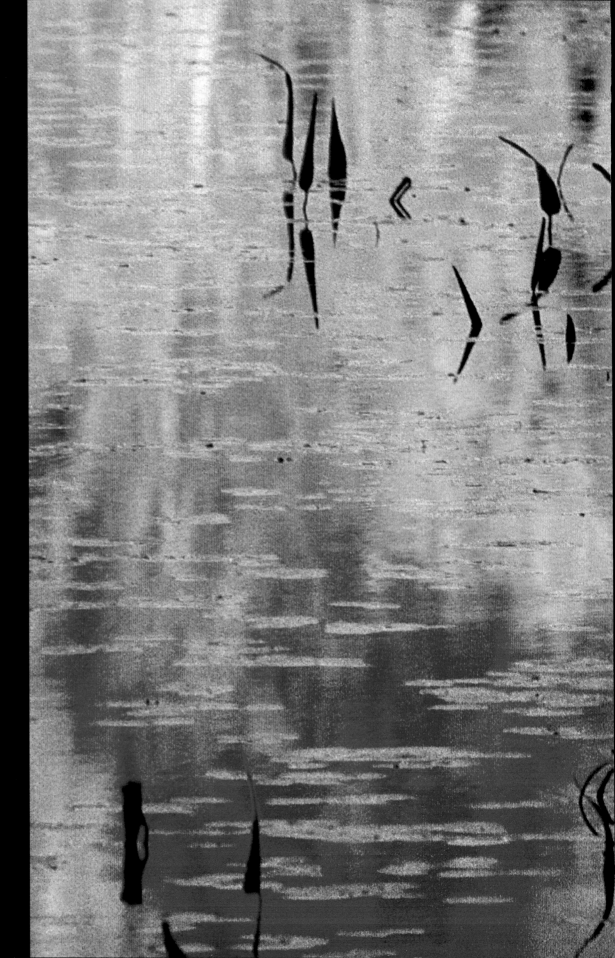

Budd Titlow
USA

**PICKERELWEED IN
AUTUMN REFLECTIONS**
The rising sun bathed Elbow
Pond, in New Hampshire's
White Mountains, in a perfect
light. Shimmering reflections
of autumn leaves danced on
the surface. I use a classic
'working sequence' in a
setting such as this.
The process involves first
photographing broad scenic
shots, then moving
systematically on to detailed
landscapes. This allows me to
capture the breadth of the
setting while creatively
exploring the abstract details
hidden in the landscape.
As the culmination of this
process, I used a 400mm lens
to 'reach out' from the
shoreline and capture the
diffuse warm colours
anchored by stalks of aquatic
pickerelweed.
**Canon EOS A2, with 400mm Canon
lens; 1/60 sec at f16; Ektachrome
Elite 100.**

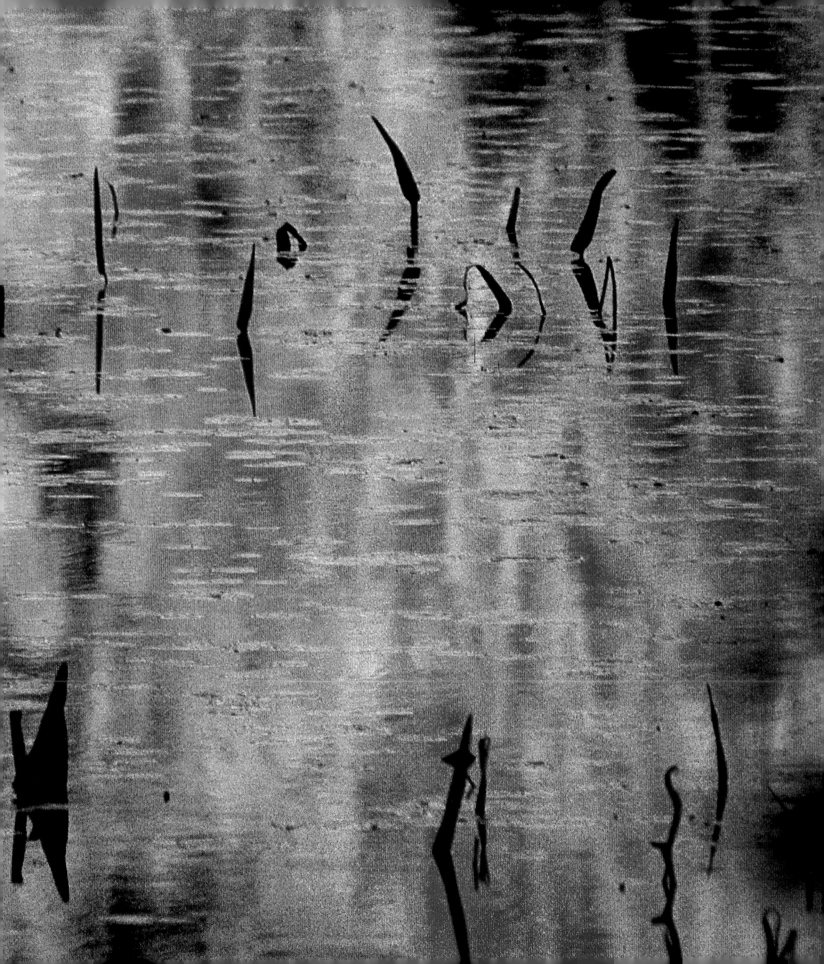

Cornelius Nelo
Germany

SHEEN ON WATER

While on a trip to the Negev
Desert in Israel, I visited a
spring each morning hoping
to photograph any wildlife
that had come to drink. One
day, I could see from the
tracks that a wild ass had
visited and waded into the
water, breaking up the surface
layer of bacteria in its wake.
**Canon EOS 33, with 180mm f3.5
macro lens; 2.5 sec at f32;
Ektachrome Elite Chrome Extra
Colour 100; extension tubes; cable
release; tripod; mirror pre-release.**

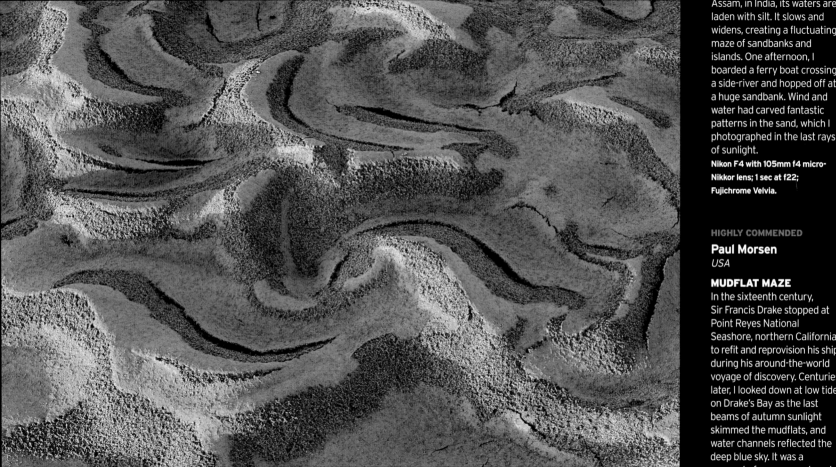

Assam, in India, its waters are laden with silt. It slows and widens, creating a fluctuating maze of sandbanks and islands. One afternoon, I boarded a ferry boat crossing a side-river and hopped off at a huge sandbank. Wind and water had carved fantastic patterns in the sand, which I photographed in the last rays of sunlight.

Nikon F4 with 105mm f4 micro-Nikkor lens; 1 sec at f22; Fujichrome Velvia.

Paul Morsen
USA

MUDFLAT MAZE
In the sixteenth century, Sir Francis Drake stopped at Point Reyes National Seashore, northern California, to refit and reprovision his ship during his around-the-world voyage of discovery. Centuries later, I looked down at low tide on Drake's Bay as the last beams of autumn sunlight skimmed the mudflats, and water channels reflected the deep blue sky. It was a

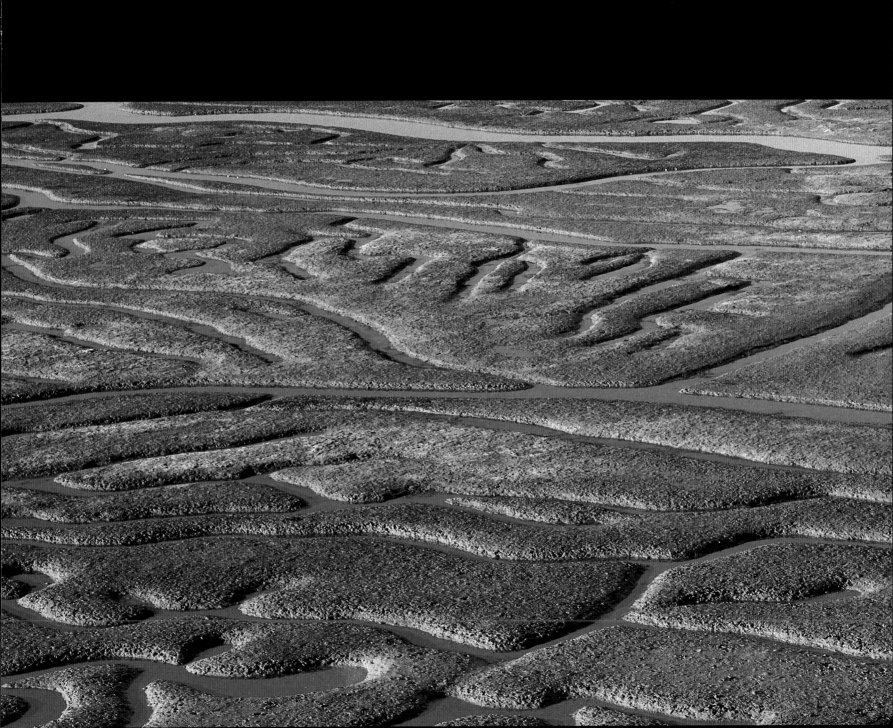

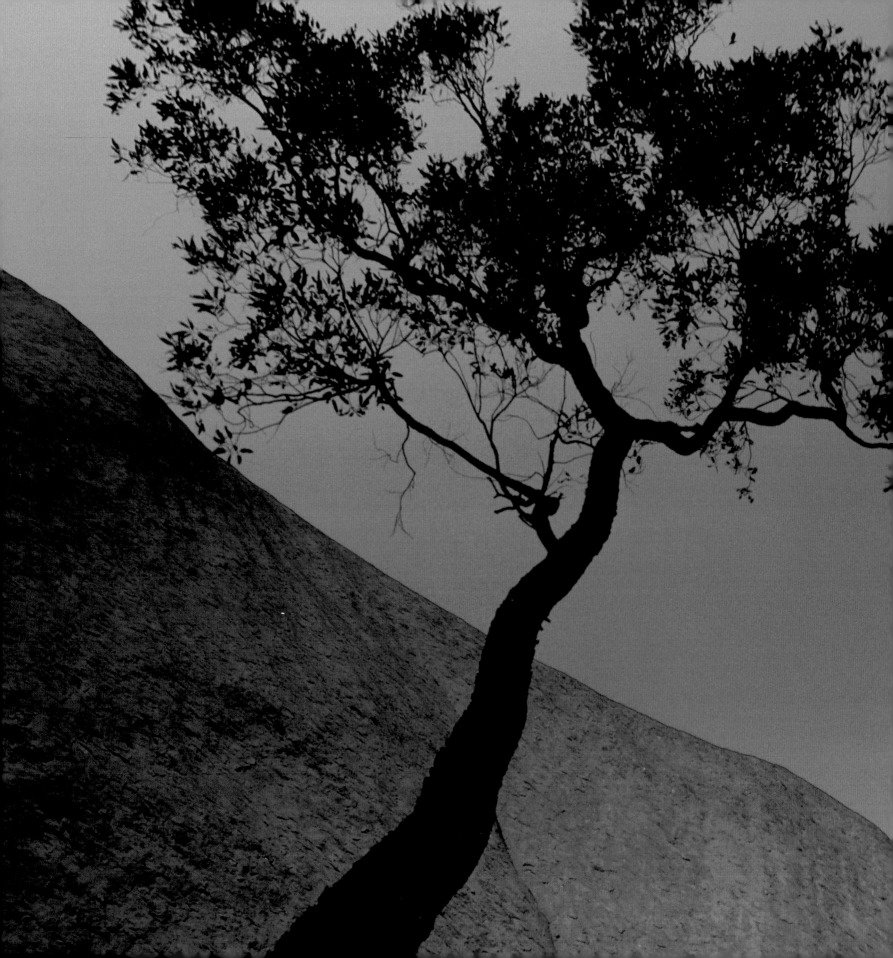

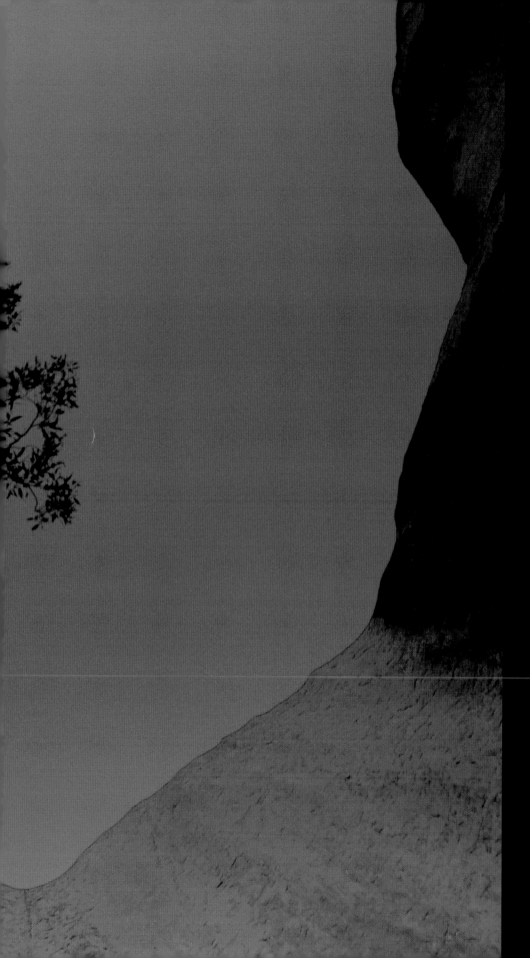

HIGHLY COMMENDED

Andy Townsend
Australia

DESERT BLOODWOOD
This bloodwood copes with all but the very driest habitats. This one had taken root in a semi-permanent waterhole next to the sheer rock face of Kantju Gorge in the Uluru / Kata Tjuta National Park, a site held sacred by the Arrente Aboriginal people of Central Australia. After a storm, water cascades 348m off the sheer sides of Uluru (Ayers Rock), turning natural hollows into transient pools.
Canon EOS 3, with 28-135mm EF IS lens; Fujichrome Velvia.

In praise of plants

This category aims to showcase the beauty and importance of flowering and non-flowering plants whether by featuring them in close-up or as an essential part of their habitat.

 WINNER

Stig-Erik Eriksson
Sweden

HEPATICA NOBILIS
Each year, when the spring flowers unwrap themselves from the earth, the subtle colours and complex shapes provide such wonderful photographic opportunities that, to me, it feels like Christmas all over again. This hepatica emerged in woodland in Hinsebo, Norberg, Sweden. Its beauty lies not just in individual flowers, but also in the context of many similar flowers clustered together. I wanted to capture the delicacy and freshness of a single hepatica but also include its environment. I used a fast exposure to soften the background.
Nikon F4, with 200mm macro lens; 1/500 sec at f4; Fujichrome Velvia.

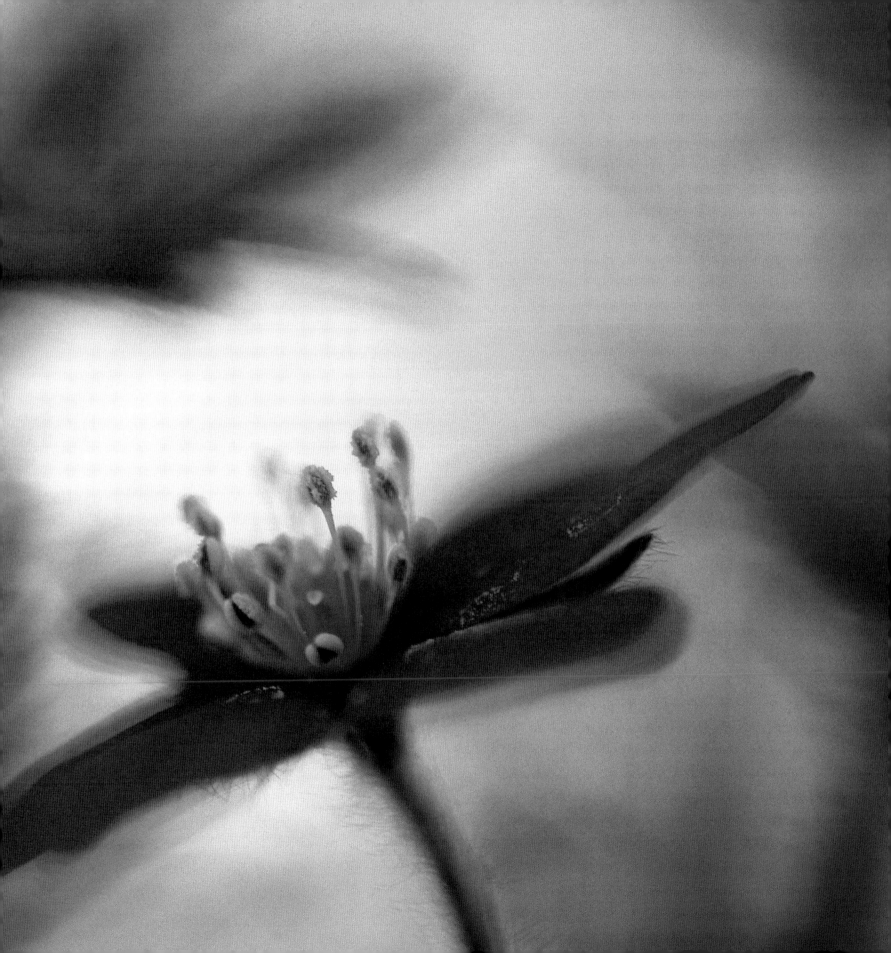

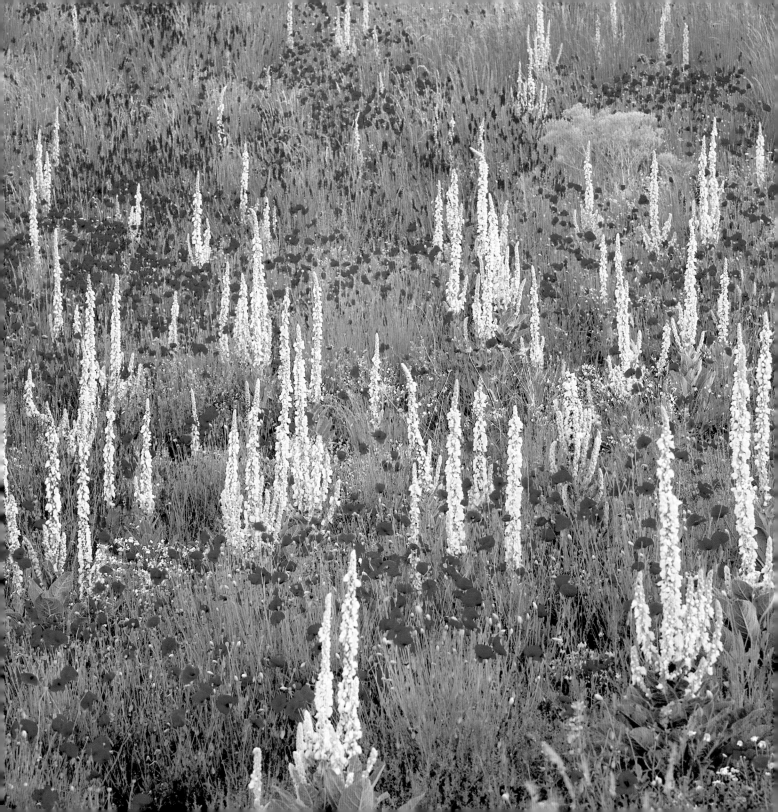

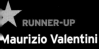

RUNNER-UP

Maurizio Valentini
Italy

SPRING MEADOW, ITALY
I was in the Gran Sasso
National Park in Central Italy,
looking for the rare Abruzzo
brown bear, when this
glorious field stopped me in
my tracks. The strong, noon
sun wasn't appropriate for a
photograph, and so I returned
at dusk, when the softer light
highlighted this explosive
mixture of colours.
Hasselblad 501 CM, with 150mm
Sonnar lens; 1/2 sec at f22;
Fujichrome Velvia; tripod.

HIGHLY COMMENDED

Per-Olov Eriksson
Sweden

**CORNFLOWERS AND
SCENTLESS MAYWEED**
Modern agricultural practices
have led to it becoming
increasingly rare to see
wildflowers in a field. Over the
years, I have tried to
document this dramatic
change in our countryside.
When I found this wheatfield
in Irvingsholm, Närke, in
Sweden, bursting with blue
cornflowers and white
scentless mayweeds, it was an
almost painfully beautiful
reminder of times gone by.
Pentax 6x7, with 135mm macro
lens; 1/8 sec at f32; Fujichrome
Velvia; soft filter.

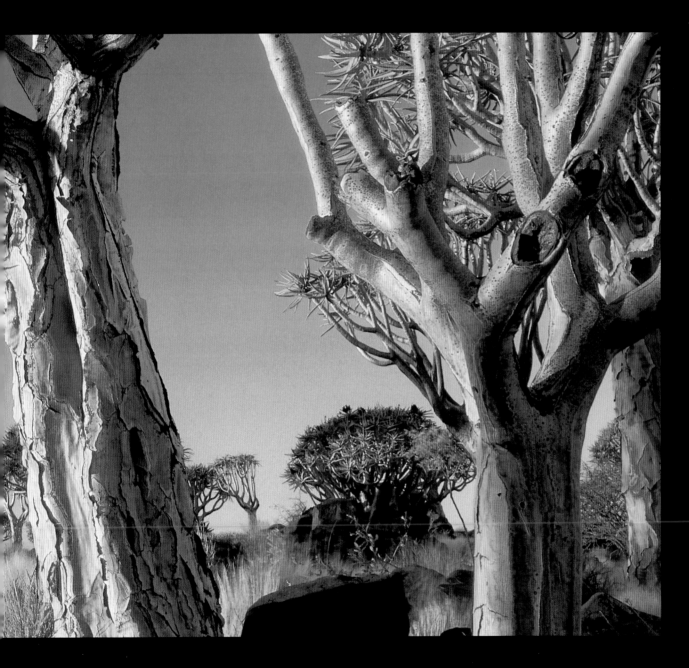

 SPECIALLY COMMENDED

Urs Lüthi
Switzerland

QUIVER TREE FOREST AT SUNSET

With its strong, shallow roots and spongy wood, the quiver tree, or *kokerboom*, has mastered survival in Namibia's extreme arid south. This gigantic succulent aloe clings to rock-faces and can grow up to nine metres high. It stores water in its trunk and doesn't blossom until it is 20–30 years old. San people made quivers for their arrows out of its easy-to-hollow, tough, pliable wood. At the magical Quiver Tree Forest near Keetmanshoop, hundreds of quiver trees grow in the same place, some of them perhaps 300 years old. The warm light of sunset made their trunks glow orange-brown.

Hasselblad xPan, with 90mm lens; 1/60 sec at f16; Fujichrome Velvia; tripod; polarizer.

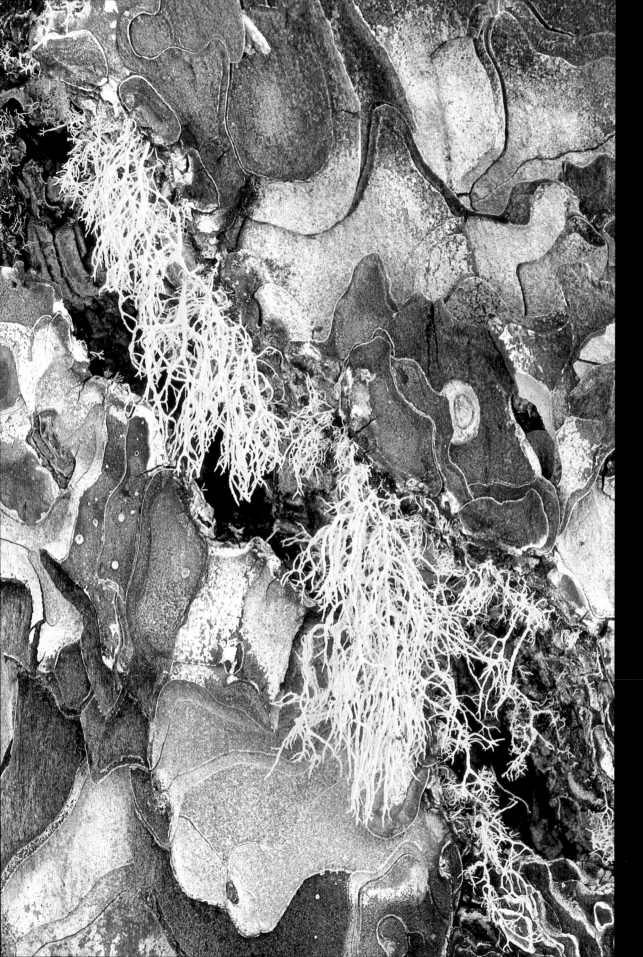

Fritz Pölking
Germany

STAGHORN LICHEN ON A JEFFERY PINE

I found this lichen clinging to a Jeffery pine in the Lassen Volcanic National Park, California. Staghorn lichen is toxic, and the Achomawi, the native American people of North-eastern California, traditionally used it to poison their arrowheads. In Europe, the lichen was used to poison wolves, hence its other name, wolf lichen.

Canon EOS 1V, with 70-200mm f4 lens; Fujichrome Velvia rated at 40; Canon close-up lens 500D.

HIGHLY COMMENDED
Andrew Davoll
UK

FLAT WATTLE
The south-west region of Western Australia boasts one of the richest and most diverse flora on Earth. This ancient landscape supports more than 4,000 species of flowering plants. Up to 80 per cent of these are endemic, including the flat wattle. This straggling shrub grows about a metre high and is covered in golden globular flowers. At the end of spring, seedpods gradually replace the dying flowers. For many years, I had searched for a specimen that demonstrated the different stages of this process. Last spring I was lucky enough to find it in Jarrah Forest, east of Perth.

Nikon FE2, with 180mm Sigma macro lens; 2 secs at f16; Fujichrome Velvia.

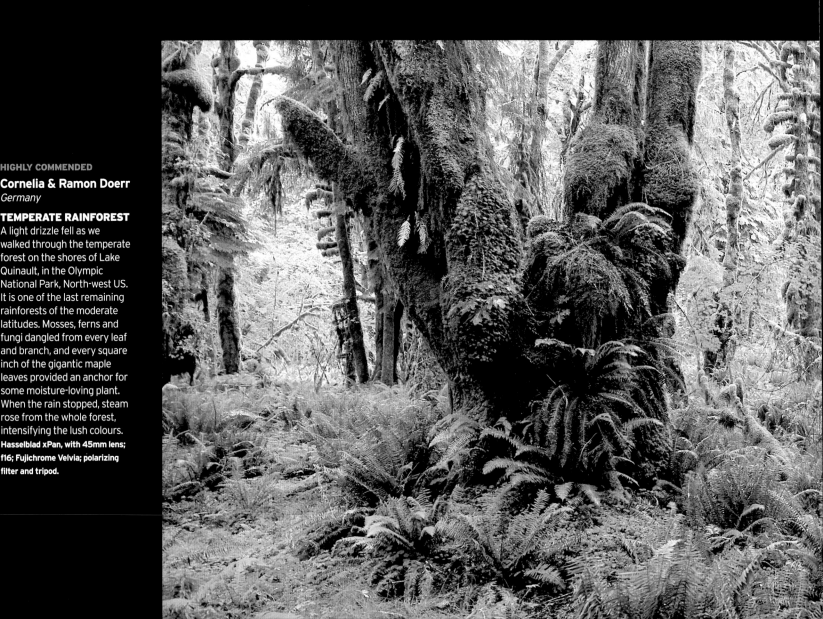

Cornelia & Ramon Doerr
Germany

TEMPERATE RAINFOREST
A light drizzle fell as we walked through the temperate forest on the shores of Lake Quinault, in the Olympic National Park, North-west US. It is one of the last remaining rainforests of the moderate latitudes. Mosses, ferns and fungi dangled from every leaf and branch, and every square inch of the gigantic maple leaves provided an anchor for some moisture-loving plant. When the rain stopped, steam rose from the whole forest, intensifying the lush colours.

Hasselblad xPan, with 45mm lens; f16; Fujichrome Velvia; polarizing filter and tripod.

Wild places

This is a category for landscape photographs, but ones that must convey a true feeling of wildness and create a sense of awe and wonder.

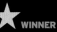 **WINNER**

Ines Labunski Roberts
UK

WATERFALL, MILFORD SOUND
Milford Sound on New Zealand's South Island teems with waterways, lakes, glaciers and mountain peaks – a photographer's dream, usually. But the day we took a boat trip around the Sound dawned dark and dreary. Photographically, it did not bode well. This waterfall looked impressive enough, but the weak light and poor composition meant that it just wasn't worth using the camera. The boat turned away and we began to leave, disappointed. I glanced back, and suddenly, for a split second, the whole scene dramatically transformed. I had time to expose just this one frame.
Canon Elan II EOS, with 75-300mm Canon lens; Fujichrome Provia RDPIII 100; tripod.

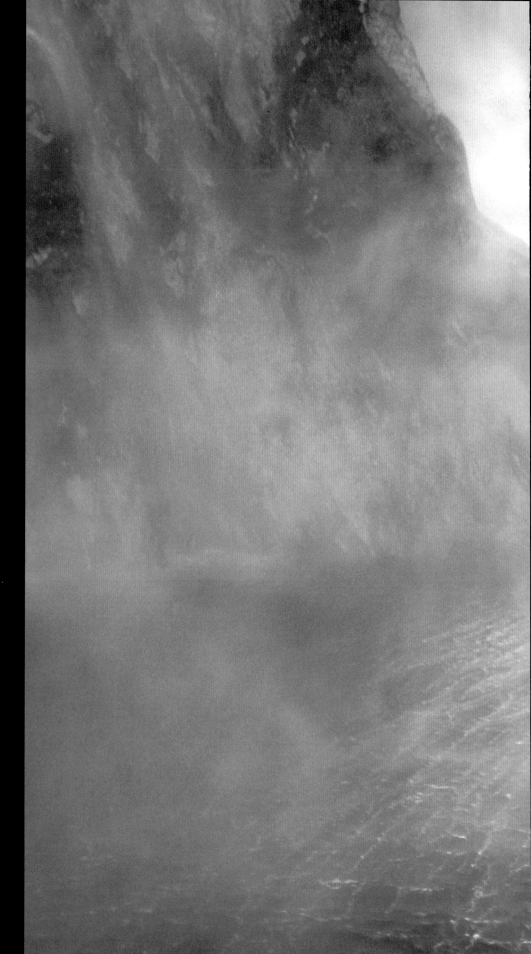

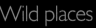 RUNNER-UP

Hannu Kivelä
Finland

**FULL MOON RISING
THROUGH THE FOREST**

In winter, photographers in
Finland keep a close eye on
the lunar timetable. It gets
very dark very early. Knowing
the moon's phases and the
times it will rise and set allows
us to photograph some lovely
winter landscapes. At the end
of a short, bright day at Lake
Iso-Timonen, near the small
northern town of Utajärvi, the
temperature plummeted.
A light, freezing mist
materialised above the lake,
through which the rising full
moon glowed gold. It was
just 4pm.

**Canon EOS , with 28-90mm lens;
45 sec; Kodak Elite Extra Colour
100; tripod.**

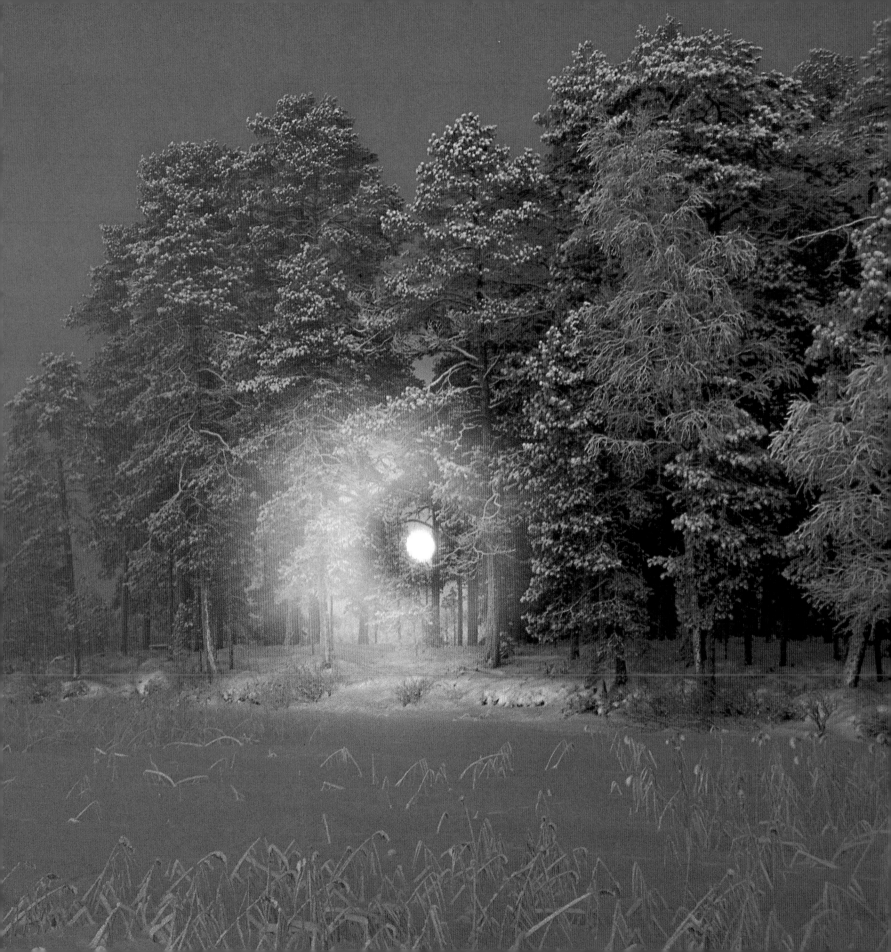

Subhankar Banerjee
India

RED AURORA BOREALIS

I took this photograph in November 2001 in the Hulahula River Valley, Arctic National Wildlife Refuge, in Alaska. The temperature was about -45°C, and I got frostbite for the first time in my life. This type of aurora (northern lights) is very rare and occurs about 480km above the Earth's atmosphere, whereas green ones take place at about 100km. An aurora is caused by charged particles, which originate from the sun, interacting with atoms and molecules in our atmosphere, creating ionization and the emission of light.

Nikon F4S, with 17-35mm f2.8 Nikon lens; about 20 secs at f2.8; Fujichrome Provia 400F rated at 800; tripod.

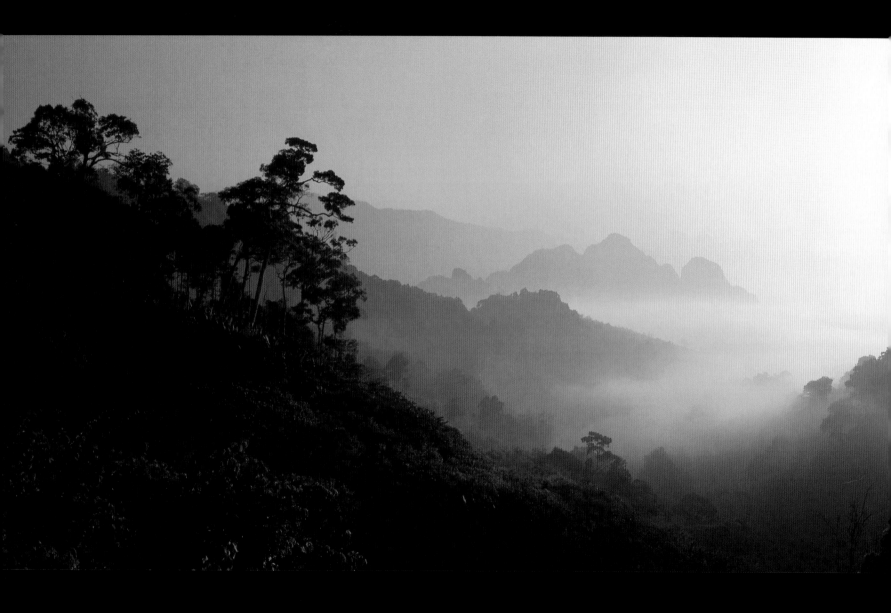

Christer Fredriksson
Sweden

KHAO SOK NATIONAL PARK

Heavy monsoon rains drench the limestone mountains that separate the east and west coasts of the Thai peninsula. They turn Khao Sok National Park into the wettest place in Thailand. The park's vast tracts of dense tropical rainforest, along with abundant fresh water and the shelter of deep valleys and caves, offer protection to several endangered species. Thai tigers, leopards and Malay sunbears roam here. The park is also home to elephants, gaur, banteng, several species of hornbill and many endemic plants, including orchids and the rare, parasitic rafflesia, with its 80cm flowers.

Fuji 617 panorama camera, with 90mm lens; probably 1 sec at f22; Fujichrome Velvia.

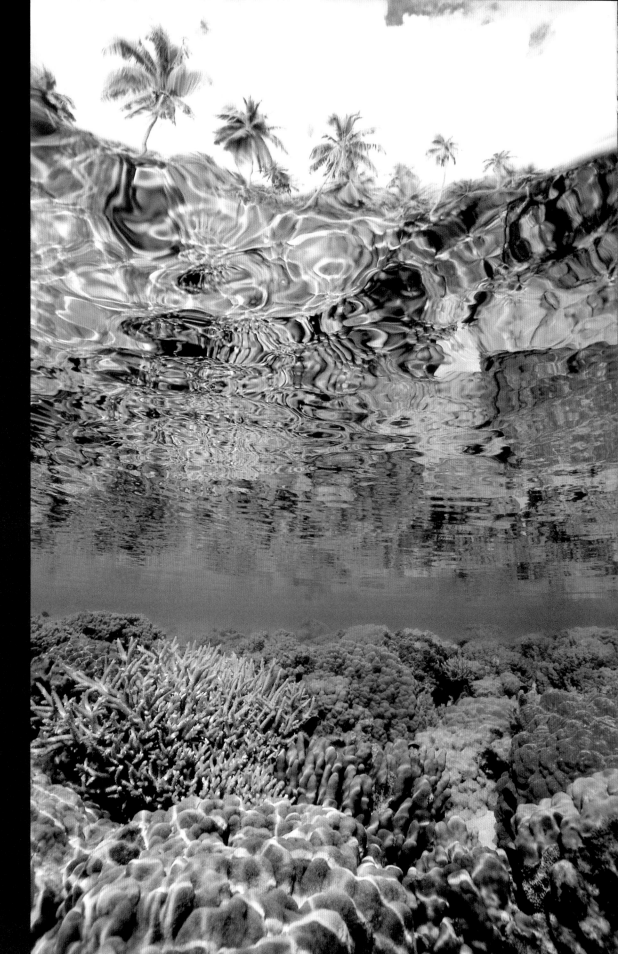

Tobias Bernhard
Germany

**CORAL GARDEN
REFLECTION**

Extensive fringing reefs
encircle the small island of
Tahaa in French Polynesia.
I discovered a narrow gap in
the reef between two motus
(low, sandy islets). The coral
here grew low, and a
perpetual current of cool,
clear, ocean water washed
into the shallow lagoon.
The flow ironed the water's
surface so flat that I decided
to attempt a shot looking up
through the reflections of
coral that would include the
palm trees on the shore.
**Nikon F4, with 16mm fisheye lens;
1/125 sec at f8; Fujichrome Velvia;
Subal underwater housing.**

Behaviour
All other animals

This category offers plenty of scope for interesting pictures, as animals other than mammals and birds comprise the majority and have behaviour that is often little known.

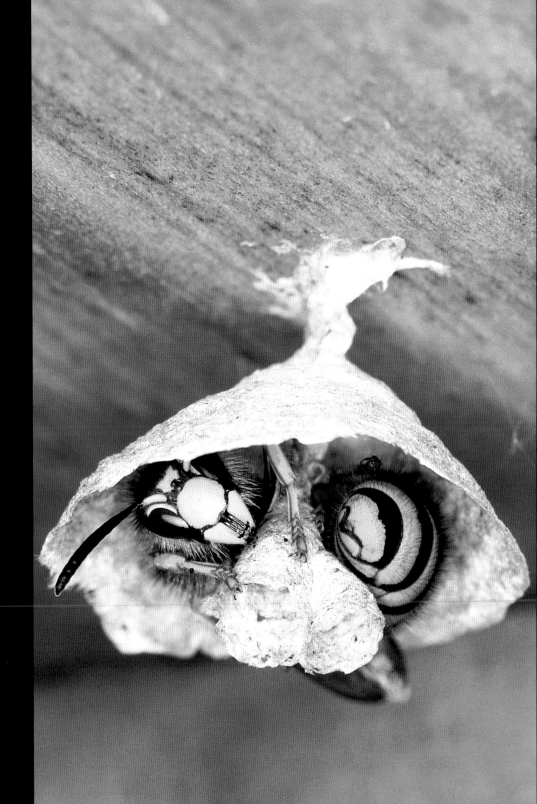

David Maitland
UK

QUEEN WASP BUILDING HER NEST

One spring, a common wasp queen founded her nest in our hen-house. This photograph shows her brooding her tiny, pearl-like eggs at the base of each cell. She must work alone until her first daughters are born to help with the chores. Her building material is chewed wood, and her construction work is both intricate and beautiful. As more and more daughters are born, the nest may expand to house up to 5,000 wasps.
Olympus OM4Ti, with 80mm macro lens; 1/60 sec at f16; Kodachrome 64; Olympus T10 ring flash; extension tubes.

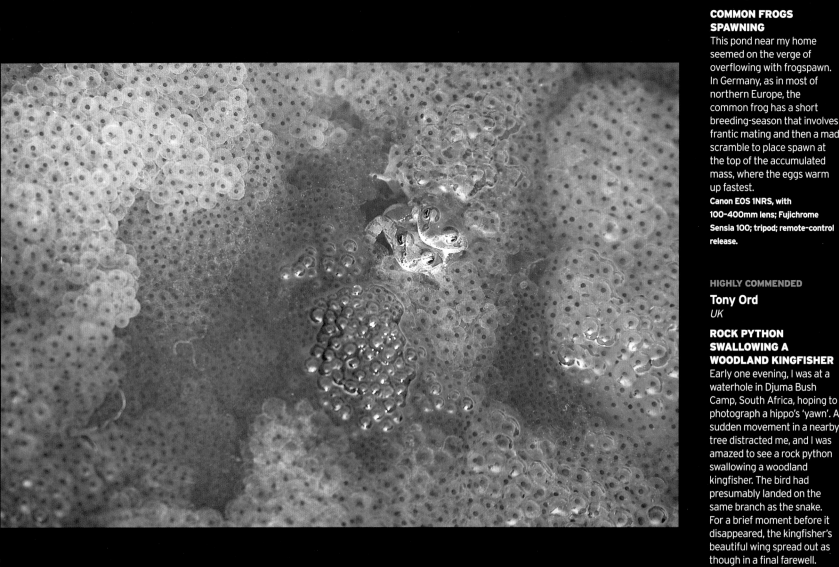

Thomas Endlein
Germany

COMMON FROGS SPAWNING

This pond near my home seemed on the verge of overflowing with frogspawn. In Germany, as in most of northern Europe, the common frog has a short breeding-season that involves frantic mating and then a mad scramble to place spawn at the top of the accumulated mass, where the eggs warm up fastest.

Canon EOS 1NRS, with 100-400mm lens; Fujichrome Sensia 100; tripod; remote-control release.

HIGHLY COMMENDED

Tony Ord
UK

ROCK PYTHON SWALLOWING A WOODLAND KINGFISHER

Early one evening, I was at a waterhole in Djuma Bush Camp, South Africa, hoping to photograph a hippo's 'yawn'. A sudden movement in a nearby tree distracted me, and I was amazed to see a rock python swallowing a woodland kingfisher. The bird had presumably landed on the same branch as the snake. For a brief moment before it disappeared, the kingfisher's beautiful wing spread out as though in a final farewell.

Nikon F90X, with 300mm f2.8 lens with x1.6 converter; f5.6; Fujichrome Provia 100; flashgun; tripod.

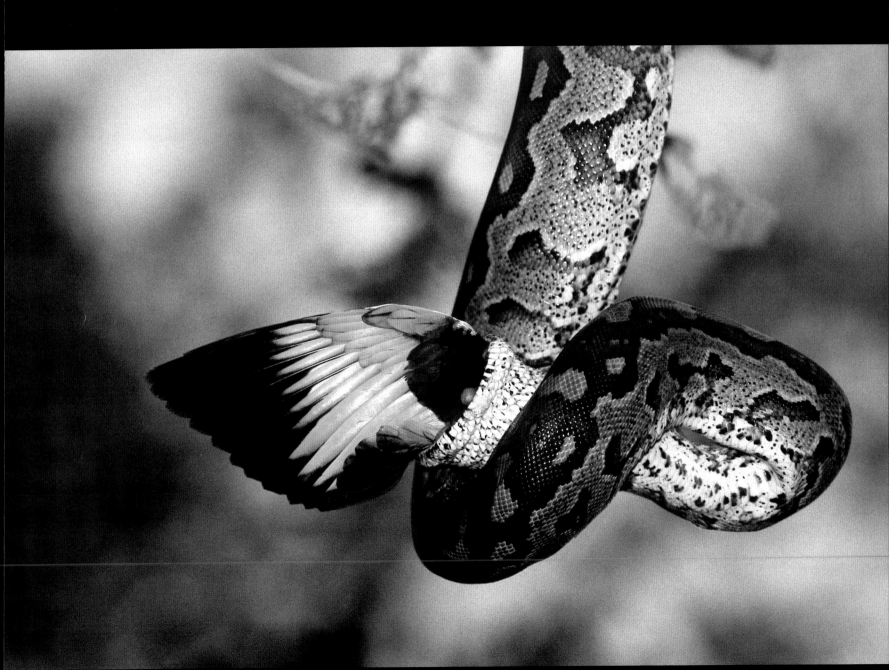

The world in our hands

These pictures illustrate, whether symbolically or graphically, our dependence on and relationship with the natural world or our capability for damaging it.

 WINNER

Gerhard Schulz
Germany

GORILLA AND BOY

**WILDLIFE
PHOTOGRAPHER
OF THE YEAR**

See p10

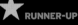 **RUNNER-UP**

Joe McDonald
USA

LIONS SURROUNDED BY TOURIST TYRE TRACKS
This pride, in the Serengeti National Park, Tanzania, often visited Lake Ndutu to drink and would lie around afterwards. One evening, after heavy rain, several lions rested in the open. The tyre tracks reveal how several tourist vehicles circled round in force to have a good look.
Canon IV, with 28-135mm f3.5 lens; 1/30 sec at f11; Kodak VS 100.

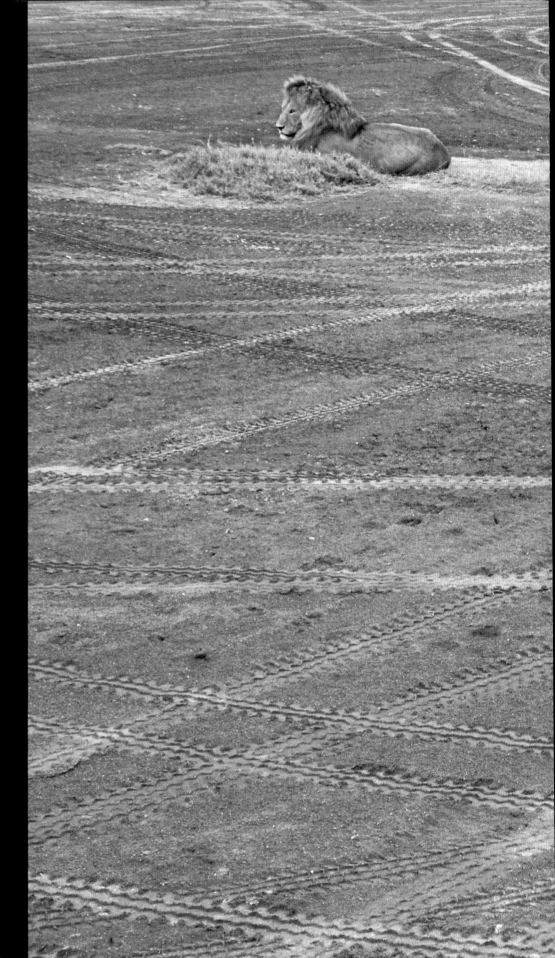

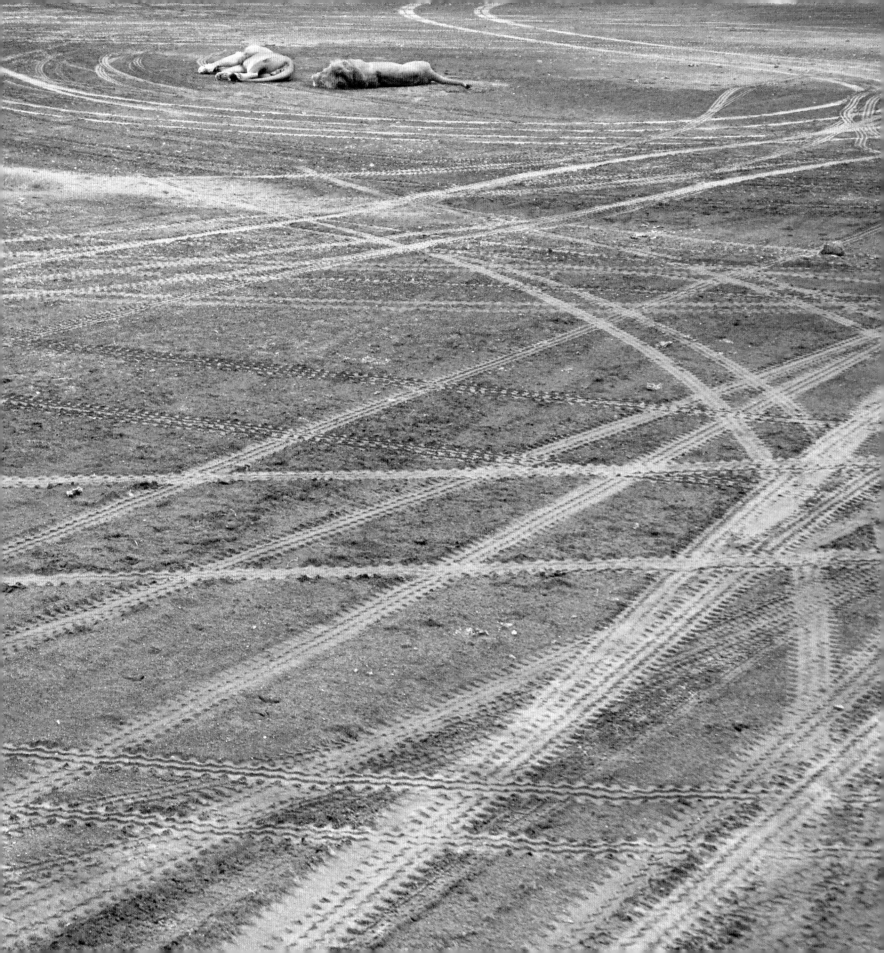

Staffan Widstrand
Sweden

BROWN BEAR TROPHY
It's legal once again to hunt bears in Sweden as, with about 1,000–1,300 individuals, they're no longer classed as endangered. Historically, hunters – especially the Sami and other Arctic peoples – have showed great reverence towards bears. It was thought that a dead bear would come back to haunt you unless treated with respect. This female had clear cause to haunt her persecutor. Hanging from the back of a tractor by a steel noose, her gutted corpse was turning in the wind, a piece of wood shoved inside to air the meat.
Nikon F5, with 17-35mm f2.8 lens; 1/125 sec at f8; Fujichrome Velvia; flash.

 SPECIALLY COMMENDED

Magnus Elander
Sweden

DEAD LYNX
Just 1,300–1,400 lynx survive wild in Sweden, and illegal killing poses a major threat – a problem I wanted to illustrate. My chance came when a captive-bred lynx in a game park had to be destroyed to avoid in-breeding (it could not have been released). I asked the keeper to drape the body across his shoulders so the focus would be on the animal and the conservation message would come across loud and clear.
Nikon N5, with 17-35mm wide-angle zoom lens; 1/25 sec at f5.6; Fujichrome Astia 100; fill-in flash.

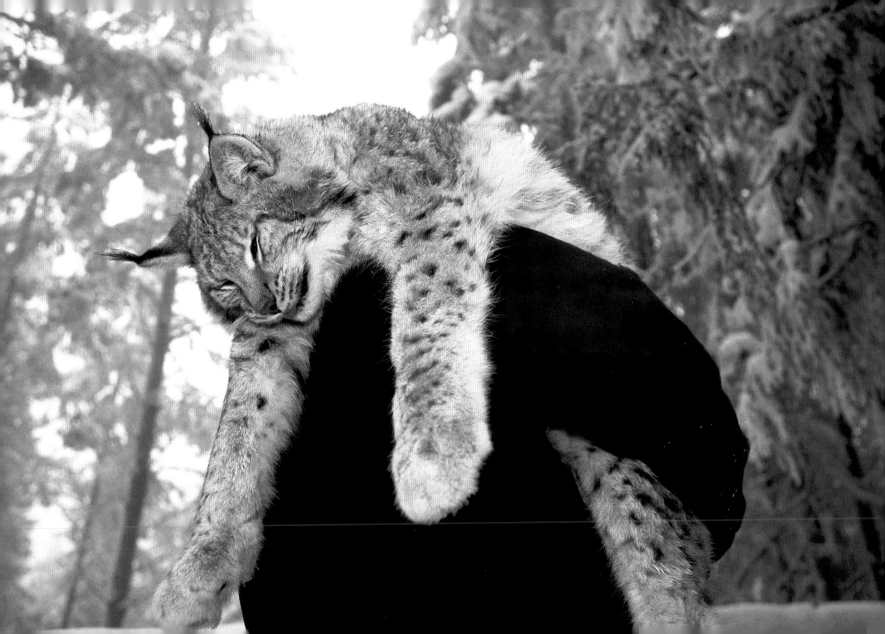

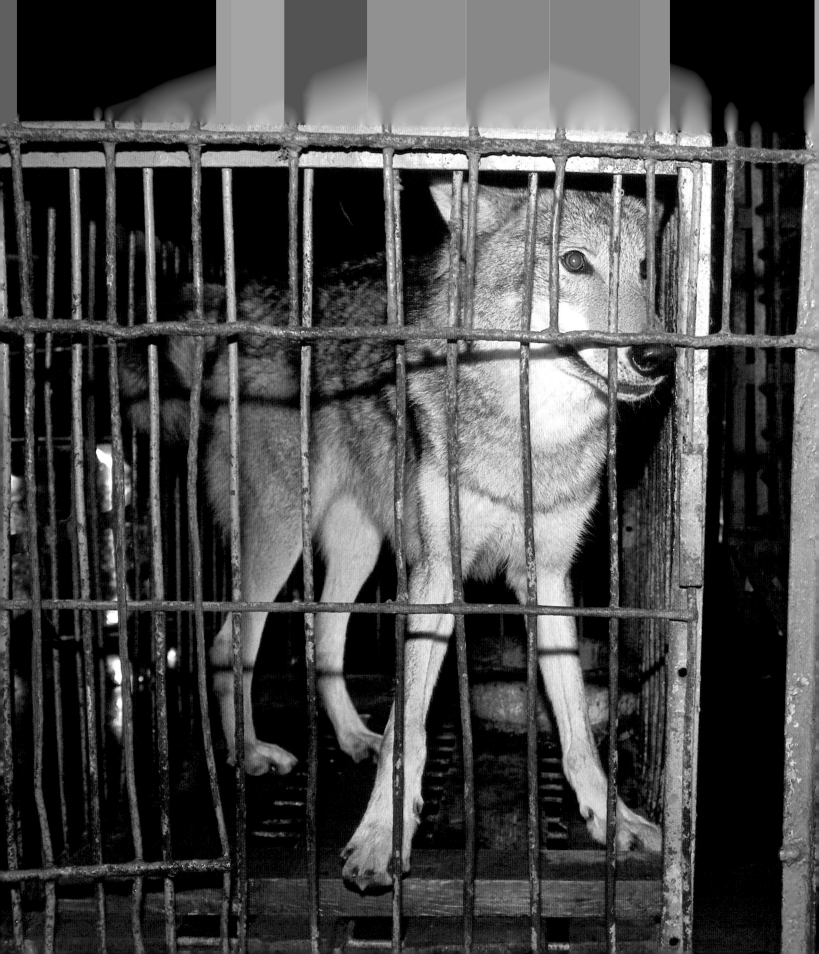

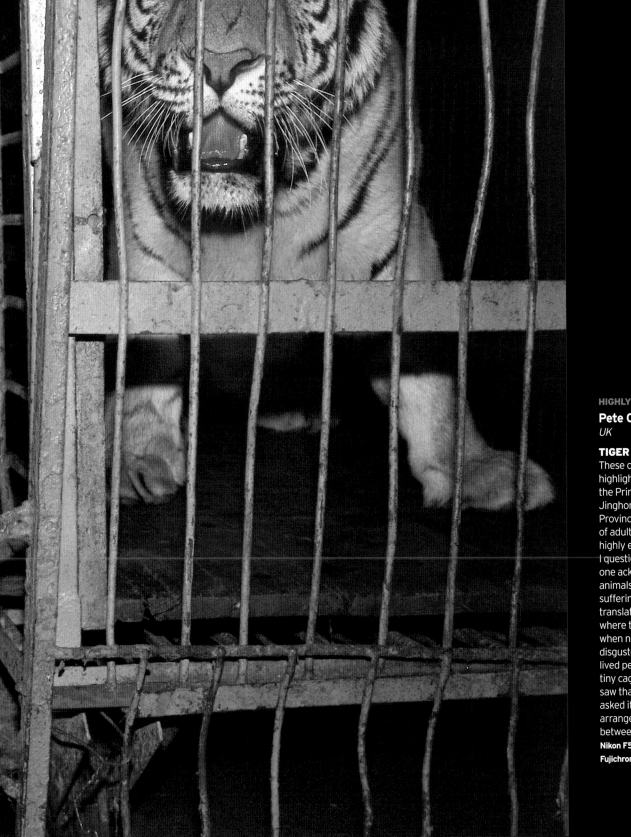

Pete Oxford
UK

TIGER AND WOLF SHOW

These creatures formed the highlight of a cruel show at the Primitive Forest Park near Jinghong, in China's Yunnan Province, which the audience of adults and children found highly entertaining. When I questioned the onlookers, no one acknowledged that the animals were capable of suffering. Through my translator, I asked the keeper where the animals were kept when not on show. I was disgusted to learn that they lived permanently in these tiny cages. When the keepers saw that I had a camera, they asked if I wanted them to arrange – for a fee – a fight between this tiger and a lion.

Nikon F5, with 600mm lens; Fujichrome Velvia; flash.

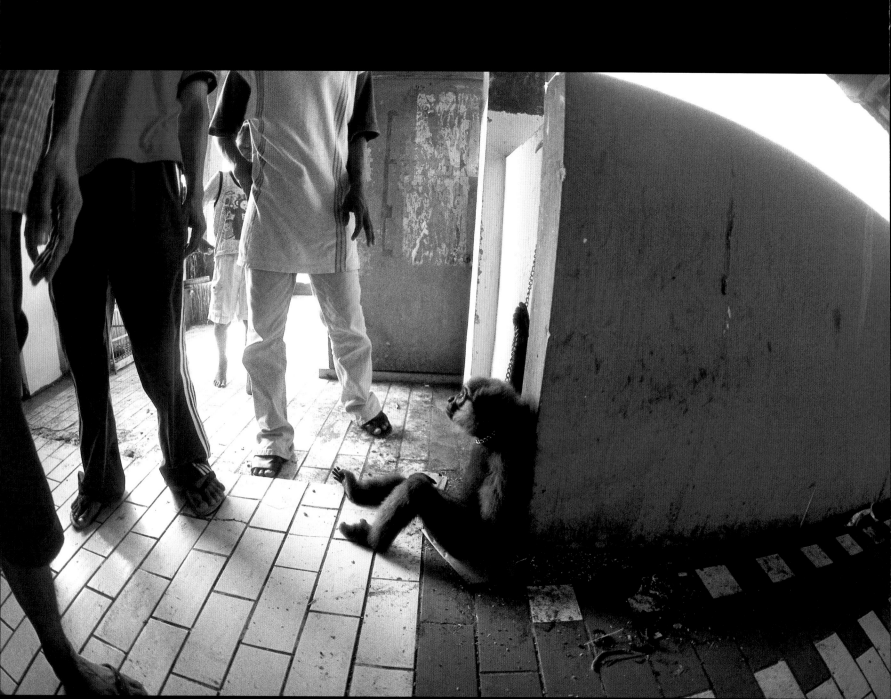

Karl Ammann
Switzerland

GIBBON FOR SALE

Prambuka Market in Jakarta is supposedly a bird market, but behind the scenes, a wide range of mammals are on offer, including protected species. On this visit, I found two orang-utans and a gibbon for sale. To take a picture like this, it's often necessary to photograph from the hip to prevent confrontation with the people selling the animals.

Nikon F100, with 20-35mm lens; automatic exposure; Fujichrome Sensia 100.

Jürgen Freund
Germany

DEAD THRESHER SHARK

In summer, local fishermen from Bicol sail to Masbate province in the Philippine archipelago. They attach fish bait onto the hooks of a long, weighted line and ease it overboard. This bait soon attracts sharks, including grey reef, hammerhead and thresher. The fins go to Chinese buyers, who use them to make shark-fin soup, and the meat ends up in local markets as a delicacy, *kinunot*. Widespread shark-fishing throughout South-east Asia

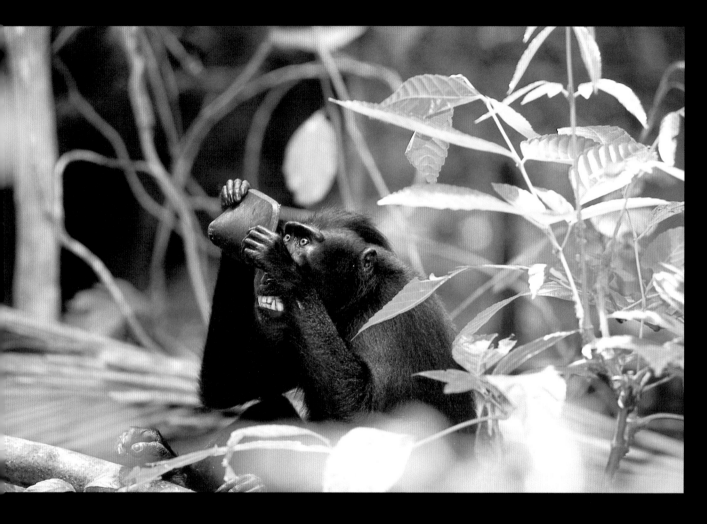

Solvin Zankl
Germany

CELEBES BLACK APE LOOKING AT HIS REFLECTION

Many of the animals on the island of Sulawesi in Indonesia are found nowhere else, including the Celebes black ape (a macaque). Logging roads now slash through the rainforest, exposing animals to things they have never experienced. I spent a few weeks following a group of black apes. One day, I noticed a male fall behind the group. He'd found a car wing-mirror and was seeing his own image for the first time.

Nikon F5, with 300mm lens; 1/125 sec at f2.8; Ektachrome E100VS; tripod.

HIGHLY COMMENDED

Karl Ammann
Switzerland

CLEARING PRIMARY RAINFOREST

This worker posed for me in South-east Cameroon, last December, having just come across yet another huge tree with vast buttress roots that needed removing to make way for a road. Two teams were cutting the trees, and bulldozers were clearing them. Another road will offer loggers better access to more rainforest and open up the forest to more illegal hunting camps, resulting in yet more poaching of animals, including gorillas and chimps, for the bushmeat trade.

Nikon F5, with 20-35mm lens; automatic exposure; Fujichrome Sensia 100.

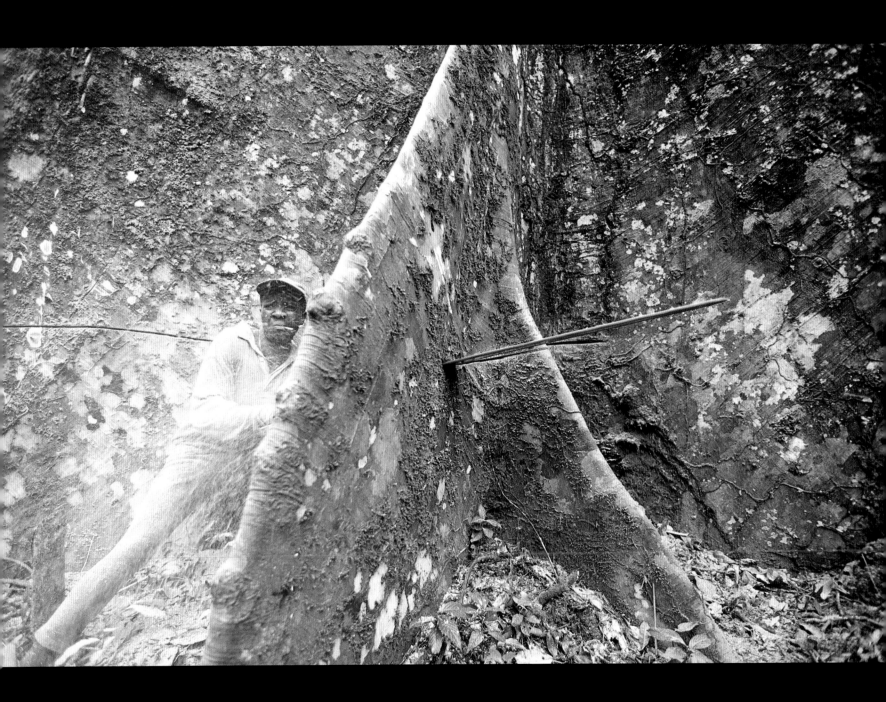

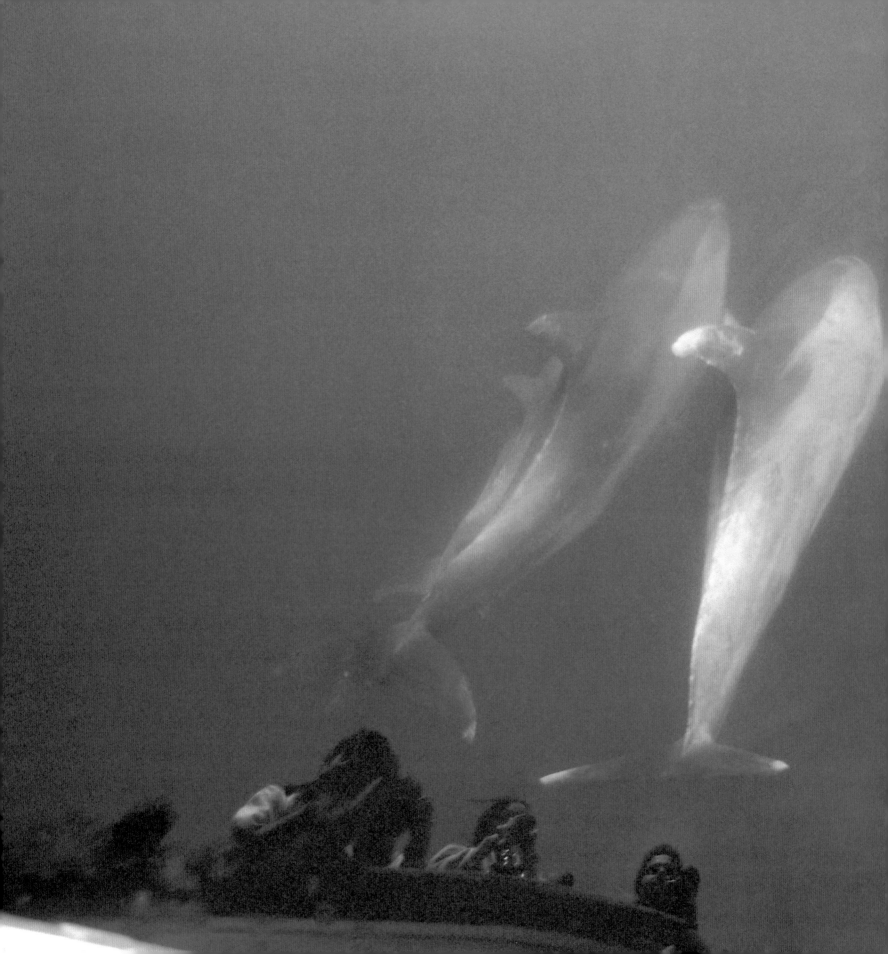

Eric Hosking Award
Frédéric Larrey

This award aims to encourage young and aspiring wildlife photographers to develop their skills and give them the opportunity to showcase their work. It was introduced in memory of Eric Hosking – Britain's most famous bird photographer – and goes to the best portfolio of six images taken by a photographer aged 26 or under.

Growing up in Montpellier in the South of France, Frédéric Larrey developed an early interest in the natural world and would go for bike rides with his brother, looking for migrants in the *garrigue*. At the age of 12, he knew he wanted to be a wildlife photographer. His parents and grandparents were keen travellers and together the family explored the fauna of Europe, Africa and America. After studying biology at university, he set up a wildlife travel and photographic company and now works for Biotope, an environmental studies centre.

BOTTLENOSE DOLPHINS
Early one morning, about a hundred kilometres offshore in the Golfe du Lion off southern France, we encountered a pod of lively bottlenose dolphins. There was no wind and so the surface of the water was as slick as oil. I noticed our sharp reflections overlapped the shapes of the dolphins as they played in front of the boat and decided to incorporate the human observers in the photograph.
Canon EOS 5, with 28-70mm f3.5-4.5 Canon ES lens; 1/250 sec at f6.7; Fujichrome Sensia 100.

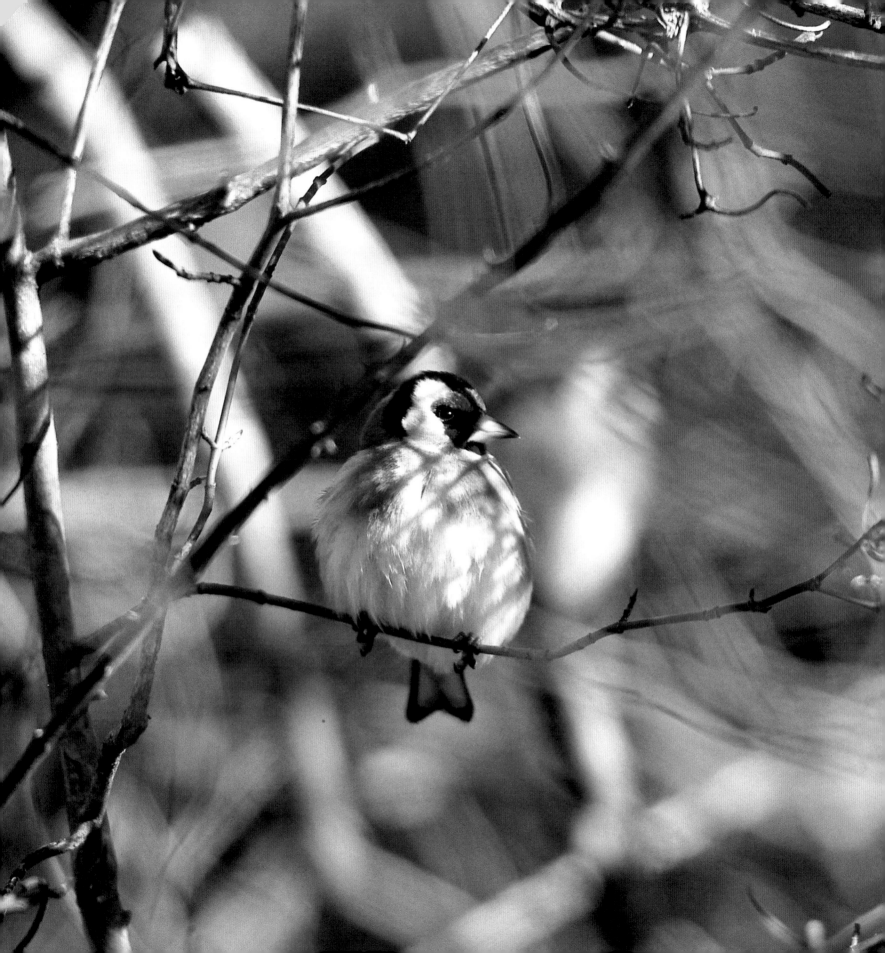

GOLDFINCH
After a snowfall in le Vaucluse, in Provence, France, songbirds moved to built-up areas to forage for precious scraps of food. I was watching several species clustered in the icy hedgerows, when a charm of goldfinches descended, their bright colours blending well with the tones of the branches.
Canon EOS 5 with 500mm f4.5 L Canon EF lens; 1/500 sec at f5.6; Fujichrome Provia 100; hide, tripod.

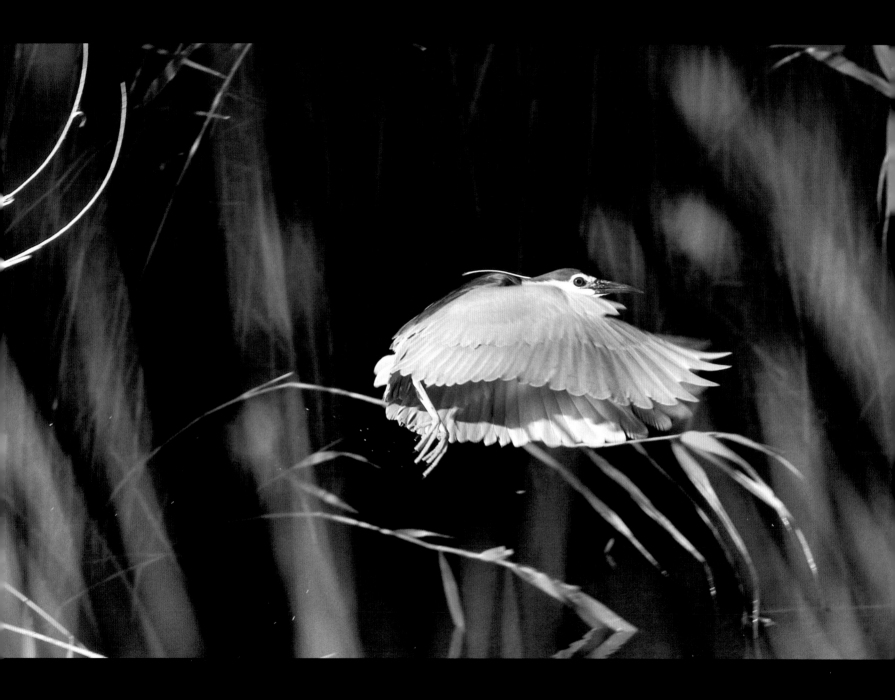

BLACK-CROWNED NIGHT HERON TAKING FLIGHT

Clumps of tamarisk and reeds provide shelter for many wading birds in the lagoons and pools of the Camargue, southern France. The black-crowned night heron usually hunts under cover of darkness, but when it has hungry chicks to feed, it often forages in daylight for fish, leeches, worms and other aquatic creatures. I had tried many times to capture its take-off, which lasts just a fraction of a second, and was delighted finally to succeed.
Canon EOS 5, with 500mm f4.5 L Canon EF lens; 1/1000 sec at f4.5; Kodak E100S.

POCHARD DUCKLING MIMICKING ITS MOTHER

Just as I was contemplating taking a quick siesta one hot, still afternoon in the Forez swamps in southern France, the behaviour of a duckling caught my eye. It was mimicking its mother's every move so rapidly, so precisely, that the two moved in near-perfect synchrony. Finally, the mother turned her head and closed her eyes. Her duckling instantly followed suit. They, at least, got to have a nap.
Canon EOS 5, with 500mm f4.5 Canon EF lens; 1/500 sec at f4.5; Fujichrome Provia 100;

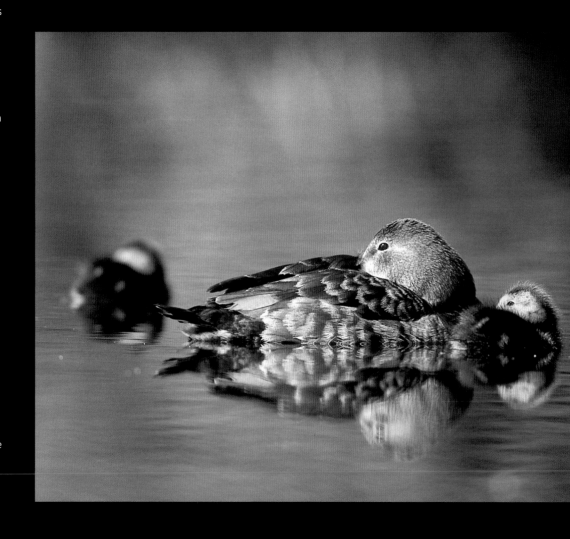

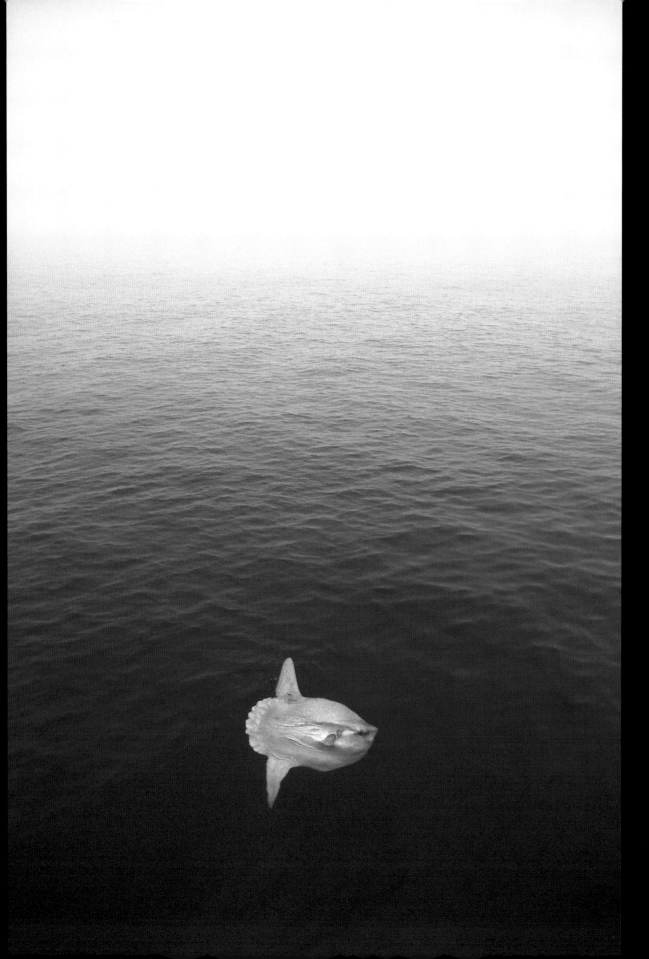

SUNFISH DRIFTING
The clammy sea-fog grew steadily thicker as our boat chugged across the Golfe du Lion off the south coast of France. Our chances of photographing anything seemed slim. But just as visibility dropped to 30 metres, a ghostly figure glided out of the gloom – a metre-long ocean sunfish, one of the biggest fish in the Mediterranean, which can grow to more than four metres in length.
Canon EOS 5 with 20mm f2.8 Canon EF lens; 1/250 sec at f11; Fujichrome Sensia 100.

BLACK-NECKED GREBE
From my hide in the Forez swamps in southern France, I watched this black-necked grebe fishing. As soon as it saw a fish, it shot up almost out of the water and then ducked, plunging its head below the surface. After a several minutes, it took a break to preen. Finally, it stretched its body from head to toe, each delicately cleaned feather slotting back into place, and resumed its business.
Canon EOS 5, with 500mm f4.5 L Canon EF lens; 1/1000 sec at f5.6; Fujichrome Provia 100; floating hide.

Young Wildlife Photographer of the Year

Iwan Fletcher

This award is given to the photographer whose single image is judged to be the most striking and memorable of all the pictures entered in the categories for young photographers aged 17 or under.

When he was nine years old, Iwan Fletcher's father gave him an old Nikkormate FT2 camera, on which he learnt the basics of wildlife photography by spending hours taking pictures of the wildflowers and insects around his home. After winning prizes in this competition in previous years, he bought a Nikon F90X and now specialises in birds, photographing waders from a camouflaged hide.

 WINNER (15-17 YEARS)

Iwan Fletcher
UK

SANDERLING RESTING
Low tide gives wading birds the chance to forage among the pebbles. This sanderling had probably recently arrived in North Wales from its summer breeding ground in the High Arctic. It ran around in search of worms and insects, regularly probing at the ground, and then stopped for a short while to rest, seeming to have actually fallen asleep. I crawled closer, my camera and lens resting on the sand, to within three metres without disturbing it.
Nikon F90X, with Sigma 170-500mm zoom lens; 1/250 sec at f6.3; Fujichrome Velvia rated at 100.

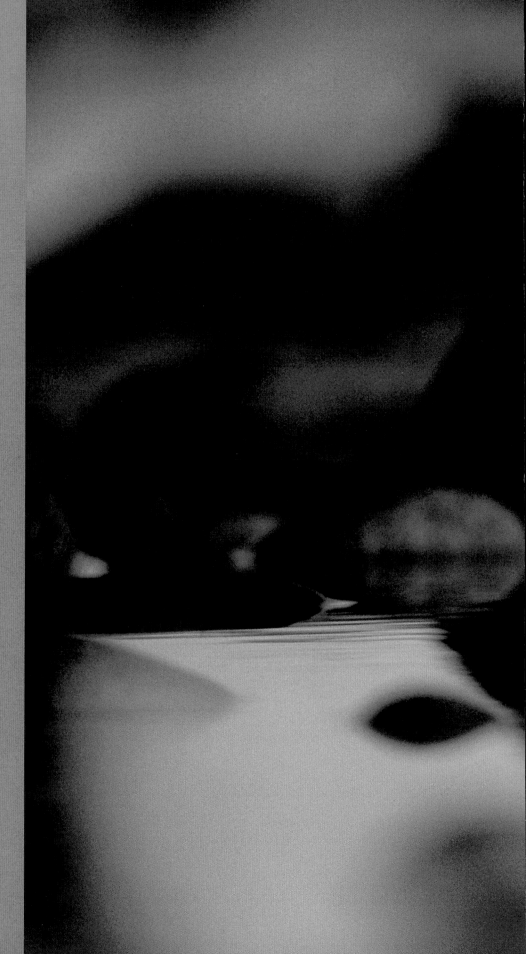

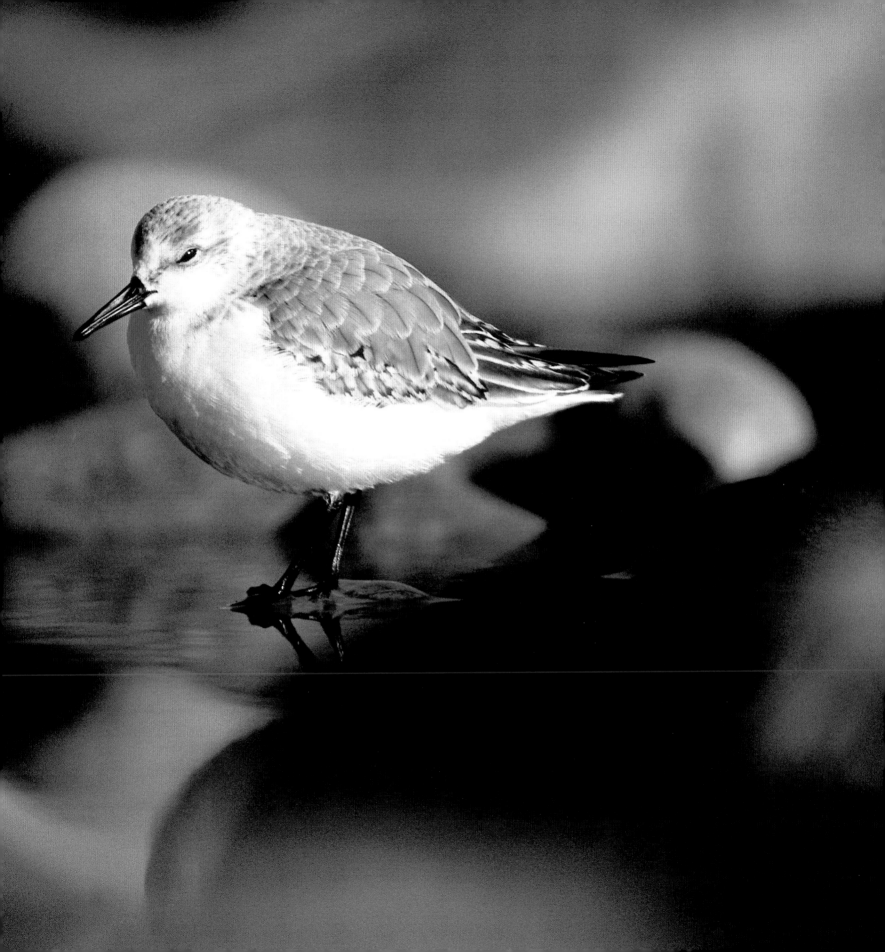

10 years and under

 WINNER

Joonas Lahti
Finland

CAPERCAILLIE

Last May, when I was seven
went on a trip to Kuusamo,
northern Finland, with my
father. We searched for
capercaillie in the evening a
slept in the forest so that w
could continue our search
dawn. We were in luck. It ha
been exciting enough to sle
in the open air, but I'll neve
forget seeing the sunrise a
this enormous bird posing
a photograph in the beauti
morning light.
Canon EOS-5, with 80-200mm
lens; automatic at f5.6;
Fujichrome 400 F.

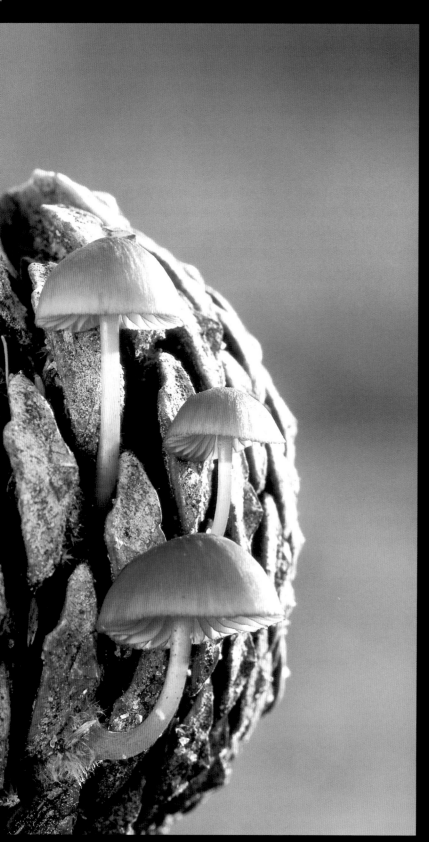

 RUNNER-UP

Rhé Slootmaekers
Belgium

FUNGUS ON A PINE CONE
I enjoy examining the surfaces of plants for miniature 'landscapes'. One autumn day, I was looking for fungi when I saw these three, tiny *Laccaria* toadstools emerging from an old pinecone, like trees out of a cliffside. The light was good, but it was hard getting low enough to take the picture.
Canon EOS 300, with 100mm lens, 1/30 sec at f11; Fujichrome Sensia 100; tripod.

10 years
and under

Philipp Kois
Germany

BLACK-LEGGED KITTIWAKE COLONY

I went on holiday with my family to the Lofotes Islands in Norway. One day, we drove along the cliffs and came across this rockface full of breeding kittiwakes. The best light had already gone, and so we came back again the following morning, when I managed to get a few good photographs while the light was good.

Canon EOS 500N, with 100-300mm lens; 1/125 sec at f5.6; Fujichrome Sensia 100; tripod.

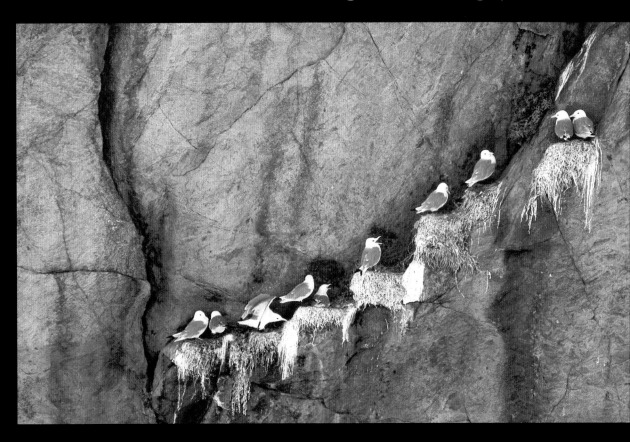

Liisa Widstrand
Sweden

BROWN BEAR SNIFFING THE AIR

My father and I spent three nights watching bears from a hide in Finland, close to the Russian border. One night we saw as many as 15. I used the video camera to catch the action, while Dad took stills. But after a while I wanted to try Dad's Nikon, and so we swapped cameras. Just then, a bear sat down close to us, watching the sky and smelling the air. I got the shot, but Dad missed it because he was changing the video's batteries.

Nikon F5, with 600mm f4 lens; probably 1/200 sec at f4; Fujichrome Astia 100, rated at 200; beanbag; hide.

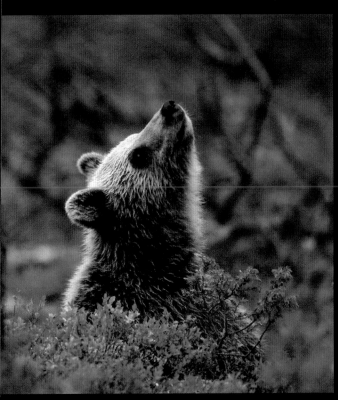

11 – 14 years

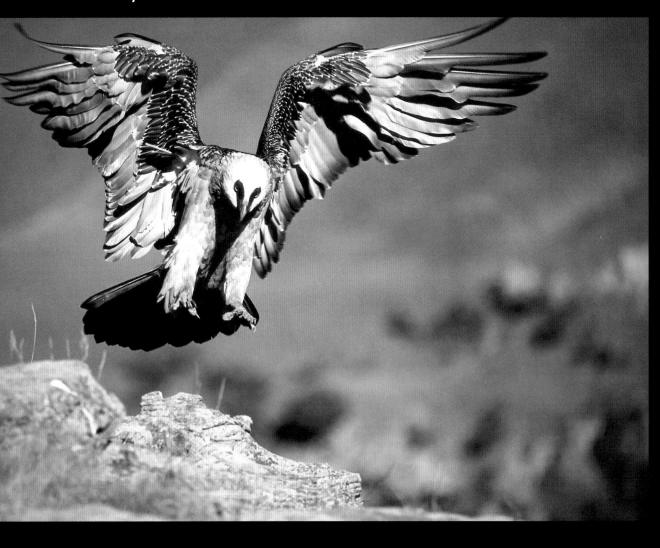

Fanie Weldhagen
South Africa

LAMMERGEIER
Until recently, the lammergeier, or bearded vulture, was persecuted to the brink of extinction because it was thought to hunt lambs (lammergeier means 'lamb-catcher' in Afrikaans). It lives at high altitudes, feeding mainly on bones, which it drops from a height onto rocks so that it can eat the marrow inside. I took this photograph on a visit to the Lammergeier Hide in the Drakensberg Mountains, South Africa.
Nikon N90S, with Sigma 170-500mm lens; beanbag.

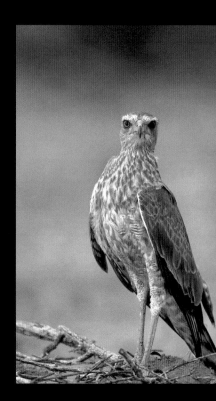

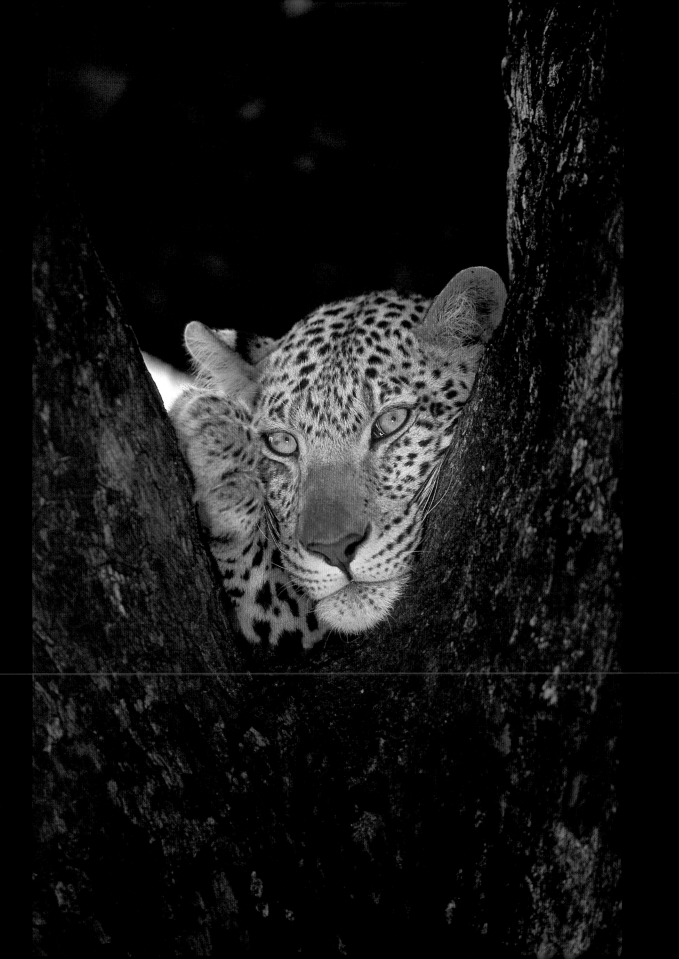

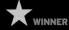 **WINNER**

Olivia McMurray
South Africa

LEOPARD RESTING
After spending the night under the starry sky at Mala Mala Game Reserve, South Africa, I came across this young male leopard and his mother. It was late morning, and his mother had just hauled a freshly killed duiker into a huge jackal-berry tree. He chased her off the carcass, fed and then rested in the fork of the tree.
Canon EOS 1, with 400mm f2.8 IS lens; 1/125 sec at f2.8; Fujichrome Velvia; beanbag.

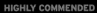

HIGHLY COMMENDED
Jaco Weldhagen
South Africa

PALE CHANTING GOSHAWK
Late one afternoon, we were travelling back to Mata Mata Camp in the Kgalagadi Transfrontier Park, South Africa, when we came across this immature pale chanting goshawk on the ground. We suspected that it was waiting for a prey animal to re-emerge. I took a couple of shots, while it stared straight at me. Though the light was low, fill flash added just the necessary crispness.
Nikon F100, with 300mm f2.8 lens; autoexposed at maximum aperture; Fujichrome Velvia; beanbag; fill flash.

11 – 14 years

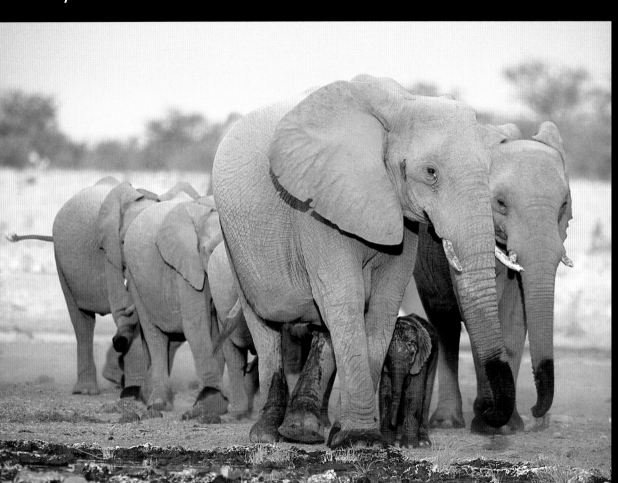

South Africa

ELEPHANTS AT A WATERHOLE

Late one afternoon at Rietfontein waterhole in Etosha National Park, Namibia, a herd of elephants cautiously approached the water. The older females kept watch for about 20 minutes while the young drank their fill and played. The matriarch then led them past our vehicle, closely guarding the calves.

Nikon F100, with 50-500mm lens; Fujichrome Provia 100; beanbag.

 RUNNER-UP

Olivia McMurray
South Africa

SPOTTED HYENA LYING IN A PUDDLE

It was an exceptionally hot March afternoon at Mala Mala Game Reserve, South Africa, and the animals were trying to escape from the intense heat. This dominant female of one of the spotted hyena clans had just stashed an impala carcass in the water. After making sure the body was safe from scavengers, she lay down in a nearby puddle.

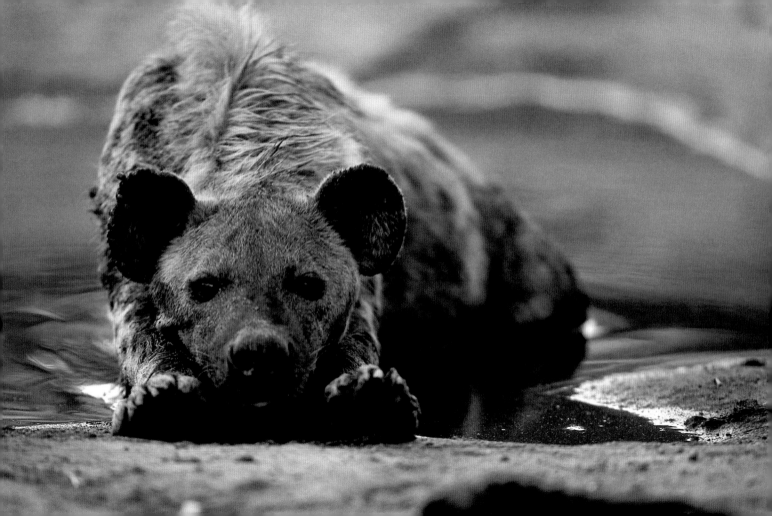

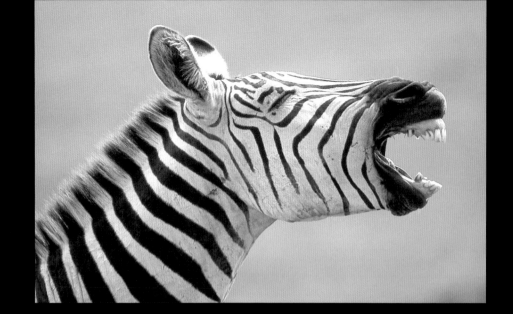

11 - 14 years

Cameron Amadeus Myhrvold
USA

ZEBRA STALLION
One day, when photographing Burchell's zebra in Serengeti National Park, Tanzania, I noticed a stallion's ears twitching. I quickly pointed the camera and managed to capture him flehming (sucking air through his mouth over his Jacobson's organ to heighten his sense of smell so he can determine if a mare is on heat).
Nikon F5, with 600mm f4 lens; 1/250 sec at f4; Fujichrome Provia 100F; beanbag.

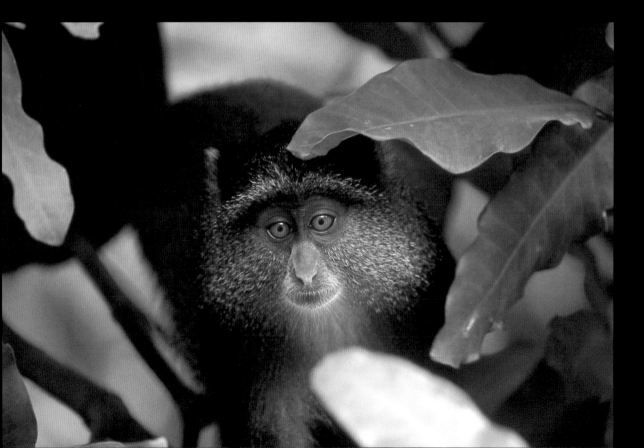

Cameron Amadeus Myhrvold
USA

BLUE MONKEY
Driving in Lake Manyara National Park, Tanzania, we were lucky to see many rare blue monkeys. This individual was too close for my 600mm lens to focus on, and so I had to change lens. The monkey watched me as I did this, politely remained still for the photograph and then disappeared into the bushes.
Canon EOS 3, with 100-400mm f4.5-5.6 lens; 1/60 sec at f5.6; Fujichrome Provia 100 F; beanbag.

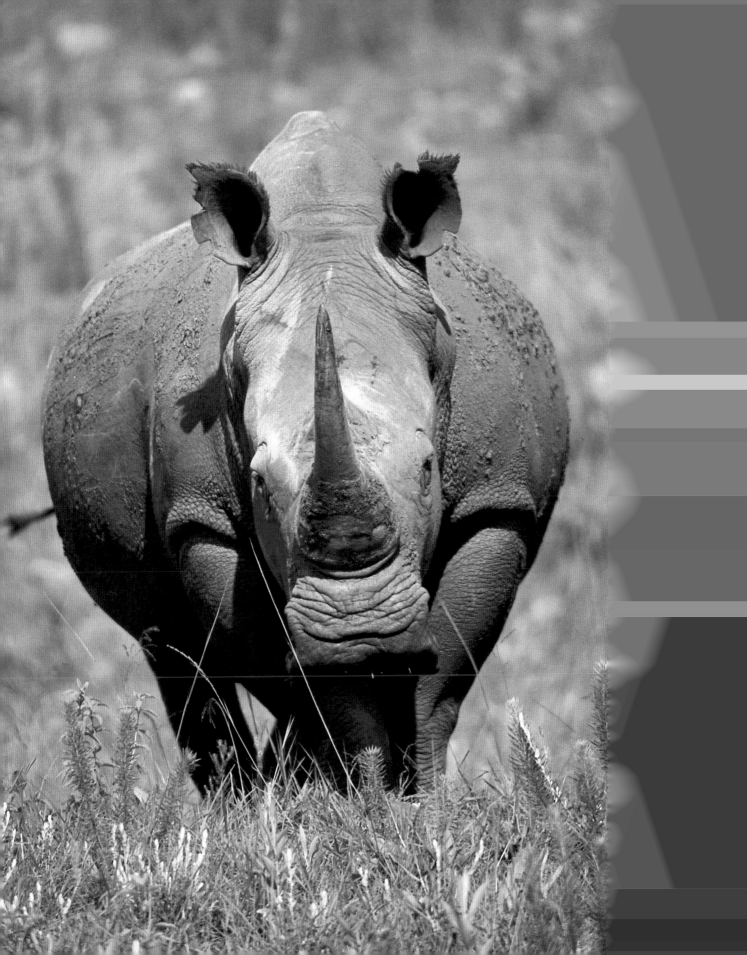

– 17 years

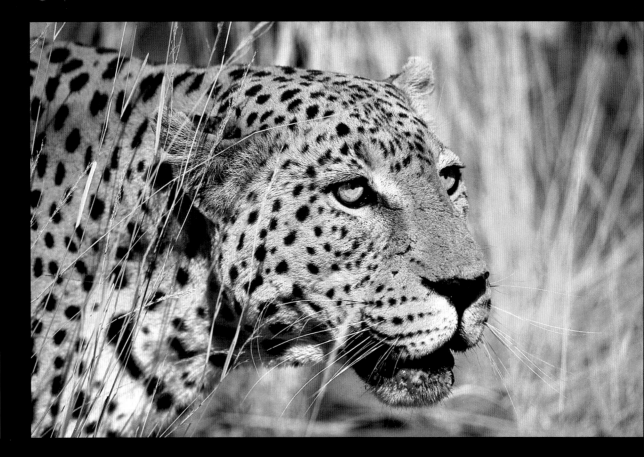

WINNER

Fletcher

DERLING RESTING

UNG WILDLIFE
PHOTOGRAPHER
THE YEAR
ARD
40

HIGHLY COMMENDED

Christoph Müller
Germany

LEOPARD

When we visited Namibia last year, I hoped to fulfil my ambition of seeing a leopard. It was not until we headed back to get our flight home that I had any luck, coming within five metres of this individual. It was the last photograph I took before boarding the plane – a wonderful end to the holiday.
Canon EOS 100, with 100-400mm LIS lens; 1/500 sec at f5.6; Fujichrome Sensia 100; beanbag.

RUNNER-UP

Simon Hallais
France

ROE BUCK DISPUTE

During the rut, male roe deer become very territorial. If one buck dares set foot in his neighbour's patch, hostilities begin. I was behind a hedge when these two suddenly emerged from the woods. They stood face-to-face, ears laid back, with threatening expressions, pawing the soil, trying to intimidate each other. Though roe deer fights can become violent, this encounter ended peacefully.
Canon EOS 100, with 500mm IS Canon lens; 1/250 sec at f6.7; Fujichrome MS 100 rated at 200; Manfrotto monopod.

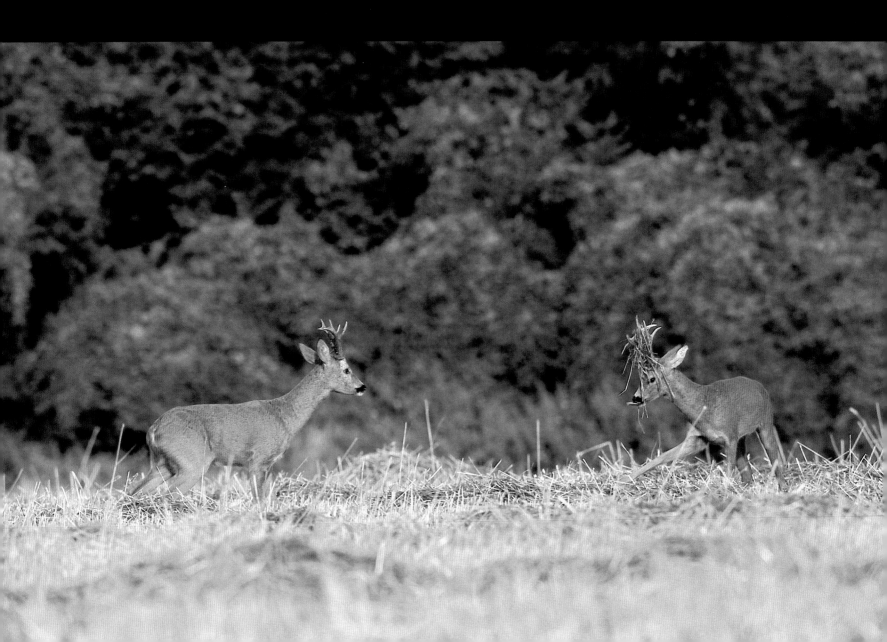

15 - 17 years

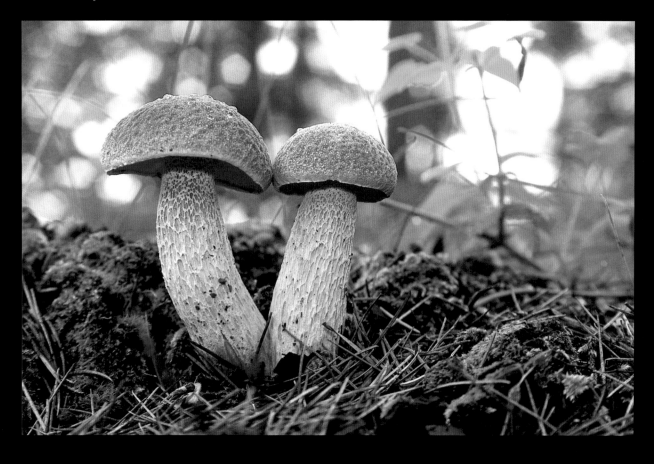

Daya Kaur
India

HIMALAYAN FUNGUS
When I found this fungus, it was late evening and drizzling, but the contrast of its warm colours with the grass made it the perfect subject. I was in Kala Top Sanctuary, in Himachal Pradesh, on a trip with my father to photograph nature, especially flowers, ferns and fungi. I shot this fungus from ground level, spreading the tripod legs wide and compensating for the bad light using flash and reflector.
Canon EOS 5 with 28-105mm f3.5-4.5 lens; Fujichrome Provia 100; tripod; flash and reflector.

Stephen Lingo
USA

MOUNTAIN GOAT AND KID
I took this photograph of a goat and her two-week-old kid on Mount Evans, Colorado. The early morning back light, together with a haze from distant wildfires, gave them a luminous glow. The goats raise their young on cliffs and rocky ledges safe from predators, and the kids are able to climb within a few days of being born. In fact, they are not goats at all but a type of antelope, related to chamois, and unique to the western area of North America.
Canon EOS 1, with 75-300mm lens; Fujichrome Provia 400F.

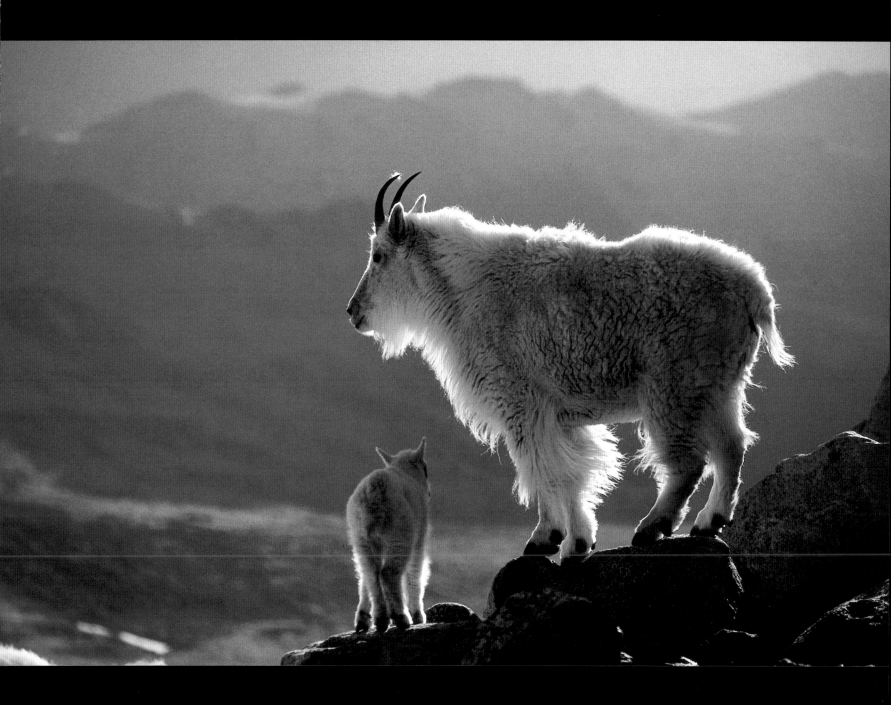

The numbers before the photographers' names indicate the pages on which their work can be found. All contact numbers are listed with international dialling codes from the UK – these should be replaced when dialling from other countries.

Theo Allofs
PO Box 31793
Whitehorse
YT Y1A 6L3
CANADA
Tel: (001) 867 667 6000
Fax: (001) 867 667 6002
Email: allofsphoto@northwestel.net
www.theoallofs.com

Karl Ammann
PO Box 437
Nanyuki 10400
KENYA
Tel: (00254) 176 22448
Fax: (00254) 176 32407
Email: kamman@form-net.com
www.karlammann.com

Pete Atkinson
Windy Ridge
Hyams Lane, Holbrook
Ipswich
Suffolk IP9 2QF
UK
Tel: 01473 328349
Email: yachtvigia@hotmail.com

Getty Images
101 Bayham Street
London NW1 0AG
UK
Tel: 0800 3767977
Fax: 020 7544 3334
Email: sales@gettyimages.co.uk
www.gettyimages.co.uk

Subhankar Banerjee
Six 149th Avenue NE
Apt. E, Bellevue
WA 98007
USA
Tel: (001) 202 207 4587
Email: banerjee@wwbphoto.com
www.wwbphoto.com

Jordi Bas Casas
Carrer Batlle Simó, num. 15
25100 Almacelles
Lleida
SPAIN
Tel: (0034) 973 74 21 72
Fax: (0034) 973 74 00 30
Email: jbas1@pie.xtec.es
www.jordibas.net

Tobias Bernhard
PO Box 1427
Whangarei
NEW ZEALAND
Tel: (0064) 9 434 3535
Fax: (0064) 9 434 3535
Email: wildimages@xtra.co.nz
www.tobiasbernhard.com

Oxford Scientific Films Photo Library
Lower Road, Long Hanborough
Oxfordshire OX29 8LL
UK
Tel: 01993 881881
Fax: 01993 882808
Email: photo.library@osf.uk.com
www.osf.uk.com

Getty Images
101 Bayham Street
London NW1 0AG
UK
Tel: 0800 3767977
Fax: 020 7544 3334
Email: sales@gettyimages.co.uk
www.gettyimages.co.uk

zefa Visual Media UK Ltd
90 Long Acre
Covent Garden
London WC2E 9RZ
Tel: 020 7849 3099
Fax: 020 7849 3189
Email: info@zefa.co.uk
www.zefa.co.uk

Werner Bollmann
Goethestr. 4
24116 Kiel
GERMANY
Tel: (0049) 431 97 0758
Fax: (0049) 431 906 6355
Email: info@wernerbollmann.de
www.wernerbollmann.de

David W Breed
PO Box 20118
Nairobi
KENYA
Tel: (00254) 2 890455
Email: davidbreed@iconnect.co.ke

Oxford Scientific Films Photo Library
Lower Road, Long Hanborough
Oxfordshire OX29 8LL
UK
Tel: 01993 881881
Fax: 01993 882808
Email: photo.library@osf.uk.com
www.osf.uk.com

RSPCA Photolibrary
RSPCA Trading Ltd
Wilberforce Way
Southwater
Horsham
West Sussex
RH13 9RS
Tel: 0870 754 0150
Fax: 0870 753 0150
Email: pictures@rspcaphotolibrary.com
www.rspcaphotolibrary.com

Claudio Calosi
Via R. Sanzio, 50
50052 Certaldo (FI)
ITALY
Email: calosi@unisi.it
www.claudiocalosi.com
www.claudiocalosi.it

Bernard Castelein
Verhoevenlei 100
2930 Brasschaat
BELGIUM
Tel: (0032) 3 653 08 82
Fax: (0032) 3 653 08 82
Email: bernard.castelein@vt4.net

Nature Picture Library
BBC Broadcasting House
Whiteladies Road
Bristol BS8 2LR
UK
Tel: 0117 974 6720
Fax: 0117 923 8166
Email: info@naturepl.com
www.naturepl.com

André Cloete
217 Oom Jochem's Place
Erasmusrand
Pretoria 0181
SOUTH AFRICA
Tel: (0027) 82 563 5754
Fax: (0027) 12 347 1903
Email: andrec@qedact.co.za

Andrew Davoll
18 Chatton Street
Dianella, Perth
WA 6059
AUSTRALIA
Tel: (0061) 89 275 3280
Email: adavoll@hotmail.com

Lochman Transparencies
5/39 King George Street
Innaloo 6018
WA 6018
AUSTRALIA
Tel/fax: (0061) 8 9446 4409
Email: lochmantrannies@optusnet.com.au
www.lochmantransparencies.com

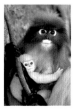

Elio Della Ferrera
Via Signorie, 3
23030 Chiuro (SO)
ITALY
Tel: (0039) 0342 213254
Fax: (0039) 0342 213254
Email: eliodellaferrera@iname.com

Nature Picture Library
BBC Broadcasting House
Whiteladies Road
Bristol BS8 2LR
UK
Tel: 0117 974 6720
Fax: 0117 923 8166
Email: info@naturepl.com
www.naturepl.com

Cornelia & Ramon Doerr
Merowingerstrasse 63
40225 Düsseldorf
GERMANY
Tel: (0049) 211 319 0425
Fax: (0049) 211 600 7101
Email: c.doerr@mail.isis.de
www.doerr-naturbilder.de

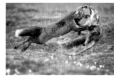

Eric Dragesco
Chalet Capercaillie
Plan Sepey
1882 Gryon
SWITZERLAND
Tel: (0041) 24 498 3348
Fax: (0041) 24 498 3350
Email: juneric@freesurf.ch

Linda Dunk
4 Aberdeen Wharf
94 Wapping High Street
London E1W 2ND
UK
Tel: 020 7702 0840
Fax: 020 7702 0845
Email: linda@pdunk.globalnet.co.uk
www.lindadunk.com

Klaus Echle
Schauinslandstrasse 125
79104 Freiburg i. Br.
GERMANY
Tel: (0049) 761 290 99 135
Fax: (0049) 761 290 9371
Email: echle.alpirsbach@t-online.de

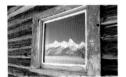

Herb Eighmy
PO Box 310
Manhattan
MT 59741
USA
Tel: (001) 406 284 6380
Fax: (001) 406 284 6379
Email: herbeighmy@aol.com

Magnus Elander
Carl Barks vag 28
163 43 Spanga
SWEDEN
Tel: (0046) 8 760 6718
Fax: (0046) 8 760 6778
Email: amarok@algonet.se
www.de5stora.com

Thomas Endlein
Peter-Schneider-Strasse 1
97074 Würzburg
GERMANY
Tel: (0049) 931 784 3077
Tel: (0049) 160 9575 6871
Email: endlein@biozentrum.uni-
wuerzburg.de

Per-Olov Eriksson
Hjärstavägen 32
703 58 Örebro
SWEDEN
Tel: (0046) 19 25 17 74
Fax: (0046) 19 25 17 74
Email: po.eriksson@mbox303.swipnet.se

Woodfall Wild Images
17 Bull Lane, Denbigh
Denbighshire LL16 3SN
UK
Tel: 01745 815903
Fax: 01745 814581
Email: wwimages@btinternet.com
www.woodfall.com

Stig-Erik Eriksson
Hinsebo 30A
738 91 Norberg
SWEDEN
Tel: (0046) 223 23405
Email: stickan.hinsebo@telia.com

Bildbyrån Lucky Look
Sigtunagatan 12
113 22 Stockholm
SWEDEN
Tel: (0046) 08 36 00 31
Email: info@luckylookimages.com
www.luckylookimages.com

Iwan Fletcher
Pen Lon
Maes Y Llan
Llandwrog
Gwynedd LL54 5TT
UK
Tel: 01286 830378
Fax: 01286 830378
Email: djfletcher4@aol.com

Michael Forsberg
Michael Forsberg Gallery
100 N 8th Street, Suite 150
Lincoln
NE 68508
USA
Tel: (001) 402 477 5030
Fax: (001) 402 477 5031
Email: mike@michaelforsberg.com
www.michaelforsberg.com

Christer Fredriksson
Fläda Medevi
591 97 Motala
SWEDEN
Tel: (0046) 141 91043
Email: cf@tiscali.se

Naturbild
Drottning 73B, Box 3353
103 67 Stockholm
SWEDEN
Tel: (0046) 8 411 43 30
Fax: (0046) 8 411 22 30
Email: info@naturbild.se
www.naturbild.se

Bruce Coleman, The Natural World
16 Chiltern Business Village
Arundel Road
Uxbridge UB8 2SN
UK
Tel: 01895 467990
Fax: 01895 467959
Email: library@brucecoleman.co.uk
www.brucecoleman.co.uk

Jürgen Freund
PO Box 93
Smithfield
QLD 4878
AUSTRALIA
Tel: (0061) 439 79 3710
Email: scubayogi@compuserve.com
www.scubayogi.de

Nature Picture Library
BBC Broadcasting House
Whiteladies Road
Bristol BS8 2LR
UK
Tel: 0117 974 6720
Fax: 0117 923 8166
Email: info@naturepl.com
www.naturepl.com

Howie Garber
3926 Feramorz Drive
Salt Lake City
UT 84124
USA
Tel: (001) 801 272 2134
Fax: (001) 801 277 0687
Email: howie@wanderlustimages.com
www.wanderlustimages.com

Nick Garbutt
Fell Side Cottage
3 Lime Street, Shap
Penrith
Cumbria CA10 3PQ
UK
Tel: 01931 716227
Fax: 01931 716227
Email: nick@nickgarbutt.com
www.nickgarbutt.com

NHPA Limited
Little Tye, 57 High Street
Ardingly
Sussex RH17 6TB
UK
Tel: 01444 892514
Fax: 01444 892168
Email: nhpa@nhpa.co.uk
www.nhpa.co.uk

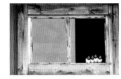

Olivier Grunewald
37, rue Montcalm
75018 Paris
FRANCE
Tel: (0033) 1 42 54 30 43
Fax: (0033) 1 48 06 48 71
Email: bernadette.gilbertas@wanadoo.fr

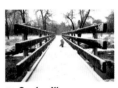

Thomas Haider
Steinergasse 2/12
1170 Vienna
AUSTRIA
Tel: (0043) 1 403 42 94
Fax: (0043) 1 403 42 94
Email: thomas.haider@univie.ac.at

Oxford Scientific Films Photo Library
Lower Road, Long Hanborough
Oxfordshire OX29 8LL
UK
Tel: 01993 881881
Fax: 01993 882808
Email: photo.library@osf.uk.com
www.osf.uk.com

Simon Hallais
Le Bas-Beaudouet
61600 La Motte-Fouquet
FRANCE
Tel: (0033) 2 33 38 19 49
Fax: (0033) 2 33 38 05 29
Email: hallaissimon@hotmail.com

Martin Harvey
PO Box 8945
Centurion 0046
SOUTH AFRICA
Tel: (0027) 12 6644789
Fax: (0027) 12 6642241
Email: m.harvey@mweb.co.za

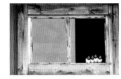

Hannu Hautala
Kiestingintie 12
93600 Kuusamo
FINLAND
Tel: (00358) 8 8511 056
Fax: (00358) 8 8523 031
Email: hannu.hautala@koillismaa.fi

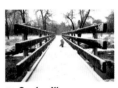

Gordon Illg
PO Box 280668, Lakewood
Colorado 80228
USA
Tel: (001) 303 237 7086
Fax: (001) 303 237 7030
Email: cgillg@cs.com
www.advenphoto.com

Rob Jordan
Stonechats, Espley Hall
Morpeth
Northumberland NE61 3DJ
UK
Tel: 01670 512761
Fax: 01670 512761
Email: rob@robjordan.co.uk
www.robjordan.co.uk

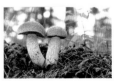

Daya Kaur
549-A, 9A Main
Indira Nagar Stage
Bangalore 560038
INDIA
Tel: (0091) 80 525 3288
Fax: (0091) 80 528 8098

Hannu Kivelä
91630 Juorkuna
FINLAND
Email: kivelahannu@luukku.com

Philipp Kois
Geitheweg 28
59071 Hamm
GERMANY
Tel: (0049) 2381 86433
Fax: (0049) 2381 487 139
Email: philipp@naturfoto-kois.de
www.naturfoto-kois.de

Ines Labunski Roberts
3340 Cliff Drive, Santa Barbara
93109 California
USA
Tel: (001) 805 682 1088
Fax: (001) 805 682 1088
Email: inesr@impulse.net

Jan-Peter Lahall
Box 402, 701 48 Örebro
SWEDEN
Tel: (0046) 19 121312
Fax: (0046) 19 187500
Email: info@lahall.com
www.lahall.com

Joonas Lahti
Tastontie 17, 21350 Ilmarinen
FINLAND
Tel: (00358) 40 583 3890
Email: johannes.lahti@pp.inet.fi

Frédéric Larrey
BP58, 22 Boulvard Marechal
Foch
34140 Meze
FRANCE
Tel: (0033) 6 09 41 39 24
Fax: (0033) 4 67 18 46 29
Email: flarrey@biotope.fr
www.biotope.fr

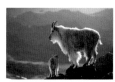

Stephen Lingo
224 South Logan, Denver
Colorado 80209
USA
Tel: (001) 303 733 9844
Fax: (001) 303 290 0274
Email: steve_lingo@hotmail.com

Urs Lüthi
Wagerten
3148 Lanzenhäusern
SWITZERLAND
Tel: (0041) 313 71 4855
Fax: (0041) 313 71 4855
Email: ulkg@freesurf.ch
www.nature-art.ch

Daniel Magnin
Les Bruyères de Bouvier
71200 Saint Sernin Du Bois
FRANCE
Tel: (0033) 3 85 80 26 52
Email: d.magnin@libertysurf.fr
http://danielmagnin.free.fr

David Maitland
15 The Canongate, St Andrews
Fife KY16 8RU
Scotland
UK
Tel: 07779 680004
Email: david@5creatures.freeserve.co.uk

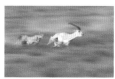

Thomas D Mangelsen
Images of Nature
PO Box 2935, Gaslight Alley, 2nd Floor
Jackson
Wyoming 83001
USA
Tel: (001) 307 733 6179
Fax: (001) 307 733 6184
Email: photo@imagesofnaturestock.com
www.imagesofnaturestock.com

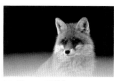

Bence Máté
2/b Mezö u.
Pusztaszer 6769
HUNGARY
Tel: (0036) 20 4166002
Email: bence@bencemate.com
www.bencemate.com

Zoltán Pupcsák
Flat 444, 235 Earls Court Road
London SW5 9FE
UK
Tel: 07808 161581
Email: pupcsakz@hotmail.com

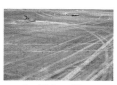

Joe McDonald
McDonald Wildlife Photography, Inc.
73 Loht Road, McClure
PA 17841
USA
Tel: (001) 717 543 6423
Fax: (001) 717 543 6423
Email: hoothollow@acsworld.com
www.hoothollow.com

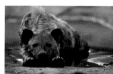

Olivia McMurray
PO Box 2128, 1200 Nelspruit
Mpumalanga
SOUTH AFRICA
Tel: (0027) 13 753 3182
Fax: (0027) 13 753 3182
Email: bushbabyliv@webmail.co.za

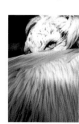

Helmut Moik
Flurweg 172
8311 Markt Hartmannsdorf
AUSTRIA
Tel: (0043) 3114 2759
Fax: (0043) 3167 090501
Email: helmut.moik@aon.at

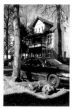

Florian Möllers
Bülowstrasse 11
23566 Lübeck
GERMANY
Tel: (0049) 451 585 5991
Fax: (0049) 451 585 9951
Email: fmoellers-wildpics@t-online.de
www.florianmoellers.com

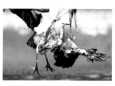

Yva Momatiuk & John Eastcott
151 Eagles Nest Road
Hurley
NY 12443
USA
Tel: (001) 845 338 4260
Email: eastcott@sprintmail.com

Paul Morsen
1708 Stuart Court
Benicia
CA 94510
USA
Tel: (001) 707 745 6043
Fax: (001) 707 745 6043
Email: p.morsen-photo@att.net

Kristin J Mosher
8146 Navona Lane
Clay
NY 13041
USA
or: PO Box 185
Kigoma
TANZANIA
Tel: (001) 315 699 0752
Tel: (00255) 741 261 477
Email: kjmosher@mac.com

Oxford Scientific Films Photo Library
Lower Road, Long Hanborough
Oxfordshire OX29 8LL
UK
Tel: 01993 881881
Fax: 01993 882808
Email: photo.library@osf.uk.com
www.osf.uk.com

Delimont, Herbig and Associates
4911 Somerset Drive, SE Bellevue
WA 98006
USA
Tel: (001) 425 562 1543
Fax: (001) 425 373 5316
Email: Danita@DanitaDelimont.com
www.danitadelimont.com

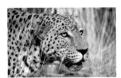

Christoph Müller
Unterer Pustenberg 66
45239 Essen
GERMANY
Tel: (0049) 201 493585
Email: christophmue@onlinehome.de

Cameron Amadeus Myhrvold
1422 130th Ave. NE, Bellevue
WA 98005
USA
Tel: (001) 425 467 2309
Fax: (001) 425 467 2350
Email: biagia98039@hotmail.com

Cornelius Nelo
St Georg-Strasse 95
18055 Rostock
GERMANY
Tel: (0049) 381 252 3197
Email: nelo@gmx.com
www.corneliusnelo.com

Michael Nichols
6094 Sugar Hollow Road, Crozet
VA 22932
USA
Tel: (001) 434 823 5184
Fax: (001) 434 823 5319
Email: nickngs@aol.com
www.michaelnicknichols.com

National Geographic Image Collection
1145 17th Street, NW
Washington DC 20036
USA
Tel: (001) 800 434 2244
Fax: (001) 800 363 9422
Email: images@ngs.org
www.ngsimages.com

Klaus Nigge
Ernst Becker Strasse 12
44534 Lünen
GERMANY
Tel: (0049) 2306 51720
Fax: (0049) 2306 73831
Email: klaus.nigge@t-online.de

Nick Oliver
White Hall Farm, Great Walding Field
Sudbury
Suffolk CO10 0RJ
UK
Tel: 01787 372116
Fax: 01787 372082

Tony Ord
The Chippings, Duckington
Malpas
Cheshire SY14 8LQ
UK
Tel: 01829 782262
Fax: 01829 782262
Email: tonyord41@msn.com

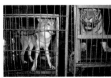

Pete Oxford
Casilla 17-07-9668
Quito
ECUADOR
Tel: (00593) 2 2226 958
Fax: (00593) 2 2226 958

Minden Pictures
558 Main Street, Watsonville
CA 95076
USA
Tel: (001) 831 761 3600
Fax: (001) 831 761 3233
www.mindenpictures.com

Richard Packwood
Nant-yr-Hendre, Llandinam
Powys SY17 5AZ
UK
Tel: 01686 413156
Email: nantyr@firenet.uk.net

Oxford Scientific Films Photo Library
Lower Road, Long Hanborough
Oxfordshire OX29 8LL
UK
Tel: 01993 881881
Fax: 01993 882808
Email: photo.library@osf.uk.com
www.osf.uk.com

Jari Peltomäki
PO Box 42, 91901 Liminka
FINLAND
Tel: (00358) 40 591 9120
Fax: (00358) 8 381 914
Email: jari@finnature.fi
www.finnature.com

Finnature Limited
Address as above

Fritz Pölking
Münsterstrasse 71
48268 Greven
GERMANY
Tel: (0049) 2571 52115
Fax: (0049) 2571 953269
Email: fritz@poelking.com
www.poelking.com

Benjam Pöntinen
Onnelantie 9
60550 Nurmo
FINLAND
Tel: (00358) 6 414 6136
Fax: (00358) 6 414 6136
Email: benjam.pontinen@netikka.fi

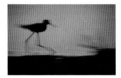

Milán Radisics
Táltos St. 15/b, Budapest 1123
HUNGARY
Tel: (0036) 1 457 8000
Fax: (0036) 1 457 8008
Email: radisics@milan.hu
www.milan.hu

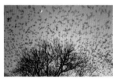

Bernd Römmelt
Volkartstreet 17
80634 Munich
GERMANY
Tel: (0049) 89 1301 2614
Tel: (0049) 89 175 526 3686
Email: bernhard_roemmelt@yahoo.de

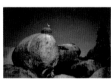

José B Ruiz
PO Box 58, 03080 Alicante
SPAIN
Tel: (0034) 96 596 1330
Email: jbruizl@hotmail.com
www.josebruiz.com

Nature Picture Library
BBC Broadcasting House
Whiteladies Road
Bristol BS8 2LR
UK
Tel: 0117 974 6720
Fax: 0117 923 8166
Email: info@naturepl.com
www.naturepl.com

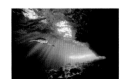

Manu San Félix
Av. Mediterráneo, 90
07870 Formentera
SPAIN
Tel: (0034) 971 32 2105
Fax: (0034) 971 19 2884
Email: manu@vellmari.com

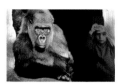

Gerhard Schulz
Luetkensallee 39
22041 Hamburg
GERMANY
Tel: (0049) 40 656 4217
Fax: (0049) 40 656 4204
Email: schulz-naturphoto@t-online.de
www.schulz-naturphoto.com

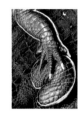

Tim Shuda
361 Stratton Ct.
Langhorne
PA 19047
USA
Tel: (001) 215 752 9879
Fax: (001) 215 752 0116
Email: tim.shuda@verizon.net

Rhé Slootmaekers
Kijkuitstraat 17
2920 Kalmthout
BELGIUM
Tel: (0032) 3 666 32 71
Fax: (0032) 3 666 32 71
Email: rhe.slootmaekers@skynet.be

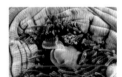

Steve Smithson
51-53 Park Lane, Macclesfield
Cheshire SK11 6TX
UK
Tel: 01625 611108
Fax: 01625 611969
Email: info@new-horizon.co.uk
www.new-horizon.co.uk

Budd Titlow
BSC Group
33 Waldo Street, Worcester
MA 01608
USA
Tel: (001) 617 896 4525
Fax: (001) 508 792 4509
Email: btitlow@aol.com

Darryl Torckler
230 Mahurangi West Road
RD-3
Warkworth
NEW ZEALAND
Tel: (0064) 9 422 0555
Fax: (0064) 9 422 0575
Email: info@darryltorckler.com
www.darryltorckler.com

Andy Townsend
22 Bramble Street, Ridgeway
TAS 7054
AUSTRALIA
Tel: (0061) 3 6239 1878
Email: andy.townsend@aad.gov.au
www.ozimages.com.au/portfolio/
atownsend.asp

Stefano Unterthiner
Via Trento 5
11027 St Vincent (Ao)
ITALY
Tel: (0039) 347 6951159
Email: unter@libero.it
www.stefanounterthiner.com

Maurizio Valentini
Via C. De Lollis 26
66100 Chieti
ITALY
Tel: (0039) 0871 33 0257
Fax: (0039) 0871 33 0257
Email: mauvalentini@tiscali.it

Alwin A K Van der Heiden Roosen
Calle Bateria # 7B, Cerro del Vigía
Mazatlán Sinaloa
MEXICO
Tel: (0052) 669 982 4459
Fax: (0052) 669 982 4429
Email: aakvdh@yahoo.com

Jenö Veres
Naszalyi Str. 3
2030 Érd
HUNGARY
Tel: (0036) 30 415 1028
Fax: (0036) 23 377 611
Email: jveres@geometria.hu
www.fenyvaraz.hu

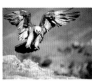

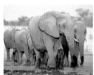

Fanie Weldhagen
PO Box 1454
Montana Park 0159
SOUTH AFRICA
Tel: (0027) 12 8080857
Fax: (0027) 12 8080490
Email: fanie@weldhagen.co.za

The Natural History Museum Picture
Library, Cromwell Road
London SW7 5BD
UK
Tel: 0207 942 5323
Fax: 0207 942 5443
Email: nhmpl@nhm.ac.uk
www.nhm.ac.uk/piclib

Jaco Weldhagen
PO Box 1454
Montana Park 0159
SOUTH AFRICA
Tel: (0027) 12 8080857
Fax: (0027) 12 8080490
Email: gerda@weldhagen.co.za

Liisa Widstrand
Smedvägen 5
176 71 Järfälla
SWEDEN
Tel: (0046) 8 583 545 47
Fax: (0046) 8 584 903 30
Email: photo@staffanwidstrand.se

Staffan Widstrand
Smedvägen 5
176 71 Järfälla
SWEDEN
Tel: (0046) 8 583 518 31
Fax: (0046) 8 584 903 30
Email: photo@staffanwidstrand.se
www.staffanwidstrand.se

Nature Picture Library
BBC Broadcasting House
Whiteladies Road
Bristol BS8 2LR
UK
Tel: 0117 974 6720
Fax: 0117 923 8166
Email: info@naturepl.com
www.naturepl.com

Bruce Coleman, The Natural World
16 Chiltern Business Village, Arundel Road
Uxbridge UB8 2SN
UK
Tel: 01895 467990
Fax: 01895 467959
Email: library@brucecoleman.co.uk
www.brucecoleman.co.uk

Corbis
111 Salusbury Road
London NW6 6RG
UK
Tel: 0800 731 9995
Fax: 020 7644 7645
Email: info@corbis.com
www.corbis.com

Naturbild
Drottning. 73 B, Box 3353
103 67 Stockholm
SWEDEN
Tel: (0046) 8 411 43 30
Fax: (0046) 8 411 22 30
Email: info@naturbild.se
www.naturbild.se

Chris Wilton
51 4th Street
Houghton 2198
SOUTH AFRICA
Tel: (0027) 11 728 4402
Fax: (0027) 11 477 1069
Email: bwilton@mweb.co.za

Winfried Wisniewski
Nordring 159
45731 Waltrop
GERMANY
Tel: (0049) 230 977 116
Fax: (0049) 230 977 117
Email: w.wisniewski@t-online.de

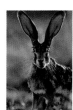

Stephen Wong
5A Everwell Garden
1 Sheung Hong Street, Homantin
Kowloon
HONG KONG
Tel: (00852) 9494 0686
Fax: (00852) 2761 0104
Email: saiwong@netvigator.com
www.stephenwong.com

Jeremy Woodhouse
4304 Standridge Drive, The Colony
TX 75056
USA
Tel: (001) 972 625 1595
Fax: (001) 972 624 1946
Email: jeremy@pixelchrome.com
www.jeremywoodhouse.com

Masterfile Corporation
175 Bloor Street East
South Tower, Second Floor
Toronto
Ontario M4W 3R8
CANADA
Tel: (001) 800 387 9010
Fax: (001) 416 929 2104
E-mail: info@masterfile.com
www.masterfile.com

Solvin Zankl
Schwartenbeker Weg 67
24107 Kiel
GERMANY
Tel: (0049) 431 311 581
Fax: (0049) 403 603 01 7116
Email: szankl@aol.com
www.solvinzankl.com

Jean-Pierre Zwaenepoel
Sint-Godelievedreef 23
8310 Brugge
BELGIUM
Tel: (0032) 50 442 666
Email: jp.zwaenepoel@pandora.be